A History of Calligraphy

A HISTORY OF
CALLIGRAPHY

Albertine Gaur

Cross River Press

A DIVISION OF ABBEVILLE PUBLISHING GROUP

NEW YORK · LONDON · PARIS

First published in the United States of America in 1994 by
Cross River Press, a Division of Abbeville Publishing Group,
488 Madison Avenue, New York, N.Y. 10022

ISBN 1–55859–870–7

First published in Great Britain in 1994 by The British Library,
Great Russell St, London WC1B 3DG

Designed by Gillian Greenwood
Printed and bound in Italy

Ioannes de Verae Sembedisi

CONTENTS

ACKNOWLEDGEMENTS

I would like to thank the following for valuable assistance with the preparation of this book: Michelle Brown, British Library Manuscript Collections; Yu-Ying Brown, British Library Oriental Collections; Ken Gardner, formerly of British Library Oriental Collections; Beth MacKillop, British Library Oriental Collections; Yasin Safadi, British Library Oriental Collections; Peter Stocks, British Library Oriental Collections; Frances Wood, British Library Oriental Collections; and Karyn Gilman, editor of *Calligraphy Review*.

The British Library is also grateful to the institutions and individuals cited in the caption references for permission to reproduce the illustrations.

Albertine Gaur, 1994

ABBREVIATIONS USED IN THE TEXT

AG ALBERTINE GAUR *A History of Writing*, 3rd revised edn., London/New York, 1992

AS ANNEMARIE SCHIMMEL *Calligraphy and Islamic Culture* 2nd edn., London, 1990

AW ANTHONY WELCH *Calligraphy in the Arts of the Muslim World*, New York, 1979

CAM C. AINSWORTH MITCHLER *Inks, their Composition and Manufacture*, London, 1937

CCM CH'EN CHI-MAI *Chinese Calligraphers and their Art*, New York, 1966

CdH CHRISTOPHER DE HAMEL *Medieval Craftsmen: Scribes and Illuminators*, London, 1992

DC DAVID CHIBETT *The History of Japanese Printing and Book Illustration*, Tokyo, 1977

DJ DONALD JACKSON *The Story of Writing*, London, 1987

DK DA-WEI KWO *Chinese Brushwork in Calligraphy and Painting, its History Aesthetics and Techniques*, Montclair, 1981

DSR D.S. RICE *The unique Ibn al-Bawwab Manuscript in the Chester Beatty Library*, Dublin, 1955

EMB EMMA M. BUTTERWORTH *The complete Book of Calligraphy*, Wellingborough, 1981

EJ EDWARD JOHNSTON *Formal Penmanship as defined by the Things*. London, 1983

FWM/HC FREDERICK W. MOTE AND HUN-LAM CHU *Calligraphy and the East Asian Book*. Princeton, 1988

HC HEATHER CHILD *Calligraphy today, twentieth' century Tradition and Practice*. London, 1988

IRF ISMAIL R. FARUQI AND LOIS LAMAYA FARUQI *The Cultural Atlas of Islam*. London, 1986

JIW JOYCE IRENE WHALLEY. *Writing Implements and Accessories, From the Roman Stylus to the Typewriter*. Vancouver/London, 1975

JS JOHN STEVENS, *Sacred Calligraphy in the East*. London, 1988

KHA/MS ABDELKEBIR KHATIBI AND MOHAMMED SIJELMASSI *The Splendour of Islamic Calligraphy*. London, 1976

LLC/PM LEON LONG-YIEN CHANG AND PETER MILLER *Four thousand Years of Chinese Calligraphy*. London, 1990

MD MARC DROGIN *Medieval Calligraphy; its History and Technique*. London, 1980

MH MICHAEL HARVEY *Calligraphy and the Graphic Arts*. London, 1988

MPB MICHELLE P. BROWN *A Guide to Western historical Scripts from Antiquity to 1600*. London/Toronto, 1990

NG NICOLETE GRAY, *A History of Lettering, creative Experiment and Lettering Identity*. Oxford, 1986

SM STANLEY MORISON *American Copy-books, an Outline of their History*. Philadelphia, 1951

SO/TK SOGEN OMORI AND TERAYAMA KATSUJO *Zen and the Art of Calligraphy: the Essence of Sho*. London, 1983

THT TSUEN-HSUIN TSIEN, *Written on Bamboo and Silk; the Beginning of Chinese Books and Inscriptions*. Chicago, 1962

WEB W.E. BEGLEY *Monumental Islamic Calligraphy from India*. Villa Park, 1985

YHS YASIN HAMID SAFADI *Islamic Calligraphy*. London, 1978

LIST OF COLOUR PLATES

Western Calligraphy

Arabic Calligraphy

Chinese Calligraphy

Calligraphy Today

94.

Doctrina Spiritus non curiositatem acuit, Sed charitatem accendit. Ipse est christianus, qui in domo sua peregrinum se cognoscit. Nouit Deus mutare sententiam : Si tu noueris emendare delictum. Vehementer Ecclesiam Dei destruit meliores laicos esse quam clericos. Quocunquè tempore non cogitaueris Deum putate tempus illud amisisse. Pudicitia est virtùs non solum impetum libidinis coercens, sed et signa cohibens. Patria nostra sursum est, ibi hospites non erimus. Sicut ligat Diabolus, qui peccata conectit: ita soluit christus qui delicta remittit. Nil magnum in rebus humanis, nisi animus magna despiciens. &.

PLATE I Mira calligraphiae monumenta, *inscribed by Georg Bocskay in 1561–62 and* *illuminated by Joris Hoefnagel.* J. PAUL GETTY TRUST, MS 20, f. 94, 86.MV.527

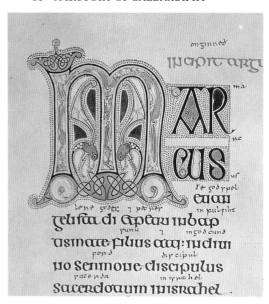

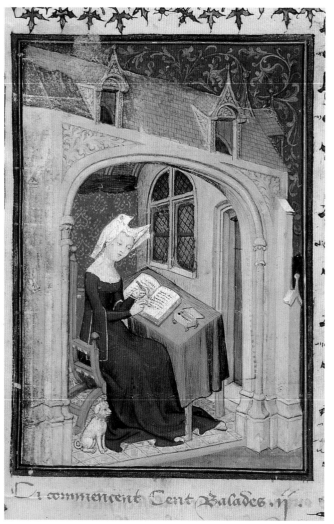

PLATE II *(ABOVE, LEFT) A page from the Lindisfarne Gospels; the main text (c.698AD) is written in Insular majuscule (a script first developed in early Christian Ireland), the Anglo-Saxon gloss (added in the mid-10th century) is in Anglo-Saxon minuscule. The elaborate initial M, marking the opening of the* argumentum *to Mark with the word 'Marcus', has elongated animal forms, painted in delicate colours, inside the outlines of the letter as well as on the ground which it encloses. The remaining five letters of the saint's name are enhanced with patches of colour against a background of red dots.*
BRITISH LIBRARY, COTTON MS NERO D.IV, f.90

PLATE III (OPPOSITE, RIGHT) *Theological Tracts, St Ambrose* De Misteriis. i; *Probably Rochester Priory, mid-12th century* AD. *This is a fine example of English Protogothic, the consistent application of sloping feet to the minims (downwards strokes), a particularly English feature, shows the influence of Anglo-Saxon minuscule. The change from Carolingian roundness to the oval aspect of Protogothic is becoming more apparent. The title is written in Rustic Capitals and the splended initial D is filled with the seated figure of St Ambrose.*
BRITISH LIBRARY, ROYAL MS 6 B. VI, f.2

PLATE IV (OPPOSITE, BELOW) *An autograph manuscript, probably written in Paris c.1410–15*AD, *containing the collected works of Christine de Pisan (1364–1430), who in the miniature is shown writing at her desk; the script of the manuscript is Bastard Secretary.*
BRITISH LIBRARY, HARL. MS 4431, f.4

PLATE V (ABOVE) *The 42-line Bible printed in Gutenberg's workshop at Mainz between 1453–55. At this early stage printers felt themselves in competition with scribes and their aim was to make the printed book look like a manuscript. For example, initials were sometimes added at a later stage with the help of wood or metal blocks, or a space was left by the printer for the illuminator/illustrator to complete the finished page by hand.*
BRITISH LIBRARY, C. 9. D. 4

PLATE VI *The* **Divan** *of Hafiz, probably from Shiraz, 1451* AD. *The paper of the individual pages has been tinted in different colours, gold-sprinkled and glazed; some pages are further embellished with Chinese-influenced designs in gold.*
BRITISH LIBRARY, ORIENTAL AND INDIA OFFICE COLLECTIONS, ADD. 7759, ff.66/61

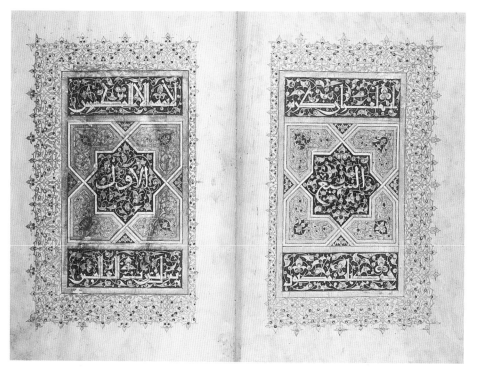

PLATE VII *Opening in a Koran copied in seven volumes by Muhammad ibn al-Wahid in 1304*AD *in Egypt for the High Chamberlain (later Sultan Baybars II). The script is Eastern Kufic in the upper and lower panels and Thuluth over a gold foliar arabesque in the centre of each folio.*
BRITISH LIBRARY, ORIENTAL AND INDIA OFFICE COLLECTIONS, ADD. MS 22406

PLATE VIII *Page from a Koran copied in Maghribi script on vellum, in the 11th century* AD, *in Spain or Northwest Africa. The vowels are in red, with other orthographical signs in blue-green and saffron.*
BRITISH LIBRARY, ORIENTAL AND INDIA OFFICE COLLECTIONS, OR.11780, ff.64V–65

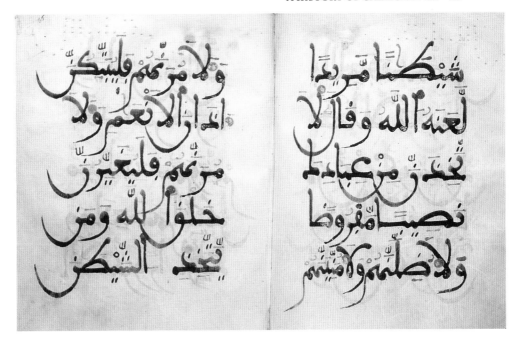

PLATE IX *Calligraphy was widely used in connection with architecture in the form of inscriptions on mosques, tombs,* madrasas, *forts, palaces, gateways, tanks, wells and* karavansarais *for religious reasons (verses of the Koran, the name of Allah, the Prophet, etc.) or for political purposes (eulogies of patrons or rulers), or to provide historical data (references to visits, endowments, etc.). Samarkand (left): glazed tiles decorating the outer walls of the tomb of Timur (reigned 1370–1405*AD*) with inscriptions in metric Kufic. Edirne (right): inscribed tiles inside the mosque built for Sultan Murat II (reigned 1421–1444*AD*).*
PHOTOGRAPHED 1978 AND 1991

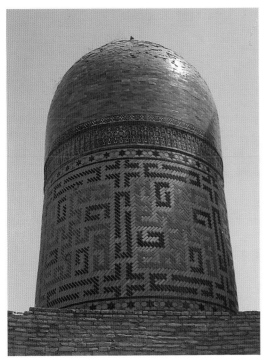

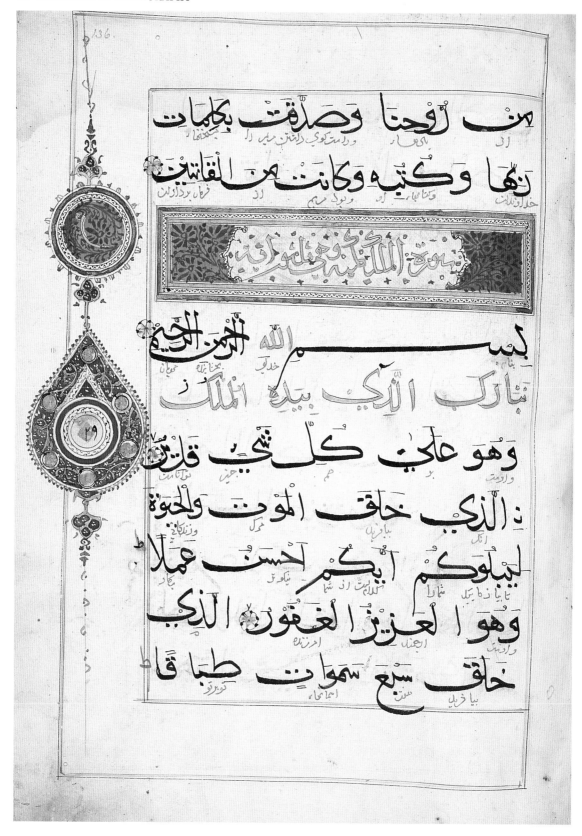

PLATE X *A page from a Koran written in Bihari script, 16th century* AD. BRITISH LIBRARY, ORIENTAL AND INDIA OFFICE COLLECTIONS, ADD. MS 5551, f.136

PLATE XI *One from a group of* munjado *panels from Korea, elegantly mounted (in Japan) as a scroll. Each panel consists of just one Chinese character (here the character for 'loyalty') representing one of the eight virtues of the Confucian classics, all written in a highly unusual style of calligraphy. End of the 19th century.* BRITISH LIBRARY, ORIENTAL AND INDIA OFFICE COLLECTIONS

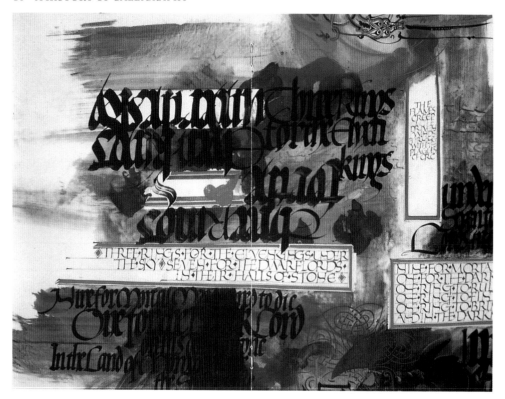

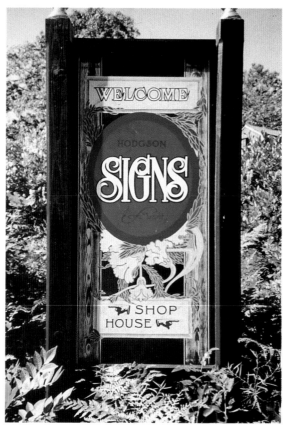

PLATE XII *(OPPOSITE, ABOVE)* In the Land of Mordor where the Shadows lie, *Variation 1; from J. R. R. Tolkien's* The Lord of the Rings *by Donald Jackson (1987). Jackson (born 1938), today one of the most prominent British calligraphers, has also been a catalyst for the revival of calligraphy in the United States. Since 1964 Official Scribe to Queen Elizabeth II and the House of Lords, he is a past President of the Society of Scribes and Illuminators, and the author of* The Story of Writing, *first published in 1981.*
REPRODUCED WITH MR JACKSON'S PERMISSION FROM *THE CALLIGRAPHY OF DONALD JACKSON,* 1988

PLATE XIII (OPPOSITE, BELOW LEFT) Polylineal calligraphy communicates visually instead of verbally and is as such already removed from Western traditions. It is a method of composition that employs fragmentation and the repetition of words. From Rene Schall's brush and watercolour Moving Line III Series.
REPRODUCED WITH PERMISSION OF MS R. SCHALL

PLATE XIV (OPPOSITE, BELOW RIGHT) In America the golden age of sign painting fell between 1850–1935 when movie posters, billboards and numerous advertisements in stores made use of hand-painted signs. Although three-quarters of signs are now produced by computer graphics, there are still a good number of professional sign painters in the United States (and in Great Britain). Boston has a sign-painting school, Chicago a strong Sign Painters Trade Union, and a magazine called Sign Craft *is published in Florida which keeps members of the craft informed. Unlike other areas of commercial art, signs are one-offs, they must be produced quickly, and there is no time to insist on achieving perfection (or, as one sign painter rather ruefully put it, 'sign painting is the illusion of perfection'); but very good work is still being done.*
PHOTOGRAPHED AT MARTHA'S VINEYARD, MASS, USA, AUGUST 1992

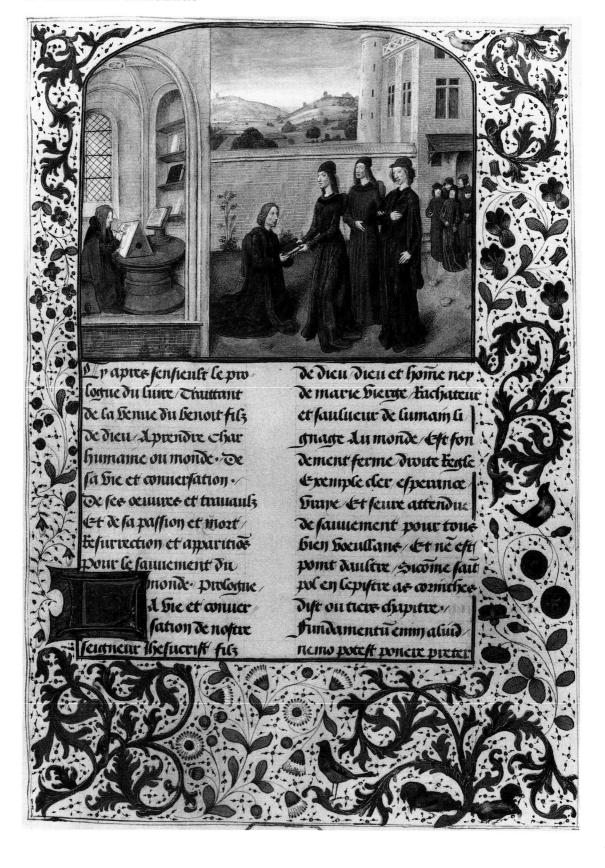

PREFACE

What is calligraphy? To answer this question we must first of all ask ourselves: what is writing, and how do the objective and purpose of writing differ from that of calligraphy?

Writing stores information essential to the social, economic and political survival of a particular group. It is thus intimately connected with the practical well-being and the physical survival of society. Calligraphy makes a statement about a particular society, a statement about the sum total of its cultural and historical heritage. Calligraphy is more than beautiful writing. It results from an interaction of several essential elements: the attitude of society to writing; the importance and function of the text; definite, often mathematically based, rules about the correct interaction between lines and space and their relationship to each other; and mastery and understanding of the script, the writing material and the tools used for writing. Unlike writing, the art of calligraphy cannot be acquired simply by learning; it demands insight and individuality, but individuality expressed within strictly prescribed boundaries. Calligraphy is to a large extent an expression of harmony, as perceived by a particular civilization. The calligrapher is in harmony with his script, his tools, the text and his own spiritual heritage.

Why then did some societies develop (or feel the need to develop) calligraphy, whereas others produced at best sporadic manifestations of beautiful writing which in the final instance failed to become codified systems of styles and scripts? A basic requirement is without doubt the presence of enabling agents such as congenial writing tools and forms of writing material. Added to this must be not only motivation, but also a definitely perceived need for a visible declaration of cultural unity. On this definition, only three civilizations have produced true calligraphy: the Arabs (and those who use the Arabic script); the Chinese (and those who use the Chinese script); and Western civilization based on Roman letters, Roman laws and the Christian Church. Though visually vastly different in each civilization, the purpose of calligraphy in each case is basically the same: to act as a 'corporate logo' for the whole extended group. The differences are based on three elements: the difference in script, the motivation which prompted the development of calligraphic traditions in the first place, and the ultimate objective of those traditions within a given cultural, religious and political context.

The position of the calligrapher within each group reflects the attitude of society to his craft and the level at which it is practised. In a hierarchical

Vita Christi and
*Vengance de la Mort
Ihesu Christ* [see 34].

society (and in the final instance all societies are hierarchical), the way in which society sees its members, and the way they see themselves, determines their value and that of their contribution to the community. In the West the calligrapher has always been 'in service' – whether to a human master (Rome), the monastic order to which he had given his life, or eventually simply to the customer who paid him. He was, for most of the time 'market-driven'. The Islamic calligrapher too was 'in service', but in the service of God and the divine revelation, his ultimate reward transcending worldly expectations. Only in the Far East did the calligrapher exist in his own right. His work was first and foremost creative (though within strictly defined lines); it did not propagate, uphold or convert to any secular or religious order but was an expression of his own inner self. There have of course always been women calligraphers; neither Christianity, nor Islam and certainly not the traditions of the Far East excluded them. But until the 20th century women have always been fewer in number and, as we shall see, constrained by different problems.

The objective of this book is to explore the history of calligraphy and the place of the calligrapher within the context of three totally different and well-defined traditions. This leads us invariably to the next question: is it possible to understand a phenomenon so closely linked with cultural identity in a society other than one's own? The answer to this question is a very definite yes, providing we approach the subject with a certain amount of humility and try to look at it not from our own point of view but from the point of view of the 'others'. Cultural identities and national characteristics are the result of interaction between a number of well-defined forces: history, geography, economics and politics (religion being frequently the continuation of politics by other means).

What this book does not attempt is an exploration or definition of the aesthetics of calligraphy since those (especially in a cross-cultural study) do not offer themselves easily to judgement and must in any case be assessed within their own cultural context. Nor is it the objective of this book to offer overall value judgements. Names and examples have been selected mainly for the purpose of illustration. There are many excellent calligraphers who, because of lack of space, have not been mentioned. This is especially true when it comes to the history of 20th-century calligraphy which could be properly explored only in a separate work devoted entirely to the subject. The order of the three great traditions into (first) Western, (then) Arabic and (finally) Chinese calligraphy too has been chosen simply as an aid to the majority of readers who will, since the book has been published in the West, be more familiar with the Roman script, Western traditions and the history which shaped Western calligraphy. There is a good deal less difference between Islam and Christianity, both of which consider the written book and the beauty of writing essential for the preservation of divine revelations (and use a similar amount of written characters and basically the same tools),

than there is between Islam and Christianity on the one hand and Far Eastern traditions based on entirely different concepts (and a vastly different writing system) on the other. One hopes that, having once firmly established his or her own base, the reader may find it easier to venture into new territory.

Albertine Gaur, 1994

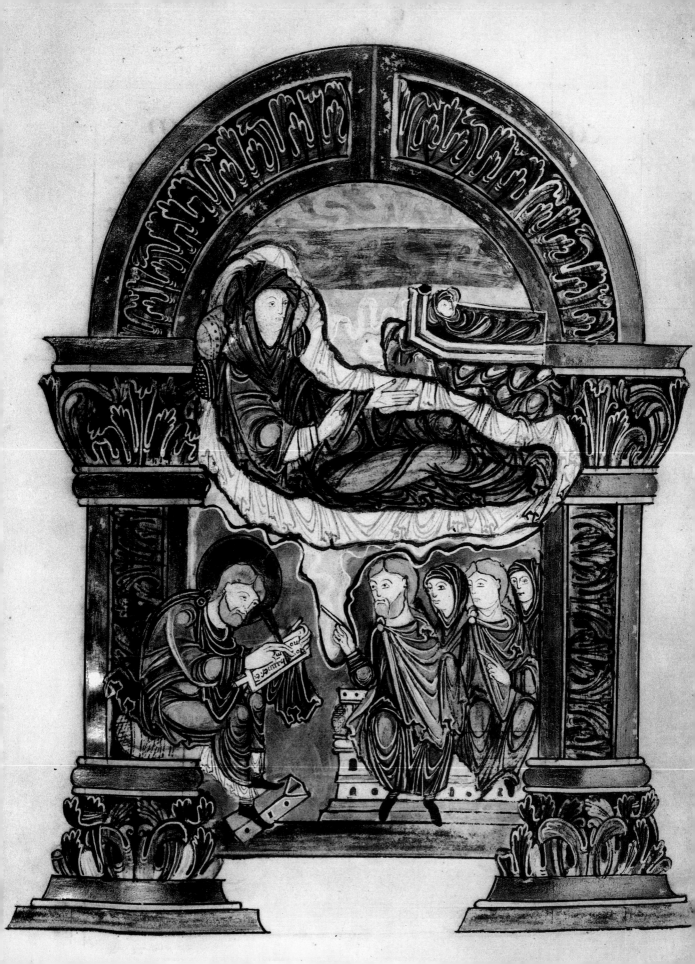

THE TOOLS FOR WRITING

The calligrapher needs five things – a fine temperament, understanding of calligraphy, a good hand, endurance of pain, and a perfect set of implements.
MIR ALI OF HERAT, DIED 1556

Calligraphy depends largely on the tools used for writing. A smooth surface which allows for swift movements across the page, writing instruments which are able to produce a variation of line: these have always been the essential prerequisites for the development of fine calligraphic styles [*see* 71]. The sharp, unyielding point of a stylus on wax, as used in Rome and Greece, wet clay in Mesopotamia and the ancient Mediterranean, or palm-leaves, in South and Southeast Asia, can produce pleasing results but not calligraphy. The enabling agents in the development of Western as well as Islamic and Far Eastern calligraphy have been paper (and before its discovery, silk) and parchment, together with the pen, brush and ink.

Calligraphers have always paid great attention to their tools; the way the pen can be trimmed to create different strokes and angles (and with it different styles), how the brush and other implements are handled (and when not in use, kept in good order), the possibilities for smoothing the surface of paper and parchment, the preparation of ink, and related issues, have been the subject of treatises and discussions throughout the centuries. The attitude to the tools used for writing largely reflects the attitude of society to calligraphy itself. In Islam, where calligraphy is part of a theocratic order, the pen becomes imbued with mystic qualities directly related to the will of God and the purpose of creation. In the predominantly secular Far East, where the ability to write a fine hand was a mark of distinction, the 'four gems of the study' (brush, paper, ink and inkstone) testify to the status of its owner. In the West the calligrapher has primarily always been a craftsman, and craftsmen take care of the tools on which their livelihood depends.

The Benedictional of St Aethelwold, written by Godeman for Aethelwold, Bishop of Winchester, 975–980AD [see 4].

Pen, brush and ink

PEN

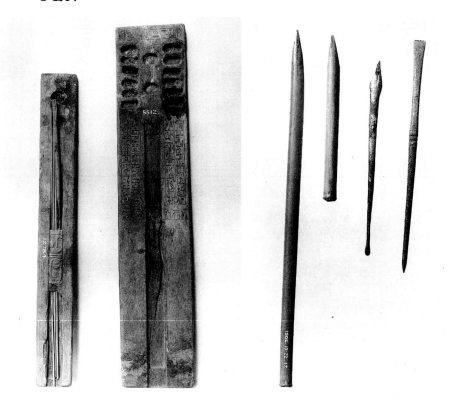

The main instrument used by Western, as well as Islamic calligraphers, is the pen – made either of reed, feathers, or metal. Historically the pen dates back to ancient Egypt, where a type of brush-pen [1] seems to have replaced a pointed, more inflexible stylus in about the middle of the 3rd millennium BC, at the time when the hieratic style of writing developed; indeed the difference between hieroglyphic and hieratic (rounding of angular signs and less detail) is more or less the result of this development. Brush-pens were cut at a length of 15–25 cm from the thin stem of a slender rush plant (*Juncus maritimus*); the scribe would hammer and chew one end to fray the fibre which allowed for a certain amount of ink to be retained during writing. In the 3rd century BC a new pen, fashioned from a hollow-stemmed marsh plant (*Phragmytis communis*), was introduced by the Greeks. This was already a much more sophisticated writing tool: one end, cut at an angle, had a slit made opposite the cut to divide the nib into two halves to draw ink down to the writing surface [2]. Such reed pens wrote well on papyrus but less so on parchment, and by the 6th century AD they were being replaced by the quill pen (*penna*, Latin for 'feather').

Quill pens [3] are tougher and more flexible than those made of reed; they need to be reshaped less often (though a busy scribe might still have to trim –

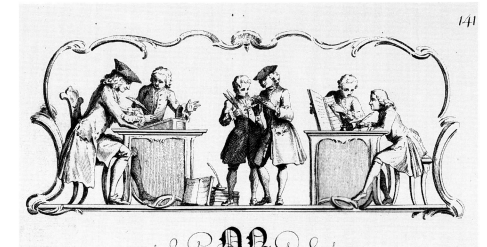

On
Promiſſory Notes.

A Promiſſory Note mentioning Order *is indorſible from one Perſon to another; which is done by the preſent Poſſeſſor's writing his Name on the Back of it, and delivering it up to the Party, to whom he intends to aſſign over his Property therein.*

It is unneceſſary to have a Promiſſory Note payable to Bearer *indorſed, if you are ſatisfy'd the Note is good: And if a Note be indorſed, it is neceſſary to write a Receipt thereon, to prevent its being negociated, after it is paid and deliver'd up.*

If the Drawer of a Note refuſes Payment, the Note is good againſt the Indorſer. The delivering up a Promiſſory Note to the Perſon who ſign'd it is a ſufficient Voucher of its being paid, nor is there any Occaſion of writing a Receipt thereon.

Promiſſory Notes, and Book-Debts, if not legally demanded in ſix Years, cannot be recover'd by Law: And if you keep a Promiſſory Note upon Demand, *in your own Hands above three Days, and the Perſon it's upon ſhould fail, the Loſs will be your own; but if he fail within the three Days it will light on the Perſon that paid it you. Let all Notes be made for Value receiv'd, and in the Form of theſe that follow.*

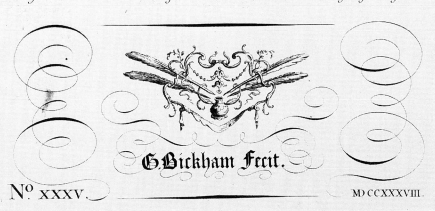

G. Bickham Fecit.

Nᵒ. XXXV. MDCCXXXVIII.

3 The Universal Penman *by George Bickham, a manual first published in parts between 1733–41, includes Bickham's own work and that of 25 contemporary penmen. Bickham was responsible for the engraving of most plates and the many decorative head pieces. The one here reproduced shows clerks working in a commercial firm; such clerks needed a good round business hand which could only be acquired through tuition (by a writing master) and practice. The quill pen, dating back to the middle of the first Christian millennium, is still the preferred writing instrument.* VICTORIA AND ALBERT MUSEUM, 86.T.10

that is, cut across the tip of the nib – as often as 60 times in one day), and it is possible to write smaller letters more easily. The best quills are fashioned from the primary flight feathers of a goose or a swan; they have to be stripped of barbs, dried for several months, soaked in water and then cured (hardened) in hot sand. Feathers from the left wing are usually preferred since they curve more easily into the hand of a right-handed person. The barrel of the quill (a tough and almost transparent tube) is in many ways similar to the stem of a hollow reed and the nib can therefore be cut in a similar manner (DJ; p.47), which no doubt eased the transition. Claims have sometimes been made that the microscopic scripts employed by some scribes were made with crow or raven quills; this is technically possible but holding such a pen would have caused the scribe a good deal of discomfort. Turkey feathers make excellent quills but as a native of America the turkey was unknown in medieval Europe. Unlike the Islamic calligrapher, the medieval scribe relied more on experience and verbal instructions than on detailed, written treatises about the cutting or manufacture of quill (or indeed reed) pens. When in the 19th and early 20th centuries Western calligraphy began to stage a tentative revival, pioneers like Edward Johnston (*see* p.185) more or less reconstructed the way the quill has to be cut from the way the letters were written in the medieval manuscripts they had studied. Judging from medieval miniatures, most scribes seem to have held the quill (and where appropriate, the stylus) differently from the way we now hold the pen: that is, pointing downwards on the inside of the tips of the middle and forefinger and steadied by the tip of the thumb, with the rest of the fingers curved away from the pen [4]. Held in such a way the quill meets the page more vertically, thus facilitating a better ink flow, but the fingers have less control and the whole hand has to involve itself in each movement.

The adoption of the quill coincided with other important changes in the way manuscripts were prepared and written. Between 200 and 400AD the classical papyrus scroll began to make way for the Christian parchment codex [4], where folded pages are gathered and sown together. The parchment codex had many advantages: it could be carried more easily, it was more cost-effective, since both sides were suitable for writing, and individual portions of the text could more readily be consulted, all elements which commended it to the new, poor and proselytizing Christian communities who looked upon the Bible as the ultimate source of their authority. In the century which followed the fall of Rome (410AD), book production, together with literacy, moved from the Mediterranean countries to northern Europe where suitable reed was no longer available. The quill, a writing instrument of great strength and flexibility, became the principal tool of Western calligraphy until the 19th century, easily surviving the change from parchment to paper in the 15th century. Even today many calligraphers prefer it because of its ability to produce crisp strokes and fine hairlines.

Islamic calligraphers used the *qalam*, the reed pen. Cut from dried reed

4 The Benedictional of St Aethelwold, written by Godeman for Aethelwold, Bishop of Winchester, c.975– 980AD. This page shows the scribe holding a stylus and writing on a wax tablet. Wax tablets were widely used in Mesopotamia, and around the Mediterranean during Greek and Roman times. In Rome the practice of lacing together several wax tablets with leather thongs influenced the development of the codex, *which consists of individual sheets of parchment (later paper) cut to the same size, folded, arranged in 'gatherings' and sewn together. Wax tablets did however continue in use throughout the middle ages as a cheap and easy means of taking notes.*
BRITISH LIBRARY, ADD. MS 49598, f.92V

(*c*.10 cm long and 1 cm wide), the upper edge was rounded and the shaft curved and blunted at the edge so as not to hurt the fingers of the scribe. Medieval Islamic scribes cut their reeds in March and covered them with fermenting manure for six months to dry the pith and harden the reed in order to make the nib more durable. The best pens came from Wasit (Iraq), and Shiraz (Persia), later also from India, Egypt and the shores of the Caspian Sea.

Arabic handbooks on calligraphy devote much space to the clipping and trimming of the reed pen. To fashion the nib, the shaft is divided into a left and right lip, with a groove for holding ink. The actual width of the nib is of vital importance since it determines the size of the rhombic dot, the most basic unit of measurement in Islamic calligraphy (*see* p.90). The point of the pen could be cut either straight or bevelled to facilitate a different thickness of stroke. While at first the nib was cut straight, in the 13th century the great calligrapher Yaqut (*see* p.95) cut it at an angle which introduced a variety of new possibilities, and with it styles (for example, the right side must be double that of the left in the case of Naskhi; the opposite for Diwani; and each side must be equal for Nasta'liq). In other words, each calligraphic style demands a different cut of pen. Occasionally a calligrapher would use a fine steel pen or a quill, but this was considered so exceptional that it was usually noted in his biography. In some early manuscripts from India and Central Asia reference is also made to the use of the brush.

In the Islamic world the calligrapher and his tools [5] enjoyed enormous prestige. Pens were treasured possessions and were considered suitable pre-

5 An illustration from a Turkish manuscript showing members of the scribal room: a scribe (holding a book), an artist (holding a drawing), and the instruments used for writing such as pen, ink, scissor, brush, pen-case and hour-glass; 1681AD BRITISH LIBRARY, ORIENTAL AND INDIA OFFICE COLLECTIONS, OR.7043, f.7V

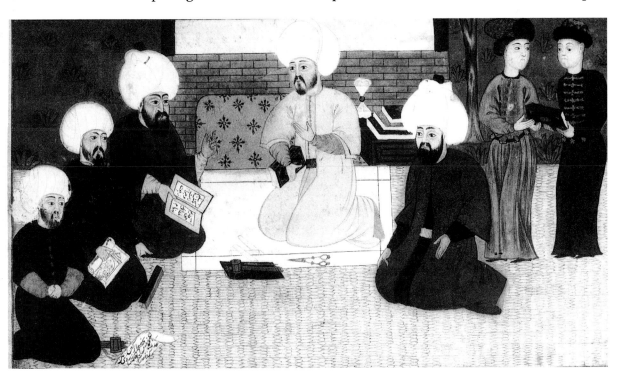

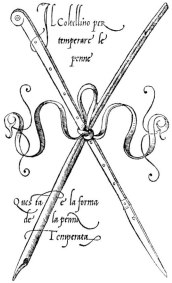

sents for high dignitaries: the Fatimid Caliph al-Mustansir (reigned 1036–1094AD) is reputed to have owned boxes full of precious pens, some of them (he believed) once used by such renowned calligraphers as Ibn Muqlah (died 940AD) and Ibn al-Bawwab (died 1022AD) (*see* p.102). A rich tradition of metaphors exists in relation to the pen. 'The Pen', writes Ibn az-Zayyat (died 847AD) 'introduces the daughters of the brain into the bridal chamber of books'; they were 'cypresses in the garden of knowledge' (AS; p.39), and so forth.

According to one of the Prophetic traditions, the Pen was the first thing God created, and Sufis look upon it as the symbol of the First Intellect, if not the First Intellect itself. In *sura* 96 of the Koran, God appears as 'He who taught man by the Pen', and the first words of *sura* 68 read '*Nun*, and by the Pen'. Everything found in the Koran has been written down since eternity on the 'Well-preserved Tablet' by the pre-existent Pen. 'The Pen has already dried up' is a saying often quoted to underline the belief that whatever has been decreed cannot be changed. Another tradition tells that when the Pen was about to write down the punishment waiting in Hell for disobedient Muslims, a terrible voice shouted 'Behave, Oh Pen' and from fear the Pen split; to this day every pen has to be split before it can be used for writing (AS; p.78).

An important tool for both Western and Islamic calligraphers was the pen-knife. Quill knives [6] usually had a large handle, and a much shorter blade, with one straight and one convex cutting edge (to make different cuts). They could also be used to erase mistakes by simply scraping offending passages from the parchment (*see* p.77). Western pen-knives were rather simple when compared with their Islamic counterparts. The latter boasted razor-sharp steel blades and were often beautifully ornamented. The cutting of the reed pen itself was usually done on a small ivory or tortoiseshell plate (or one made of similarly hard material) called *makta*. A 10th-century poet claims that the pen-knife is 'angry with the pen and hurts it' (AS; p.40).

6 *Idealized drawing of a pen and a quill knife, as shown on the back cover of* The Journal of the Society for Italic Handwriting, *1963.*
BY COURTESY OF MISS KATHLEEN STRANGE

By the middle of the 18th century the rapid increase of business, adminis-
tration and school education in Western Europe created a demand for a more
durable and simpler pen, one which did not need constant re-cutting and
would, if possible, also hold more ink. Various claims for the 'invention' of the
first metal pen have been registered from France, Germany, America and
England; one claimant (a magistrate from Aachen) boasted that God himself
had inspired him (DJ; p.130). But in reality the metal pen is much older.
One-piece pens (later also with detachable nibs made of bronze, gold, silver
and other metals) were known at least as early as Roman times, but though
they wrote reasonably well on parchment, they did not write as well on the
much more fragile papyrus. The metal pen has other disadvantages too:
carbon ink clogs the nib and iron-gall ink, which works well with the quill,
erodes the metal. Another difficulty was how to shape the nib (and make the
right kind of slit) in order to achieve some of the quill's flexibility. The first
mass-produced models were made entirely by hand, but by the middle of the
19th century Birmingham entrepreneurs produced machine-made nibs
which during the following decades greatly reduced the price. A skilled
operator could make as many as 28,000 blank steel nibs in a day and by the
end of the 19th century Birmingham boasted thirteen major pen factories
producing some 175 million nibs every year (DJ; p.136) which were exported
all over the world. At the same time a non-eroding form of ink came on the
market (invention as so often following need) and soon mass-manufactured
metal pens took the place of the quill.

Already during the 19th century experiments had been made to design a
portable fountain pen [7], and by the 1930s America had taken the lead with
this product. But it seems the fountain pen was not an entirely new concept.

Already in the 10th century AD, we are told that the Caliph al-Mu'izz had expressed a wish for a pen capable of carrying a supply of ink which would flow freely when writing, but not otherwise (since this might have soiled his clothes), and after a number of abortive attempts his craftsmen did indeed produce the required pen, made (naturally) of pure gold.

Whatever the technical and commercial advantages, calligraphically the metal pen, which successfully imitated the then still fashionable copperplate writing (*see* p.176), could never quite match the quill. As Donald Jackson has remarked:

> Using the quill, you have to move your hand more quickly and with speed, like skating on ice, which is an essential ingredient of calligraphy. The quill will do this for you where the steel nib cannot. You have to go quickly with the quill. It has acceleration and flexibility, it can be bent right back on itself and go back together again. If you feel good about the tool, you will write well and it unlocks feelings in you.

The fountain pen proved even less adequate. But the final horror, as far as calligraphy is concerned, occurred after 1945 with the increased use of the ball-point pen. Generally based on a ball revolving in the mouth of a tube, it glides over the page producing thin lines of unrelieved, equal thickness, hardly different from the lines made by a stylus, but often a good deal less tidy.

BRUSH

Chinese calligraphy begins with the brush (*bi*). Tradition names Meng Tian (died 209BC) as the inventor, but this is probably more a reference to the growing importance of calligraphy during the succeeding Han period (206BC–220AD). The earliest writing brush so far discovered dates from the Warring States period (480–222BC), but brushes as such were probably known before. Brushes, perhaps made of some kind of hard fur, seem to have been used to apply designs (slips of colour and dye) on pottery vessels belonging to the 3rd millennium BC (DK; p.50). Some scholars argue that for writing, too, the brush may have been used at an earlier date. Characters inscribed on Shang (1751–1122BC) oracle bones and Zhou (1100–770BC) bronze vessels often give the impression of having been formed after writing-brush patterns [8]. During excavations in 1919 three oracle bones (*see* p.108) were found containing incompletely written characters; an indication, it was thought, that before being incised characters were first written down with brush and ink (THT; p.28). But such evidence is not really conclusive; a bamboo stick dipped in a colouring agent (later an established practice) could have served a similar purpose. Meng Tian's role may well have been that of an improver; the Han period witnessed a great many developments in the field of Chinese calligraphy, developments which to no small extent were

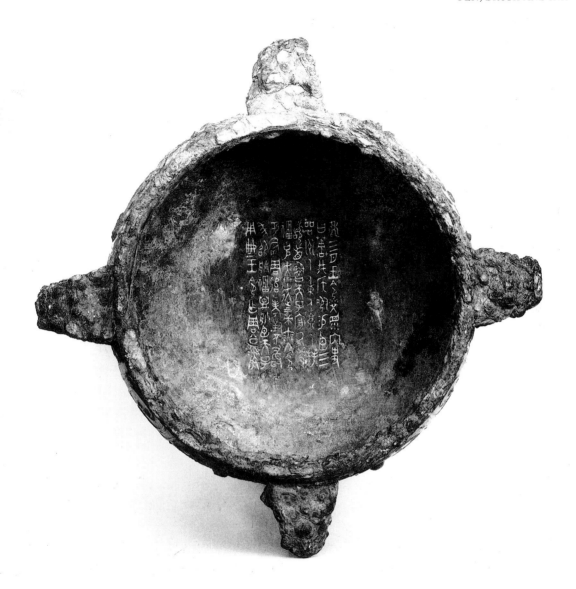

8 Inscription in sunken characters inside a bronze vessel from the Zhou period (1050–771BC). BRITISH MUSEUM, DEPARTMENT OF ORIENTAL ANTIQUITIES, 1936–11–8–1 (11)

brought about by the availability of new, softer, writing materials (silk, silk paper, and finally paper) on which the (improved?) brush could be used to full effect.

The traditional Chinese brush, about 23–30 cm long according to ancient measurements, consists of holder, hair part, and sheath. According to the type of animal hair used, brushes are generally classified into hard-fur brushes (*jian hao*) and soft-fur brushes (*rou hao*). The first are mainly made of weasel hair, are more elastic, and have the ability to produce lines almost as fine as those made by a steel pen. The second category relies mostly on goat hair which makes the brush softer, with a weaker spring, harder to control, but better able to produce a variation of strokes; a certain amount of rabbit and deer hair might be added to increase responsiveness to manipula-

tion. Only the longer hairs of healthy animals were used; they were bound into clusters of equal length, carefully de-greased to enable them to hold ink and water, and then blended with plant fibre (usually hemp) for softness. Washed and trimmed, a suitable number of clusters, treated with an adhesive, was collected to form the final brush head. This brush head had to be carefully dried (first on a bed of charcoal ashes, then by hanging it up), inserted in a handle made of bamboo, wood, ivory, horn, or porcelain, and finally glued into it with molten resin (DK; p.126). The most commonly used brushes fall into two basic categories: *dakai bi*, for writing large characters, and *xiao kai bi*, for writing small characters as well as letters or documents. In Japan (where writing implements have not changed since calligraphy was first introduced from China) the thick brush (*futofude*) produces the main body of the text, and the slender brush (*hosofude*) is used for inscriptions, signatures at the end of a work, or for small and/or more cursive characters.

For writing (and painting – in China painter and calligrapher use the same tools and the same materials) the brush is held, vertically and unsupported, between thumb and index finger, the middle and ring finger resting on the holder as guides. The fingers are only lightly closed; Chinese calligraphers stress that it should be possible to hold an egg in the hollow of one's hand. Using the brush is very different from using the pen. Whereas Western and Islamic calligraphers achieve their results largely by the way they carefully trim the nib of the pen, and by the angle at which the pen is held during writing, Chinese calligraphy is a rhythmic art. While the pen moves, the brush dances. (The Tang calligrapher Zhang Xun who was active between 710–750AD claims to have derived his Mad Grass style from watching a sword dance performed by the lady Gong Sun.) Effects are achieved by lowering and raising the brush, drawing it towards, and flicking it away from oneself. Not only the fingers, but the hand, the arm, the whole body, indeed the whole personality of the scribe are involved in the process of writing. The shoulder should start each movement by leading the arm, the arm should lead the hand; at the beginning of a line the right shoulder should balance the brush at the left side, at the middle of a line both brush and body are in balance, towards the end of a line the left should gradually serve as a brake and at the same time balance the brush on the right side (DK; p.134). To achieve mastery of the brush [9] is no mean feat. The deceptive speed with which the writing is executed is the result of discipline, much training and practice, long periods of concentration, and a deep understanding of the characters, the lines of each character, the order in which they have to be written, the relationship of the individual lines within each character, and of the characters to each other; and, finally, of the correct position of each line and each character in space. Space is of the utmost importance in Chinese calligraphy and painting; Laozi (born 571BC), the founder of Daoism, explains its function by saying 'vessels may be made of clay but it is the space inside them which renders them useful'.

9 Pu Quan (1912–1991), the cousin of the last Chinese Emperor and great grandson of the Qing Emperor Daoguang, a well-known 20th-century painter and calligrapher, demonstrates the use of the brush.

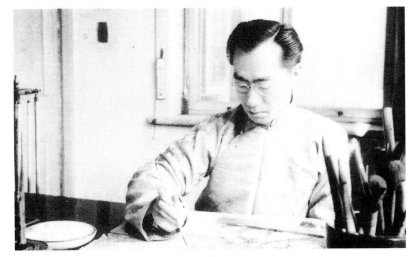

The first treatise on calligraphy, written by Lady Wei Shao (272–349AD), states that a character must have neither too much 'bone' (structure) nor 'flesh' (consistency) nor 'sinew' (composition), but that all three must be in the right relationship to each other. Some of the principal brush strokes are: centre brush (the foundation of both painting and calligraphy, it produces a neat, clear-cut line with a hard edge on both sides and is written with the tip of the upright brush), side brush (tilting the brush to produce a wider stroke), rolling brush, pulling the brush, point brush, split brush, turning and folding the brush (DK; pp.141–170) and so on. Other important considerations are the pressure of the brush on paper, and the speed of writing. Speed affects the flow of the ink and creates a feeling of movement within each line; moreover, a line once drawn is a final entity, which cannot be corrected or improved.

INK

Until the middle of the 19th century two basic types of ink were used: carbon inks and iron-gall inks. Carbon inks are normally made of a lamp black (obtained by burning carbon-containing organic matter with insufficient air supply) which is mixed with water and glue, or vegetable gum (for example gum-arabic, the dried-up sap of the acacia tree brought to Europe from Egypt and Asia Minor). The purest form of lamp black can produce a fine, intensely black image. Carbon inks were used in Egypt on pottery and papyrus as early as 3000BC and many of the surviving examples have retained their dense black colour to this day. Being chemically very stable, carbon inks contain no substance injurious to any writing material, but since the carbon particles are simply deposited on the surface, they can also easily be wiped off and erased.

After 300AD the increasing popularity of parchment (in place of papyrus) in Western Europe and in the Middle East made iron (that is, oak gall) inks a better medium; but carbon-based inks continued to be used alongside iron-gall inks in medieval manuscripts up to the 12th century. Iron-gall ink is prepared by soaking crushed galls (which contain gallo-tannic acid) in water and adding copperas (ferrous sulphate) and gum to the infusion. Copperas was manufactured naturally in Spain by evaporating water from ferrous earth; by the late 16th century it was probably produced by pouring sulphuric acid over old nails and mixing the liquid with alcohol. This mixture was then added to the iron-gall potion and, according to a 16th-century calligrapher/scribe, stirred 'ofte' with a fig stick (CdH; p.33). The final product was a colourless mixture which darkened after oxidation and eventually developed a black deposit. Iron-gall inks can fade with age and often eat into the parchment causing considerable damage; they are however not easily erased from the page. Medieval scribes also used a variety of coloured inks, mainly red (for headings, titles, initials, rubrics, or for marking 'red-letter days' in calendars); red ink was mostly made with the aid of vermilion and was in consequence rather costly.

Recipes for making ink abound from antiquity. In his dissertation on the medical use of herbs, Dioscorides, the physician of Antony and Cleopatra, gives an exact account of the proportion of lamp-black and oil necessary to produce fine carbon ink. The Roman architect Vitruvius (30BC–14AD) advises that soot from pitch-pine should be collected from the walls of a specially constructed chamber, mixed with gum, and then dried in the sun. In the middle ages not only calligraphers, but also housewives had their own recipes for preparing ink which were often passed down as a family heirloom. Such a recipe might go as follows:

'take four ounces of gum arabick, beat small, two ounces of gall beat gross.
One ounce of copperas, and a quart of the comings of strong ale. Put all
these together and stirr them three or four times a day about – fourteen
days then strein it through a cloth' (CAM; p.6/14).

When the writing masters (*see* p.169) began to publish their copy-books in the
16th and 17th centuries they often included what they claimed to be their
own recipe for making ink. But not all of them were truly original; Edward
Cocker (*see* p.173), for example, writing in the second half of the 17th century,
recommends a recipe which closely follows that given by Giovanni Battista
Palatino (*see* p.122) in 1540. While making one's own ink every time one sat
down to write, in the manner of Chinese calligraphers, was no doubt desir-
able, it was also very time-consuming and with the growth of education and
commerce it became impractical; by the 18th century a new profession
arose, that of the travelling inkseller (JIW; p.79) who competed with sta-
tioners and other similar shops.

Ink suitable for the quill severely damaged the steel pen, one of the main
problems confronting 19th-century pen makers. The first supposedly non-
corrosive ink was made in the 1830s but it was not before the discovery of
aniline dyes in 1856 that inks were devised which gradually eliminated these
difficulties.

Islamic calligraphers have left prolific and detailed instructions about the
way ink should be prepared, some of them more exotic than others. In the
Maghrib (*see* p.95), for example, basic black ink was made from wool taken
from a sheep's stomach, which was shredded, put into an earthenware pot
and placed over fire to scorch the wool. This was then ground to dust with a
stone, water was added, and the mixture was once more heated; cooling
produced a hard block which had to be diluted in water (KHA/MS; p.86); pellets
made from this type of hard ink were useful if a calligrapher had to go on a
long journey. Ink was also made of soot, honey and gum; soot from the oil
lamps in the Suleymaniye mosque in Istanbul is still considered especially
auspicious and full of *baraka* (the power of blessing). Islamic scribes used
carbon as well as iron-gall inks, and sometimes an ink contained a mixture of
both. Great importance was attached to producing an ink of black lustre
which did not fade. The basic ingredients were usually soot, added to a
heated mixture of water, salt, gum-arabic, grilled gall nuts, iron sulphate and
honey; an addition of myrrh was recommended to repel insects. Islamic
calligraphers also employed coloured inks to highlight passages, words, dia-
critical marks, or decorative ornaments, though this was done sparingly and
with great care as to the overall effect of the page [*see* PLATE VIII]. Apart from
gold and silver, colours made of vegetable dyes such as blue, green, red,
orange, yellow or violet would be used.

In the Far East ink has always been carbon-based (carbon being obtained
by burning certain kinds of wood or liquid, including tung-tree oil or lac-
quer). Its use for painting and, later, calligraphy goes back to archaic times,

and the name of the inventor, Cang Jie, and the dates attached to him (697–2597BC) are probably just a tradition. The first documented ink maker was the calligrapher Wei Tan (179–253AD) who, we are told, refused the ink the Emperor had bestowed on him, using instead the one he had made himself and writing much better calligraphy in consequence. His ink was supposed to be so black that, as a prince of the southern Jin dynasty (497–501AD) wrote, 'every drop was like lacquer'. A 5th-century work on agriculture gives the recipe, under 'methods of mixing ink', as follows:

> 'fine and pure soot is to be pounded and strained in a jar through a sieve of thin silk. This process is to free the soot from any adhering vegetable substance so that it becomes like fine sand or dust. It is very light in weight, and great care should be taken to prevent it from being scattered around by not exposing it to the air after straining. To make one catty of ink, five ounces of the best glue must be dissolved in the juice of the bark of the *qin* tree which is called *fanji* wood in the southern part of the Yangtze Valley . . . add five egg whites, one ounce of cinnabar, and the same amount of musk, after they have have been separately treated and well-strained. All these ingredients are mixed in an iron mortar; a paste, preferably dry rather than damp, is obtained after pounding thirty thousand times, or pounding more for a better quality' (THT; p.166).

It comes as no surprise to learn that some emperors thought ink a suitable form of tribute.

Chinese ink is greatly superior to other forms of ink and especially valued for its smooth and delicately balanced colour tone. Tone is more important in the context of Chinese visual art than colour; black is capable of producing a large range of tones, all of them skilfully exploited by the calligrapher (and of course the painter). In addition, Chinese ink has a particular transparent quality, it is water proofed and does not fade with age. The ink of the inscriptions found in tombs dating from the 5th century BC has remained unchanged. According to general consent the best ink is made from the pine growing in the Yellow Mountain area, in An-Hwei province. Burned and purified soot is mixed with animal glue and then moulded into cylindrical or (more popular) rectangular block bars. Chinese ink sticks vary in size, they are frequently decorated, often used as special gifts, and they can become valuable collectors' items (DK; p.129).

Before the calligrapher can begin his work he has to prepare the ink by rubbing the ink stick against a special inkstone, while at the same time mixing it with water, carefully added from a small dripper. Grinding the ink is an important stage in the process of calligraphy. The quality of the stone (slate and silk stones are popular), the amount of water, the pressure applied while grinding, the rhythm of the movement – all these will be reflected in the quality, consistency and the all-important tone of the ink. It also gives the calligrapher time to compose himself, concentrate his mind and reflect on the planned composition before writing the first line.

Parchment and paper

Many factors influence the choice of writing material. Availability no doubt plays a decisive role (palm-leaves in India and Southeast Asia, bamboo in China) coupled with technological know-how (papyrus in Egypt). Another factor, often overlooked, is cultural predetermination. Parchment was not (in fact could not be) used much further east than Iran. Buddhists would not write their texts on the skins of slaughtered animals and to Hindus leather was a material ritually so unclean that only the lowest castes would touch it. In the West, where no such taboos existed, animal products have always been used naturally, not only for food, clothing and shelter, but also as writing material. The earliest surviving leather (skin which has undergone curing and manipulation with oil) documents come from ancient Egypt (*c.*2500BC), but leather, the forerunner of parchment, was also widely employed in western Asia, in what are now Iraq and Persia, and, later, also in Turkestan. When Christianity and Islam replaced Judaism and the other old 'non-book' religions in this area, skin-based writing materials (leather and parchment) continued in use. East of Iran the situation was different. Plant products had for long been the preferred writing materials: bamboo, wood, later silk, and eventually, more or less as a natural progression, paper. Parchment and paper in turn respond best to different types of writing instruments and to different inks: in the case of parchment the pen and the iron-gall ink, and in the case of paper the brush and carbon-based inks.

PARCHMENT

An entertaining story is attached to the invention of parchment. The city of Pergamum in Asia Minor (present-day Turkey) gained considerable importance under Eumenes II (197–158BC) when, after the defeat of Antiochius the Great in 190BC the Romans greatly extended his realm. The king, a passionate book collector, used his new wealth to create a library which soon began to rival that of Alexandria. According to Pliny the Elder, King Ptolemy of Egypt, greatly resenting Eumenes' growing reputation as a book collector, held up a cargo of papyrus which in turn prompted the latter to perfect the only freely available writing material at his disposal, namely leather, and, in consequence, invented parchment (Latin *pergamenum*), aptly named after the city of Pergamum.

In truth the 'invention' was probably the end-result of a lengthy process. By the 2nd century BC papyrus was in short supply and becoming more and more expensive. The expanding Roman Empire depended heavily on an ever-increasing amount of papyrus documents to sustain its administrative infrastructure. Greek demand too was rising. The situation was further aggra-

vated by the fact that with the disintegration of the Egyptian Empire and the deterioration of the Mediterranean trade routes, the way of life and the form of economy which had supported the large papyrus plantations in the Nile delta (the place where the plant grew plentifully) were in rapid decline. The search for a suitable and affordable substitute had become imperative.

The process by which parchment is manufactured is fairly complex. The whole skin (usually that of a sheep or goat) has to be thoroughly cleaned, treated with lime, dehaired and defleshed, scraped on both sides, washed for a couple of days to remove the lime, stretched on a frame, scraped again, rubbed with pumice, treated with hot water and then dried. Some of these actions have to be repeated several times – an altogether long and labour-intensive procedure. Stretching and scraping are important: the thinner the parchment, the finer the quality (CDH; pp.11–17). In the finished product, recto and verso are clearly recognizable: the inner (flesh) part is tougher, more yellow and in general better able to retain ink; the outer (hair) part is smoother and easier to write on, but has a tendency to cause certain types of ink to flake. Vellum is produced from calf or cow skin in exactly the same manner; in general terminology all skins are referred to as parchment. Or, as

10 Leather Megillah scroll (Book of Ecclesiastes) written in Hebrew in the Yemini hand; 15th century AD. Writing materials have influenced not only the development of letter-forms but also the shape of the book. Whereas leather and papyrus are best suited for writing on one side only (hence the scroll format of Antiquity and of Jewish Books of Law), no such limitations exist in the case of parchment and paper (which greatly aided the development of the codex).
BRITISH LIBRARY, ADD. MS 4707

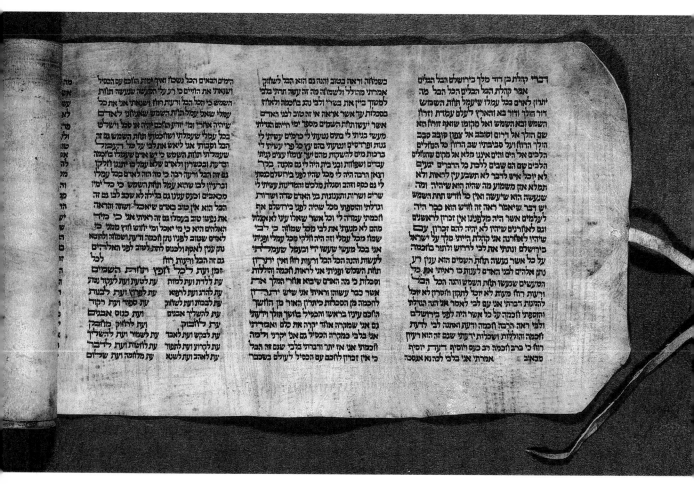

one William Hornman wrote in the early 16th century 'that stouffe that we wrytte upon: and is made of beestis skynnes: is somtyme called parchment and somtyme velem.'

Parchment is exceedingly durable and fragments have survived from the 2nd century BC. It was however not before the 2nd century AD that it began to rival papyrus in the Roman world, and two more centuries passed before it was used for the best books. More or less simultaneously, the codex (*see* p.52) began to replace the old scroll format [10] since it was no longer necessary to write on one side only; in addition, good parchment is soft and velvety and can (unlike papyrus) easily be folded. In Europe parchment remained the most popular writing material until the Middle Ages when it was gradually supplanted (for economic and practical reasons) by paper.

PAPER

According to the Chinese historian Fan Yie (397–445AD) paper was invented by Cai Lun (*c*.61–121AD), a eunuch at the Court of Han Emperor Wu Di, in the year 105AD. In fact Cai Lun was probably more of a supervisor than an inventor (he was charged with collecting information and reporting on the various experiments in papermaking that were taking place in China), and the invention of paper was in all likelihood the outcome of an evolutionary process based to no small extent on the knowledge of making silk paper. Some Chinese historians of the 8th and 12th centuries thought paper existed before the time of the Eastern Han (25–220AD), and recently paper fragments (made of hemp fibre) found in a grave in Baqioa in the province of Shaanxi in northern China, which have been dated not later than 140–87BC, are indeed putting the time of the 'invention' back at least another 200 years.

Silk was first cultured in China at the time of Huang Di (2640BC), the legendary Yellow Emperor whose Court Recorder is supposed to have invented writing [11]. For a long time silk was a prized export article, its production a carefully guarded Chinese monopoly and death by torture the punishment for informers. There are various stories about the way the Chinese eventually lost the monopoly. One tells about a Chinese princess who, in 140BC, was sent in marriage to Khotan; since she could not bear the thought of spending the rest of her life without her customary silk clothes she hid some mulberry seed and a few silk worms in her headdress. In 300AD the Koreans brought four Chinese girls who understood the process of silk production to Japan; and in 550AD the Byzantine Emperor Justinian persuaded two Persian monks who had lived in China to smuggle silk worms to Constantinople in the hollow of their bamboo canes.

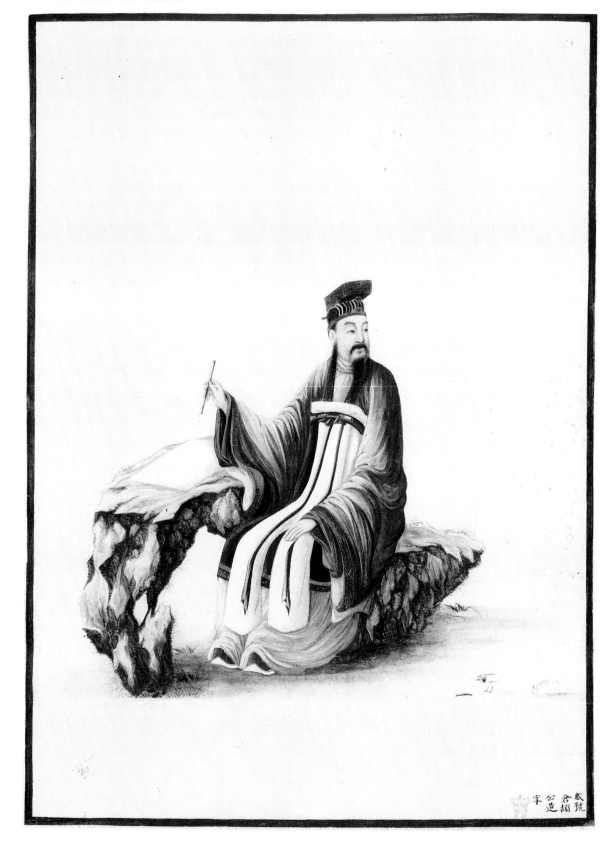

As a writing material silk performs well with brush and ink and a number of 4th and 5th century BC Chinese writers mention it in a manner which implies frequent use. Some silk fragments inscribed with Chinese characters have recently been found, dating from the 4th century BC. By the time of the Eastern Han (25–220AD) silk was widely used for letters, literary composition and official documents. Silk was however an expensive form of writing material and around the beginning of the Christian era a method developed by which old silk rags could be pulped; the resulting mixture, thinly spread on a frame, produced a material which could justifiably be called silk paper.

Paper had, from the beginning, a considerable advantage over silk: it was much cheaper and could be manufactured by recycling waste products. According to contemporary records, paper was originally made from tree bark, fish nets and old rags. Botanists who have examined early paper fragments (from the 2nd century AD) have pronounced it a mixture of raw fibres (mulberry, laurel, waste hemp, Chinese grass) and old rags. A reconstruction of the earliest technique of papermaking would look as follows: young mulberry stems, tied into bundles, are placed for a considerable period of time into a running stream to loosen the bark; the bark is then stripped off, cut into pieces and soaked in water for up to 100 days. To separate the inner (white) bark from the (dark) outer one, the cut pieces are pounded in a mortar and the outer bark, being of no further use, is then discarded. (In Japan these tasks were often performed by women who would trample the mulberry stems in the freezing water before sitting down and laboriously picking off the dark outer bark piece by piece.) The remaining pulp of white

11 A portrait of Cang Jie, the Court Recorder of the legendary Yellow Emperor (trad. 2697–2597BC) who is traditionally credited with the invention of the Chinese script. According to the Shuo wen jie zi, *the first etymological dictionary of Chinese characters, c.120AD, he 'looked down and saw the marks left by the tracks of birds and animals. He realised that by distinguishing such patterns he was able to differentiate one thing from another. Thus he first created the script and carved letters'. A 19th-century album of export paintings from southern China.*
BRITISH LIBRARY, ORIENTAL AND INDIA OFFICE COLLECTIONS, OR.2262, f.13

12 Papermaking in China:
(a) Tree bark and plants are cut into pieces and soaked in water. (b) After pounding, and the separation of plant fibres, the remaining pulp is mixed with other ingredients and boiled.

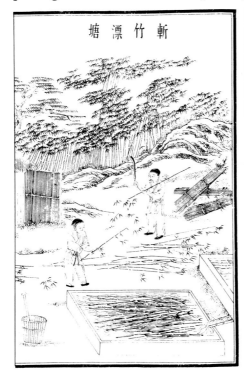

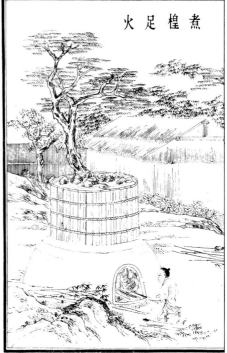

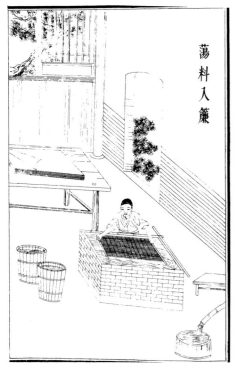

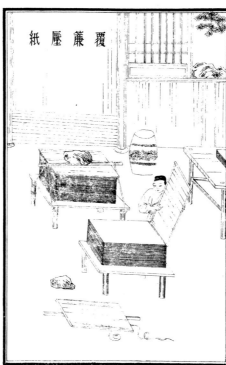

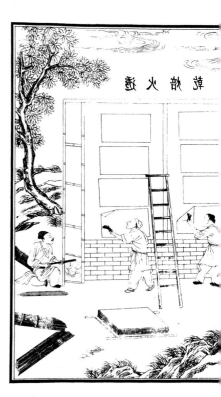

bark is mixed with either lime or soda ash, heated over a fire to boiling point for at least eight days and nights, and washed until the fibres are softened. This mixture is then strained and pounded into a soft doughy substance, and bleached. The bleach is removed by further soaking and the mixture is placed in a large vat with added starch to prevent the finished sheets from sticking together. To make individual paper sheets a bamboo frame is dipped into the vat and a thin layer of the solution lifted from it; this is the most skilful part of the whole operation. The lines of the bamboo frame leave a water mark on each sheet which remains visible in the final book. The individual wet sheets have to be well dried, either in the sun (perhaps on a brick wall) or on heated wood [12 a, b c, d, e].

Papermaking became (like silk making) a closely guarded Chinese monopoly and for about 600 years the technique was known only in China, from where it did not spread much further West than Chinese Turkestan. In 751AD the Muslim governor of Samarkand took captive a large number of Chinese prisoners, some of them adept in the art of papermaking. According to one account these men voluntarily set up papermaking shops in Samarkand; another version claims that they betrayed their secret only under torture. Whatever the truth of the story we know for certain that in the late 9th century AD the Viziers of Harun al-Rashid (786–809AD) established paper mills near Baghdad. From there the industry spread to various towns of the Middle East: Damascus, Sana'a and later Cairo became important manufacturing centres (AG; p.47). The basic ingredients of Islamic paper were

Papermaking in China (contd):
(c) After further processing the final mixture is placed into a large vat and the sheets are lifted from it by means of a bamboo frame. (d) The sheets are well drained and collected. (e) They are finally dried on a heated wall. From the reproduction (Beijing, 1929) of a 17th-century edition.
BRITISH LIBRARY, ORIENTAL AND INDIA OFFICE COLLECTIONS, 15258.CC.13 (VOL.1)

linen (instead of mulberry bark) and hemp. Eventually the growing demand for paper put pressure on the supply of raw materials; 'Abd al-Latif, a doctor from Baghdad who stayed in Egypt between 1193–1207AD, tells a somewhat gruesome story about Egyptian peasants robbing graves to obtain mummy wrappings made of linen which they sold to paper factories.

Paper greatly stimulated the development of ornamental cursive hand-writing in Islamic calligraphy. The demands of calligraphers encouraged papermakers to refine their product and invent a number of additional embellishments. In Persia coloured paper was already popular during the Timurid period (1380–1506AD). Later anthologies often consisted of pages in different colours mixed with marbled as well as gold-sprinkled sheets [*see* PLATE VIII]. Such conventions spread to Mughal India and were further perfected in Turkey. The highly burnished surface, a characteristic of Islamic manuscripts, was achieved by sizing the paper with vegetable starch (or a mixture of rice powder, starch, quince kernel and egg white) and gum to fill in the pores. The surface was then burnished with a piece of stone (preferably an agate), a glass egg (in Turkey) or a broad ended pestle (Mughal India) to remove all unevenness [13].

13 Finely made burnishing tools from Turkey. The sizing and burnishing of paper was done either by the paper dealer or the calligrapher himself. PHOTOGRAPHED AT AN EXHIBITION, LATE 1980s

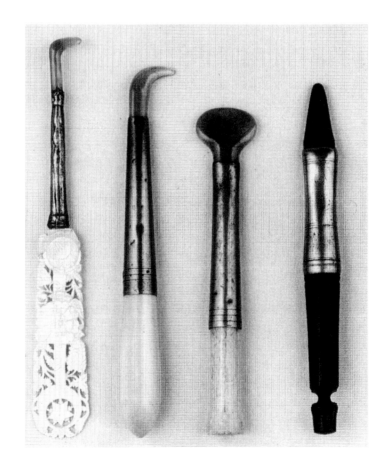

According to tradition, paper was introduced to Japan (once again via Korea) in 610AD by the monk Doncho and it is perhaps no accident that Japanese calligraphy becomes noticeable about a century later. During the Heian period (794–1185AD), when the art of writing reached its zenith (*see* p.124), paper production achieved a high level of sophistication. The prominence of the Court and the break from Buddhist dominance created a demand for paper: ordinary paper for official documents as well as luxuriously decorated sheets (stamped, tinted, stencilled, gilded, decorated with washline drawings and so forth) for writing diaries, poems and letters. Particularly fine paper was produced at the time of Emperor Heijo (reigned 806–809AD); a paper mill in Kyoto supplied 20,000 paper sheets to the Imperial Court alone. The Heian period also had a great penchant for elegantly-coloured paper. Gentlemen carried it in the folds of their clothes, while ladies had to understand its importance and know what type of paper should be chosen for what occasion; above all, it was (together with calligraphy) an important accessory in the intricate games of courtship played by fashionable society (*see* p.134). During the Meiji period (1868–1912AD) Western papermaking technology and Western typography (*see* p.166) were introduced to Japan, but craftsmen papermakers (albeit in much smaller numbers) have retained their position until the present day.

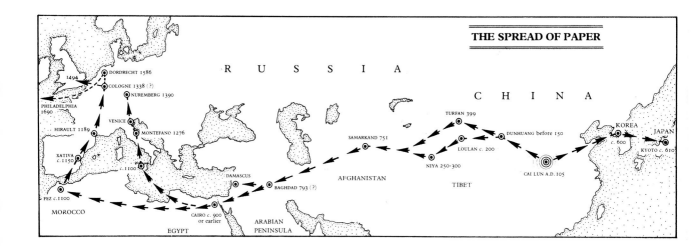

THE SPREAD OF PAPER

Paper reached Europe a thousand years after its invention by a tortuous and not always easily verifiable route [14]. In the 12th century (perhaps even a century earlier) the Arabs introduced the art of papermaking to Spain and Sicily (and a century later to India). Rags were still the most important ingredient for its manufacture; in the laws of Alfonso X of Spain (1236AD) paper is referred to (rather fittingly) as *pagamino de paño* (cloth parchment). In 1492 the Muslims finally lost Spain and the art of papermaking passed into the hands of less skilled Christian craftsmen. But paper had

14 A map showing the spread of paper.

already begun to establish itself firmly in the Western world. In 1338 a paper-producing factory was established in France, at Troyes; in 1390 papermaking reached Germany (Nuremberg), in 1498 Austria (Wiener-Neustadt) and in 1690 America (Germantown and Philadelphia). By 1400 paper was commonly used for cheap textbooks, tracts, and small books of sermons, though it was not as yet always given equal status to parchment; as late as 1480 Cambridge University ruled that only parchment books were acceptable as security for a loan (CdH; p.16). What finally established paper as the preferred writing material in the West was without doubt the rapid advent of printing (*see* p.169) after the middle of the 15th century.

The manufacturing process of paper remained basically the same until the 19th century. Then, for economic reasons (the spread of general education together with the increasing needs of commerce and administration which caused a huge increase in demand), methods for manufacturing paper from wood pulp were developed. Fibre and fibre fragments were separated from the wood structure either by mechanical means, or wood was exposed to a chemical solution which dissolved and removed lignin and other wood components, leaving cellulose fibre behind. At first paper sheets were still made by hand but in 1798 a conveyor belt for making an unbroken sheet of paper was invented in France; this method was improved in England within a

15 Women working in the newly established papermaking factories. Illustration from Galerie industrielle; ou, applications des produits de la nature aux arts et métiers, *1822.*
DIDEROT'S *ENCY-CLOPÉDIE*; P.19

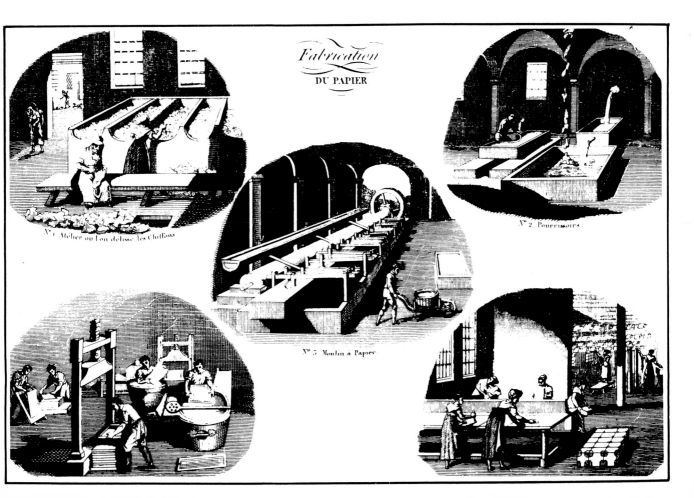

decade and by the mid-19th century the whole process of making paper became mechanized [15]. The introduction of wood as a substitute for rags had guaranteed the supply of paper but irrevocably diminished its quality, durability and appearance.

Even today Chinese paper is without equal. As far as its quality is concerned it can generally be divided into two broad categories: raw (untreated) and mature. Raw paper is soft and absorbent, almost like blotting paper. For calligraphy (and painting) the best paper is *xuan* paper produced in the city of Xuan in the province of An-Hwei. The secret of its production has for long been the property of two local families who have handed it down from generation to generation. Outsiders, especially in Japan, have repeatedly tried to imitate the process but without much success.

There are many different kinds of *xuan* paper. *Dan xuan*, a thin single-layered paper, is rather porous and absorbent and encourages the ink to run fast and bleed quickly; writing is hard to control but good calligraphers appreciate its sensitivity. *Jia xuan*, a double-layered paper, is equally absorbent but water and ink do not run so fast and the ink is easier to control. Another paper, *zhu zhuei*, is half raw and half treated. Mature paper usually has some alum added to seal the texture and make it less absorbent. *Yuban xuan* is well soaked in alum and reacts more slowly to water and ink. *Hubi xuan*, dyed orange with a tiger skin pattern, is mainly used for writing couplets for social occasions and similar events (DK; p.128).

Other less traditional kinds of papers are *mao bian*, a paper made of straw or grass and *zhu* paper, made primarily from bamboo; both are half treated with alum. *Gaoli* is a Korean paper with a heavy hemp mixture; it is strong, almost like parchment, and similar to Japanese hemp paper. If treated with alum it becomes hard and no longer absorbs water. It is mostly used for kites and for covering windows (instead of glass) but occasionally some calligraphers chose it for their work (DK; p.129). The Western term 'rice paper', which is often used to refer generally to all Oriental paper, has in fact nothing to do with rice. Correctly used it denotes either *xuan* paper, or a paper made from the pith of a small tree (*Aralia papyrifera*) which grows mainly in the swampy forests of Taiwan.

THE THREE GREAT TRADITIONS

Western calligraphy

All Western styles of calligraphy have their roots in the Roman system of scripts used in the area of the Roman Empire between the reign of the Emperor Augustus (31BC–14AD) to the papacy of Gregory the Great (590–604 AD) (MPB; p.14/5). The basis of Western calligraphy is the Roman (or Latin) alphabet which appeared for the first time in Italy in inscriptions dating from the 7th or 6th centuries BC. The Roman alphabet now consists of 26 individual letter signs (for vowels and consonants), and is written from left to right – though some of the earliest examples show a right to left, or even boustrophedon (that is, from right to left and left to right alternatively) direction. Historically this form of writing can be traced back, via the Etruscan and the Greek alphabet, to the Phoenician consonant script which flourished between the 13th and the 3rd centuries BC (AG; pp.91/126).

An important element in Western calligraphy is the connection between form and function; scripts, broadly speaking, are either book hands or documentary hands. The first, used foremost for the copying of literature, aimed at clarity, regularity and (to some extent) impersonality. Usually the work of professional scribes, deliberate stylization can give these hands an element of imposing beauty. Documentary styles cover a much wider range of purpose; they include chancery hands as well as the workaday writings of officials and private persons. For this type of script the ability to write quickly is of great importance, and to achieve this, the pen should be lifted as rarely as possible from the writing material. This is turn can lead to ligatures (cursive appearance), loops and an increasing number of abbreviations. At first it may seem strange that these, seemingly illegible, hands should deliberately have been chosen to communicate information vital for the economic, administrative and military well-being of a large and powerful Empire, but the contemporary standing of literacy was high (in fact that prevailing in Rome during the 1st century AD was not matched in Europe until the 19th century), and those who were literate had been carefully taught how to write and read.

Apart from form and function the development of Western and (indeed all) calligraphy is also closely connected with the materials and the instruments used for writing. In Rome, calligraphy developed with the use of parchment in the early part of the Christian era; materials such as wax and the metal stylus, or pieces of pottery, wood, or even papyrus with its more

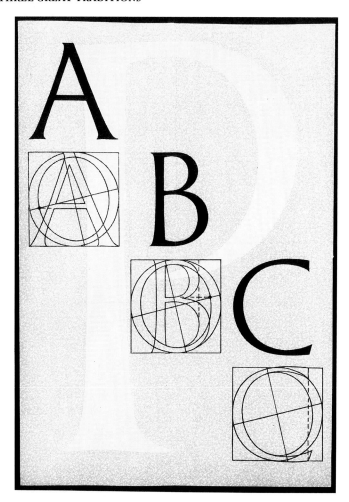

16 With the growing importance of typography, printed treatises on the technique of letter designing appeared: Damiano Moille (1480), Hartmann Schedel (1482), Fra Luca Pacioli (1497), Francesco Torniello (1517), Albrecht Dürer (1525), Giambattista Verini (1526), Geoffroy Tory (1529), Urban Wyss (1553). In many ways the systematic study of Western calligraphy and its recorded history begins with such works, in which very often mathematical principles were brought to bear on the structure of Roman letterforms. Western calligraphy has always been based on lettering, and with the advent of typography it was felt that the rules had to be codified to safeguard excellence. In this way the introduction of printing helped to stimulate and protect fine writing. Illustration from an advertisement for Walter Kaech's book, Rhythm and Proportioning in lettering.
BY COURTESY OF MISS
KATHLEEN STRANGE

uneven surface, had not been equally congenial. An important element was the resistance of the material to the instruments used for writing: the hard, split reed pen (*calamus*), and, from the 6th century AD onward the quill (*penna*), produced just the right combination.

Foremost in the hierarchy of the 'Old Roman System of Scripts' are Square Capitals; this was an imposing script of great harmony, used primarily in monumental, epigraphic inscriptions (on stone, wood and metal), and occasionally also for some of the best manuscripts, and for titles. The geometrical bases of this style are the square, the circle within the square, and the half-square [16]. The square also provides the 'perfect number', namely ten; the width of the main line of each letter is supposed to measure one-tenth of its height. The finishing lines (serifs) at the top and/or foot, a by-product of the way letters were cut into stone with a chisel, accentuate the impression of overall harmony. The most used book script of this period, however, from which all Latin and vernacular handwritings of Western Europe descend, are Rustic Capitals [17], a slightly more narrow and condensed hand, better suited for the reed pen and, later, the quill. The pen, cut with a broad end and

17 The Vespasian Psalter, written in Rustic Capitals, copied probably 725/750AD in St Augustine's monastery, Canterbury.
BRITISH LIBRARY,
COTTON VESP. A.1, f.31

3

ETSICUBI QUIS FEROACRABIDOFUROBERAPTETUR SIFORTENERIT PSALMUM UT ITA
DIXERIMCARMINIBUS INCANTATUS CONTINUO OMNIS RABIES FEROCITATIS
ABSCEDIT. PSALMUS TRANQUILLITAS ANIMARUM EST SIGNIFER PACIS
PERTURBATIONES UEL FLUCTUS COGITATIONUM COHIBENS IRACUNDIAM REPRIMEN
LUXUM REPELLENS SOBRIETATEM SUGGERENS AMICITIAS CONGREGANS ADDUCENS
IN CONCORDIAM DISCREPANTES RECONCILIANS INIMICOS QUIS ENIM ULTRA IN
IMICUM DUCATEUM CUMQUO UNAM ADDM PSALM EMISERIT UOCEM
EXQUO INTELLEGITUR QUIA ET QUOD BONORUM OMNIUM MAXIMUM EST CARI
TATEM PSALMUS INSTAURAT CONIUNCTIONEM QUANDAM PER CONSONANTIAM
UOCIS EFFICIENS ET DIUERSUM POPULUM UNIUS CHORI PER CONCORDIAM CONSO
CIANS PSALMUS DAEMONES FUGAT ANGELOS IN ADIUTORIUM SALUTIS INUITAT
SCUTUM IN NOCTURNIS TERRORIBUS DIURNORUM REQUIES EST LABORUM
TUTE LAPUERIS IUUENIBUS ORNAMENTUM SOLAMEN SENIBUS MULIERIBUS
APTISSIMUS DECOR DISSERTA HABITARE FACIT ORBIS SOBRIETATEM DOCET
INCIPIENTIBUS PRIMUM EFFICITUR ELEMENTUM TOTIUS ECCLESIAE UOX AHA
PSALMUS SOLLEMNITATES DECORAT PSALMUS TRISTITIAM QUAE SECUNDUM
DM EST MOLITUR PSALMUS ETIAM EX CORDE LAPIDEO LACRIMAS MOUET
PSALMUS ANGELORUM OPUS EXERCITIUM CAELESTIUM SPITALE TYMIAMA
O UERE ADMIRANDI MAGISTRI SAPIENS INSTITUTUM UT SIMUL ET CANTARE
UIDEAMUR ET QUOD AD UTILITATEM ANIMAE PERTINET DOCEAMUR
PER QUOD MAGIS NECESSARIA DOCTRINA NOSTRIS MENTIB INFORMATUR
PRO EO QUOD SIQUA PER UIM ET DIFFICULTATEM ALIQUAM ANIMIS NOSTRIS
FUERINT INSERTA CONTINUO DI LABUNTUR EA UERO QUAE CUM GRATIA ET DI
LECTIONE SUSCIPIMUS NESCIO QUO PACTO MAGIS RESIDERE IN MENTIBUS AC ME
MORIAE UIDENTUR INHERERE QUID AUTEM EST QUOD NON DISCATUR EX PSALMIS
NON OMNIS MAGNITUDO UIRTUTIS NON NORMA IUSTITIAE NON PUDICITIAE
DECOR NON PRUDENTIAE CONSUMMATIO NON PAENITENTIAE MODUS
NON PATIENTIAE REGULA NON OMNE QUICQUID DICI POTEST BONUM
PRO CEDIT EXIPSIS DI SCIENTIA PERFECTA PRAENUNTIATIO XPI IN CARNE
UENTURI ET COMMUNIS RESURRECTIONIS SPES SUPPLICIORUM METUS
GLORIAE POLLICITATIO MYSTERIORUM REUELATIO

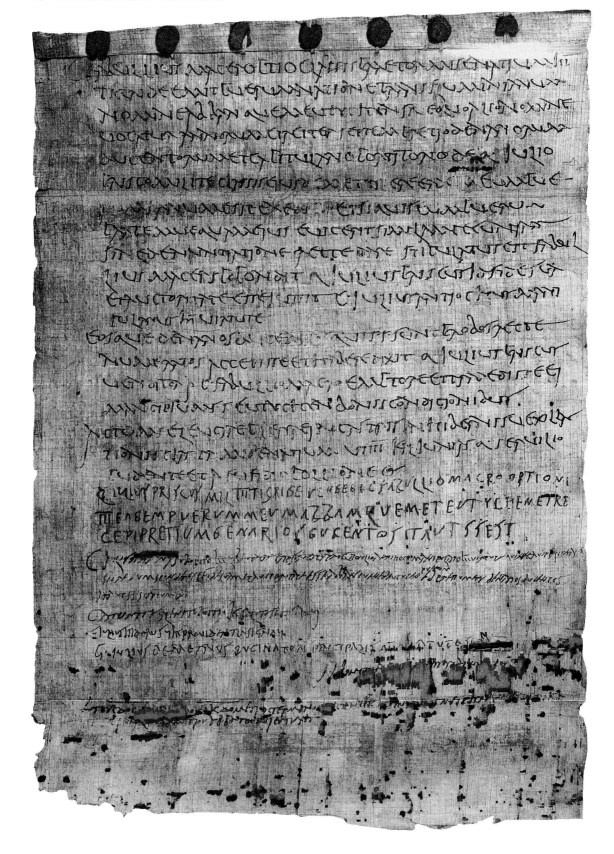

held in such a way as to ensure that the thickest stroke fell in an oblique angle to the line of writing, was held at a steeper angle and had to be lifted several times to form a single letter. Like Square Capitals it was a majuscule script with all letters of equal height, as if written between two horizontal lines; there were as yet no ligatures or abbreviations. A more informal script used for correspondence and documents was Old Roman Cursive [18], where the pen cut to a sharp point, was still held at an oblique angle but lifted less often, producing simpler, more 'cursive' letter forms; some had descenders beyond the body of the letter. At first used mainly for writing on wax tablets and on papyrus it eventually influenced the development of minuscule letters.

18 Deed of sale of a seven-year-old boy, Syria, 24 May 166AD. The script is an example of Old Roman Cursive. Many letterforms are simply cursive written capitals, but several others have changed into new forms; the text is written without punctuation and there are autograph signatures at the end.
BRITISH LIBRARY, PAPYRUS 299R

19 Bede, Expositio in Lucam. *A good example of what came to be known as 'the hierarchy of scripts': Rustic Capitals (for the major headings), Uncials for the first line of the* Liber tertius, *and Carolingian minuscule for the rest of the text; Tours, c.820AD, with late 10th-century additions.*
BODLEIAN LIBRARY, OXFORD, MS BODLEY 218, f.62

20 De Bellis Macedonicis, *fragment of a lost work in Latin on the Macedonian wars of Rome* c.*2nd century* AD. *This is the only surviving example of Roman Literary Cursive which combines elements of Rustic Capitals, Uncials and Old Roman Cursive. This fragment is also the earliest extant example of a parchment* codex.
BRITISH LIBRARY, PAPYRUS 745R

Between the 2nd and the 4th centuries AD a number of changes occurred; papyrus was replaced by parchment, and the old classical (and Hebrew) scroll format of the book by the new, Christian codex. In calligraphy the rather elaborate Rustic Captials gave way to more simplified letterforms, written with a broad pen held either obliquely or, sometimes, straight, so as to allow the thickest strokes to fall at right angles to the line of writing. This led to the development of what is called the 'New Roman System of Scripts' which boasts two elegant book hands: Uncial [19] and Half-Uncial (a more rapid script produced with a straight pen). When book production

21 Draft petition of Flavius Abinnaeus to the Emperors Constantius and Constans, requesting a new posting; probably from Egypt, c.345AD. New Roman Cursive, a script which served for administration and everyday matters in late Antiquity, and became influential in the evolution of the sub-Roman 'National Hands'.
BRITISH LIBRARY, PAPYRUS, 447R

(pagan as well as Christian) passed into the hands of the Christian Church, Uncial remained the favoured script of the monastic centres (especially those observing the Rule of St Benedict) until the 9th century; the originally slightly oblique pen was however replaced by a straight one which gave the hand a more rounded but slightly contrived look. The second of the two book scripts, Half-Uncial, making use of a perfectly straight pen, could be written more quickly and was generally used for less formal manuscripts. At the same time a more fluid version, Cursive Half-Uncial (going back to Literary Cursive [20]), became the common handwriting of the educated person of late Antiquity. Cursive Half-Uncial was important as a style because it stimulated the formation of the Insular system of scripts (the basic stimuli for Continental scripts being Half-Uncial and New Roman Cursive); revived later by the Humanists (*see* p.67) it became the inspiration for modern typefaces. In addition, from the 4th century onward, a cursive script, New Roman Cursive [21], came into use, written with a pointed pen held straight. Though basically the same as Half-Uncial, the cursive minuscule of its ligatures gave it an entirely different appearance.

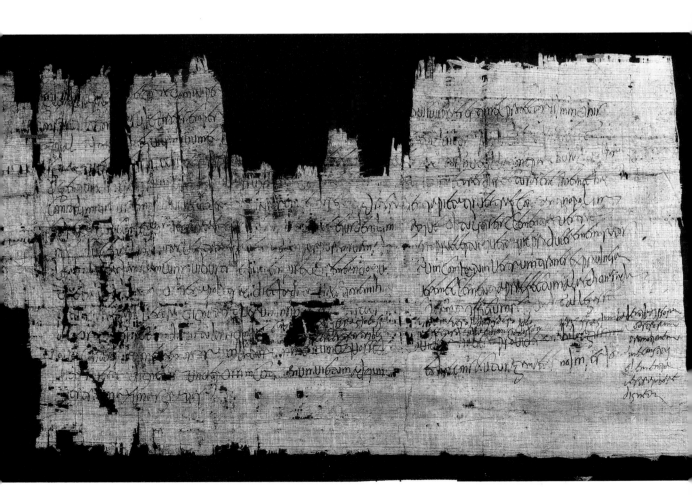

mßcaa annnamßa dnm . ßcccvul
aæuia spsmeuf Indo salucacoß nßo :

ɳno quincaodccimo Impe
hɪ ɑʒbeɳi ceßaeɳf : pƒocu
cenaæ pongo pɪlaoʒo Iu
dæam · acæafoæ ʃchae oeu
gaelɪlæe heʒode . phɪlɪp
po auiæ ffe ehuf æafoer
chæ lauʃæ & acacoɪnaʒdɪf ʃeʒʒonɪf.
&lɪʃaeniæ oebɪlɪɳʒ aæafoæchæ . ʃub
phɳeipɪbuf ʃoeoeʃdoauum ænnæ &
ooeyphæ :, Faeoaum eʃt ueʃbum dñi
fupɪoɪæm ʒaechaæɳʒ flɪum Indeʃæ'
oeo :, Cauænia Inomê' feʒʒonæm lor
dænif : pƒedɪoaenf bæpaɳfmum pæn
aenʒe, Inʃænɪʃʃɪonæm peoeoeoeoɪ ;,
ʃɪeuia ʃcŋʃpoaum eʃt Inlɪbƥo ʃæʃmonu'
eʃaeɳʒ pƒopƥæ · uaex olaemanaɳʃ Iɪ

22 *Gospel Lectionary,
Dalmatia (Zadar)
written in the Beneven-
tan script which
remained in use in
southern Italy for
nearly 500 years; late
11th century* AD
BODLEIAN LIBRARY,
OXFORD, MS CANON BIBL.
LAT. 61, f.7V

23 Sacramentum Gelasianum. This fragment, one of several removed from a binding, is written in the difficult to read Merovingian style of the pre-Carolingian period; 8th century AD. BODLEIAN LIBRARY, OXFORD, MS DOUCE f.1. F.LV

In the 5th century the Roman Empire disintegrated under the onslaught of tribal insurrections which swept through Western Europe, and in 410AD Rome itself was sacked by the Goths. The civilized and highly organized way of life that had prevailed for so long came to an abrupt end, and the need for common literacy decreased. Without the Christian Church (after the Manifesto of Tolerance in 311AD Christianity became more and more dominant in the Empire), which took over the mantle of Rome, it may well have vanished altogether. Unlike the Roman religion, which had depended on outward ceremonial, Christianity is (like Islam) a 'book' religion; it possesses in the Bible the revealed and written-down basis for its existence. In the following centuries Christian missionaries began to move along the old (Roman) lines of communication, taking the Bible, the parchment codex, the quill pen, and contemporary forms of writing to the northern part of Europe. Consequently, between the 5th and the 14th centuries a number of distinct 'National Hands' developed in the various states carved from the disintegrating Empire by Ostrogoths, Visigoths, Vandals, Franks, Burgundians, Angles, Saxons, Lombards and other 'barbarians' (MPB; pp.32/3). The basis for much of this development was either New Roman Cursive (for the chancery scripts of Ravenna); and for the Merovingian script [23], or Half-Uncial. This is especially noticeable in the scripts which developed in monastic centres such as Luxeuil, Bobbio and Corbie; or in the Benevento [22] region of Italy, and in

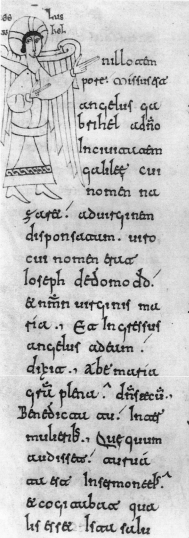

24 *Offices and Masses of the Mozarabic Liturgy; Spain, 10th century AD. Visigothic minuscule, a highly legible script which fused New Roman Cursive and Half-Uncial letterforms, was amongst the more successful of National Hands. The freedom from Carolingian political influence in most parts of Spain allowed this style to continue until the 12th century AD* BRITISH LIBRARY, ADD. MS 30844, f.41

the Visigothic [24] script. Those 'minuscule' scripts were quattrolinear book hands: instead of the old two-line systems they appear written between four lines so as to accommodate individual ascenders and descenders. This characteristic, together with the interchange of capital and small letters in later styles, became an important element in the formation of Western calligraphy, giving scribes the possibility of introducing variations in an otherwise limited number of letterforms.

In the 5th century, Ireland, which had never been occupied by Roman legions, was converted to Christianity through the intermediary of the British Church – according to tradition by the Romano-British apostle St Patrick. Christianity introduced literacy, together with the Cursive Half-Uncial script, and the latter was soon taken up and modified in the newly established monastic centres. By the 7th century two distinct Celtic hands had emerged:

25 An idealized minia-
ture of the Evangelist
St Matthew from the
Lindisfarne Gospels
(c.698AD), composing
his own gospel,
accompanied by his
symbol: an angel
blowing a trumpet and
what is probably the
figure of Christ, both
carrying books. In
reality texts were first
written on loose sheets
and bound into a
codex only after all the
pages had been
complete.
BRITISH LIBRARY,
COTTON MS NERO, D. IV,
f.25B

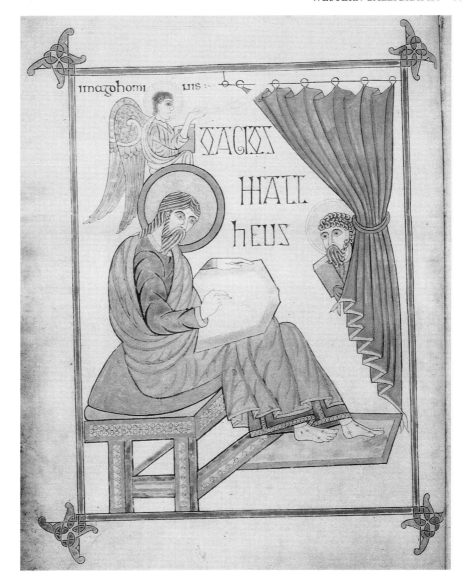

25 An idealized miniature of the Evangelist St Matthew from the Lindisfarne Gospels (c.698AD), composing his own gospel, accompanied by his symbol: an angel blowing a trumpet and what is probably the figure of Christ, both carrying books. In reality texts were first written on loose sheets and bound into a codex only after all the pages had been complete. BRITISH LIBRARY, COTTON MS NERO, D. IV, f.25B

Insular Half-Uncial, a book hand resembling Roman Half-Uncial but less formal and more given to calligraphic elaboration; and Insular Cursive minuscule which had a tendency towards pointed features, ligatures, loops, and abbreviations. When in the 6th and 7th centuries enterprising Irish missionaries such as St Columba and St Columban founded monasteries in Britain (Iona) and on the Continent (Luxeuil, Corbie, St Gall, Bobbio), Irish, or Anglo-Celtic Insular hands, were introduced to a much wider audience. The books produced in the Anglo-Celtic monasteries are among the finest achievements of Western calligraphy and manuscript illumination. The two most outstanding examples – often reproduced, often quoted – are without doubt the Book of Kells (probably copied in Iona in c.800AD), and the Lindisfarne Gospels (written on the holy island of Lindisfarne around 698AD [see PLATE II and 25].

LIBER SALOMONIS
IDEST PARABOLAE
EIVS SECVNDVHE
BRAICAM VERITATE
TRANSLATA E AB EV
SE BIOHIERONI MO
PRBOPETENTECHRO
MATIOETHELIODOR
EPISHIERONIMVS

UNGAT EPISTOLA QUOS IUN
git sacerdotium immo carta
non diuidat quos xpi nec ut
amor. Commentarios in
osee amos zaccariam ma
lachiam quae poscitis scrip
sissem si licuisset praeualetu
dinem mittas solacia sump
tuum natas nostros ecli
brarios sustentas ut uobis
potissimum nostrum desudet
ingenium. Et ecce ex latere
frequens turba diuersa pos
centium quasi aut aequum sit
me uobis esurientib: aliis la
borare. aut in ratione dati et
accepti cui qua prae uos obnoxius sim
Itaq: longa aegrotatione frac
tus ne paenitus hoc anno rea
cerem. et apud uos simutus essem.
triduo opus uestro nomini conse
craui. inter praetationem uide
licet trium salomonis uoluminu
masloth quas hebraei para

26 Biblia Sacra Latina, ex versione vulgate *of Alcuin of York. The complete manuscript of this Bible is thought to have been presented to Charlemagne in the early 9th century, though the patron may have been Charles the Bold. This folio is written in an earlier style which was later superseded by the Carolingian script in which the rest of the manuscript is written.* BRITISH LIBRARY, ADD. MS 10546, f.249

27 *Charter of a gift of land at Northtun by Ealdred, Bishop of Worcester, Worcester, 1058*AD. *The body of the document is (as usual) written in Latin in a form of English Carolingian minuscule which has additional feet to minims (downwards strokes) under the influence of Anglo-Saxon minuscule. Carolingian minuscule is also used for the first two expanded entries of the witness list. Display capitals, incorporating Uncial and Rustic Capital letterforms, are used for the key names. The central part of the document, which gives the land boundaries, is written in Old English (again a common feature in charters, since this is the part which must be understood by everybody and not just those versed in Latin learning); the witness list and some names cited in the text use Anglo-Saxon round minuscule.* BRITISH LIBRARY, ADD. CHARTER 19801

In 796AD the English cleric Alcuin of York (735–804AD) accepted Charlemagne's invitation and, as Abbot of St Martin's at Tours, took charge of the scriptorium to put into effect the emperor's ambitious plans for a wholesale reform of scholarship, education, and, with it, the standards for making books throughout his Western Empire. The most lasting and influential result of these efforts was the creation of a new style of writing: Carolingian (or Caroline) minuscule [27]. This was a clear, round script of great harmony which used the four-line system, few ligatures and abbreviations, and often artistically embellished Capital and Uncial letters for headings. Written with the shaft of the pen pointing slightly to the right (instead of straight back over the shoulder), letters had to be formed deliberately, stroke by stroke, in the same way every time; it was a script easy to write and easy to read. One of Charlemagne's aims had been the standardization of texts, and Carolingian minuscule offered a disciplined alternative to the many National Hands and sub-Roman scripts used in his Empire. In the 9th century Carolingian minuscule spread rapidly throughout most of Western Europe but was not adopted in England before the second half of the 10th century, where it was then reserved mainly for Latin texts (Old English texts continuing to be written in Anglo-Saxon minuscule [28].

Carolingian minuscule dominated European book production for most of the 9th century. Then a new trend became noticeable. Letterforms changed from round to oval and became laterally more compressed. This new style (first adopted in St Gall, Switzerland) is now usually referred to as Protogothic [see PLATE III]. It is both a book and a documentary script; in the case of

Apologetica se excusatio dilatico dicelli.

lun quod urginitatis sconiu sicut sup parti opusculo pethopicis prela
cib; disertu + sta Infuturo ope metpicis capinimib; sepolietus.

REUC RENTISSIMIS XPI
urginib; omni que deuotus zepinanitatis
sappectu uenepandis. & non solum copapoalis
pudicitiae praeconio celebrandis quod plusumopus est uspud
stiam rpipitalis castimoniae zpatia glopipicandis quod pauco
pus est hildilithae pegulapis disciplinae & monasticae conubspius
omis mazistpae simulque lustinae de cuthbupze nsse non orbupzsi
mihi contpibulibus necessitudinum nexibus conglutinatae.
illgsthae ac scolasticae hydbupzs & bspnzydss eulalae ac teclas.
pumospae scitatis concopdisp secletiam opnantibus:
illdhelmus segnis xpi cpucicola et supplse ecclesiae uspnaculus
optabilem pstpetuae ppospepitatis salutem:

MDVDVM ald pontificale pps
psopiscsspis conciliabulus spatspnis sroda
plum catspuis comitatus. illmitatis uespsae scpipta meae
mediocsitati allata patis libentsp suscipiens spectss adaethspa
sp menpas xpso ppospspitate uespsa zpatulabundus sp
psndsyp spasp cupaui. quo sslo non solul ecclesiastica s missosium
ssspus paedspa quae spda pollicitatione ppopondistsp ubspss claptss.

llchelmus fuit psmsp Epsl Sherborn, nunc Salisburiensis,
obiit Ao dm DCCVII. fuit Beda Coætanes.

Vide Beda
Lib. 5. ca. 19.
&c. &c. Angl.

the latter there is however a tendency towards the introduction of semi-cursive features (MPB; p.71). Up to a point Protogothic was a by-product of the easier way the pen could move over the page when held in a slanting position (as for Carolingian minuscule). However, held at this angle a straight-cut nib does not produce body strokes of full thickness, and, eventually, scribes began to choose an obliquely-cut nib which, remaining parallel to the top of the page, could create perpendicular strokes of maximum width.

Protogothic reduced the cost of manuscript production, because writing took less time and the text could be written on less writing material. It is probably no accident that this style evolved in areas under the influence of the Normans and Angevins, whose patronage and administrative and ecclesiastical reforms initiated an increase in book production. Protogothic was basically a transitional style; in the 12th century it led towards the development of a complex hierarchy of formal and cursive scripts which are variously referred to as Gothic, Black Letter (so called because the density of letters deepened the colour of the page), or Textualis (the variety of forms on one and the same page can make it look like a piece of woven material).

The Gothic system of scripts, though never universally admired, was used in most parts of Europe between the 12th and the 16th centuries (even later in some conservative areas). Already during the 12th century the lateral compression of letters which had characterized Protogothic, increased, curves became more angular, and (most important) the basic upright stroke of letters acquired a more compact and elaborate appearance. During the 13th and 14th centuries the letters became smaller and stiffer and despite the fact that in the following century the script regained its size, they remained narrow and rigid. Four grades of book hands are generally recognized. They are, in descending hierarchical order: *textualis precissa* [29] (letters stand flat and without feet – serifs – on the baseline): *textualis quadrata* (with square and diamond-shaped, consistently-applied feet); *textualis semi-quadrata* (which has sporadically-applied feet on some minims, others being just rounded off); and *rotunda* [30], which was to become the preferred script of Italy until the Renaissance (feet are simply rounded off with an upward curve of the pen). Though it was *textualis precissa* which had most claim to calligraphic excellence, *textualis quadrata* was to become the model for the early (Gothic) printing types.

In the 12th century the Church monopoly on scholarship and learning began to decline and the gradual secularization of society led to the foundation of independent universities and schools. The monastic scriptoria remained active but gradually ceased to be the main centres of book production as the market, now catering also for the needs of students, scholars and the newly wealthy merchant classes, expanded. In the towns, professional scribes set up workshops (*see* p.77) and formed themselves into guilds to protect their interests. Side by side with traditional book hands used in the scriptorium, less formal and more cursive hands gained prominence.

296

29 Queen Mary Psalter, Magnificat, *London or East Anglia, c.1310–20*AD*. An example of the highest grade of Gothic book hand (textualis prescissa). Despite the generous proportions of the script, the spacing illustrates why this form of writing was often referred to as Black Letters or Textura.*
BRITISH LIBRARY, ROYAL MS 2.B.VII, f.296

30 Decretals of Pope Gregory IX (the Smithfield Decretal), Raymund's compilation, with the glossa ordinaria of Bernard of Parma. Written in Italy, probably for French use (the prologue is addressed to Paris University), it is a good example of the complexities involved in the page layout and the transmission of texts often associated with manuscripts produced for universities; the illumination was done in England. The main text is written in Italian Bolognese Gothic Book Script, a more rounded form of Gothic popular in Italy; the gloss surrounding the main text is basically a smaller version of the same script.
BRITISH LIBRARY, ROYAL MS 10.E.IV, f.248

31 Registrum Brevium, *Register of Writs, from the time of Edward I, 13th/14th century* AD. *English cursive Gothic (cursiva anglicana) used as a document as well as a book hand. A new stylistic feature is the increased complexity of capital letterforms.*
BRITISH LIBRARY, ADD. MS 11557, f.44V

Whereas Carolingian and Protogothic had served as book and documentary scripts, the new Gothic style saw the rediscovery of proper cursive hands. In England, during the 12th century, Protogothic semi-cursive developed (for documents) into a fully cursive style – English Cursive [31] – which linked letters and introduced a number of decorative new features (as, for example,

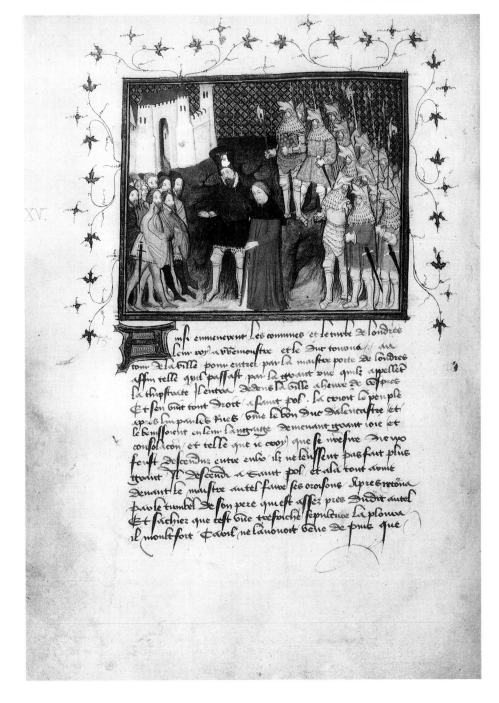

32 Jean Creton
Histoire du Roy
d'Angleterre Richard,
15th century AD. *French
cursive 'Secretary'
script; the speed of the
cursive ductus (the way
in which a script is
written) is offset by the
attention paid to
calligraphic elabora-
tions.*
BRITISH LIBRARY,
HARL. MS 1319, f.53V

loops). By the 14th century the French chancery had developed a distinct
cursive Secretary hand [32] which was introduced to England and Germany.
From the late 13th century onwards, cursive forms were also used for books,
especially those connected with professional university book production. In
consequence a range of contaminated (that is, mixed) scripts occurred,

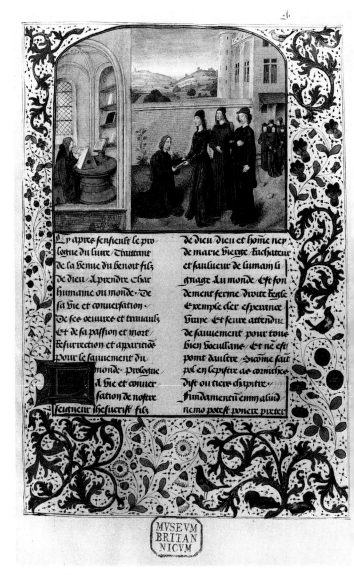

34 Vita Christi and Vengance de la mort Ihesu Crist, *compiled and written in Bâtarde (Lettre Bourguignonne) by David Aubert, scribe to Philip the Good, Duke of Burgundy; Ghent, 1479AD. The miniature at the top of the page shows (on the right) David Aubert presenting the manuscript to his patron; on the left he is depicted copying the text from an exemplar on to a single folio not yet bound into a codex.*
BRITISH LIBRARY, ROYAL MS 16.G.III, f.8

LEFT

33 *Lactantius* Institutiones divinae, I. 8–9; *Netherlands, 1433AD. An example of Gothic Hybrid script which, during the 15th and 16th centuries, was widely used for a variety of books.*
BRITISH LIBRARY, HARL. MS 3154, f.7

35 *Narrative by James Hall who served as principal pilot to an expedition which travelled from Denmark to Greenland in c.1605*AD. *A late cursive English hand of rather low quality which combines features of* cursiva anglicana *with 'Secretary'. The three lines underneath the drawing incorporate some Italic features.*
BRITISH LIBRARY, ROYAL MS 17.A.XLVIII, f.4

termed either Bastard or Hybrid. Between the 13th and 16th centuries this new range of cursive scripts more or less supplanted the original book hands for all but the most formal manuscripts, an especially fine example being a style generally associated with the patronage of the Burgundian court in France known as Bâtarde [34]. In England, Cursive and Secretary [35] remained in use (for administration and everyday handwriting) until the 18th century, when they finally gave way to copperplate writing (*see* p.176).

The Humanistic system of scripts, the last major calligraphic development before the printed book replaced the manuscript, began in Florence in association with an essentially literary movement called Humanism. Its founder, the poet Petrarch (1304–74AD), had been greatly interested in the collection and preservation of old manuscripts and fine penmanship. This enthusiasm

Omnipotens promisit. certus promisit. Verax promisit. Sustine domi
num utiliter age. noli dissolui ne sis inter eos quibus dicitur. Ve his q
perdiderunt sustinentiam. Sustine dominum omnibus nobis dicit et
uni homini dicit. Vnum sumus in christo. Corpus christi sumus. qui na
illam desideramus. qui unam illam petimus. qui in his diebus malorum
nostror. ingemiscimus. qui credimus nos uidere bona domini in terra ui
uentium Nobis omnibus qui unus in uno sumus dicitur sustine dnm.
utiliter age confortetur cor tuum. et sustine dominum. Quid aliud tibi
dicat. q̃ ut hoc repetat quod audisti. sustine dominum. utiliter age. Er
go qui perdiderit sustinentiam effeminatus est. perdidit uigorem. hoc ui
ri. hoc femine audiant. quia in uno uiro uir et femina. talis in christo nec
masculus nec femina est. Sustine dominum. utiliter age. et confortetur.
cor tuum. et sustine dominum. Sustine dominum habebis eum. habebis
quem sustinebis. aliud desidera si maius si melius si suauius inueneris

EXPLICIT. DE. PSALMO. XXVI.
INCIPIT. TRACTATVS. ET. EXPO
SITIO. AVR. AVG. EPI. DE PSAL
MO. XXVII. HUIC DAVID. PSALMUS.

PSIV. DAVID. IPSIVS.
mediatoris uox est manu fortis in conspectu passionis.
Que autem uidetur optare inimicis. non maliuolentiae
uotum est. sed denuntiatio poene illorum. sicut in euange
lio ciuitatibus in quibus miracula. cum fecisset. neq; credi
dissent. et non maliuolentia optat. qua dicat. sed quid eis immineat pdicat.

EXPLICIT. DE. TITVLO. IN
CIPIT. DE. PSALMO. XXVII.

DE DÑE CLAMAVI
deus meus ne sileas a me. Ad te domine clamaui deus
meus ne separes unitatem uerbi tui ab eo q̃ homo sum
ne quando sileas a me. et ero similis descendentibus in
lacum. Ex eo enim q̃ eternitas uerbi tui non intermit
tit unire se mihi fit ut non sim talis homo quales sunt
ceteri qui nascuntur in profundam miseriam seculi huius ubi tanq̃ sile
as non cognoscitur uerbum tuum. Exaudi uocem deprecationis mee.
dum oro ad te. dum extollo manus meas ad templum sanctum tuum.
Dum crucifigor ad eor salutem qui credentes fiunt templum sanctum.
tuum. Ne simul tradas me cum peccatoribus animam. et cum operan
tibus iniquitatem ne comperdas me. Cum his qui loquuntur pacem
cum proximo suo. Cum his qui mihi dicunt Scimus quia a deo uenisti

36 Augustine of Hippo In Psalmos, in psalmum xxvii, written in Naples by Rodolfo Brancalupo for Ferdinand of Aragon, King of Naples; dated 1480AD. A fine example of the Humanistic book script as used by Poggio Bracciolini in 1402–3AD. The Humanistic movement led to a revival of the pre-Gothic Carolingian form of writing and was to serve as a model for early Italian printers.
BRITISH LIBRARY, ADD. MS 14779, f.71V

for antiquity, coupled with a scholarly interest in classical texts, led a group of scholar/author/scribes to attempt a serious reform of script and book design, and to replace the medieval, German Black Letter hands with an Italian system that could boast clarity, legibility and elegance. As a result of their studies and experiments two major new styles evolved. One, a round and formal Humanist Book Script [36] was developed by Poggio Bracciolini (1380–1459AD) with direct reference to late Carolingian minuscule; it eventually served as prototype for 'Roman' type fonts. The second style, the Humanist Cursive Book Script (*littera antiqua* [37]), was invented by Poggio's friend, Niccolo Niccoli (1364–1437AD). Written with a narrow rounded nib, at reasonable speed, it was slightly inclined and became the inspiration

37 Apuleus Platonicus, Herbal, Italy, 15th century. An example of the Humanistic cursive book script invented by Niccolò Niccoli in c.1420AD. Herbals are manuals facilitating the identification of plants for medicinal purposes. In India and China they were in vogue well before the Christian era; according to the elder Pliny the first Greek manual of this type dates back to the 1st century BC. Handwritten herbals were used in medieval Europe; after the 15th century printed examples achieved a much wider circulation and were sometimes considered suitable gifts for foreign potentates (see 60).
BRITISH LIBRARY, ADD. MS 21115, f.23V

38 Pandolfo Collenuccio of Pesaro (died 1504AD), Apologues *and* Dialogues *from Lucian. Written by Ludovico degli Arrighi in his favourite cursive Cancellaresca hand. This was developed from Gothic chancery hands by Humanistic scribes who (like Arrighi) were involved with chancery work as well as book production. Towards the middle of the century this script became a quite formal calligraphic book hand. Arrighi was the author of the first copy-book, printed in Rome in 1522, which initiated the profession of the writing master (see 43).*

BRITISH LIBRARY, ROYAL MS 12.C.VIII, f.34

for the printers' 'Italic'. These new styles were initially confined to centres like Florence, Venice, and, later, Ferrara and Naples; in 1403 Poggio introduced his new script to Rome (where he eventually took up the position of Papal secretary). Scribes at the Papal chancery, such as Ludovico degli Arrighi (*see* p.169), were also instrumental in promoting a modified Gothic chancery script into Humanistic Cursive (or *Cancellaresca* [38]); this hand, which could boast a high degree of calligraphic accomplishment, was at first only a documentary but later also a book script. From the late 15th century onwards Humanistic scripts [39] spread their influence throughout the rest of Europe, sometimes replacing, but more often mixing with, indigenous scripts (MPB; p.127).

Epistola beati Pauli

firmi fuerimus in hac parte. In quo quis audet, in insipientia dico, aude o & ego. Hebrei sunt & ego. Israeli tæ sunt: et ego. Semen Abraæ sunt: et ego. Ministri sunt christi. & ego. Vt minus sapiens dico: plus ego. In la boribus plurimis: in carceribus abu dantius: in plagis supramodum: in mortibus frequenter. A Iudeis quin quies quadragenas vna minus acce pi. Ter virgis cesus sum: semel lapi datus sum: ter naufragium feci. Noc te & die in profundum maris fui. In itineribus sepe periculis fluminuȝ: periculis latronum: periculis ex gene re: periculis ex gentibus: periculis in ciuitate: periculis in solitudine: peri culis in mari: periculis in falsis fra tribus. In labore & ærumna: in vi giliis multis. In fame & siti in ieiu niis multis. In frigore et nuditate. Præter illa quæ extrinsecus sunt: instantia mea quotidiana: sollici tudo omnium ecclesiarum. Quis

*1. ad Corin. 4.
Supra. 6.
1. ad Timo. 3.*

*2. ad Thes. 3
Deute. 28.*

Ad Corinthios. II

infirmatur & ego non infirmor? Quis scandalisatur: & ego non vror. Si i gloriari oportet: quæ infirmitatis: meæ sunt gloriabor. Deus pater do mini nostri Iesu christi scit, qui est benedictus in secula, q. non mentior. Damasci præpositus gentis Arethæ regis custodiebat ciuitatem damasce norum vt me comprehenderet: et per fenestram in sporta demissus sum: per murum: & sic effugi manus eius.
Cap. seq. Recommendat se Aposto lus ex diuinis reuelatiombus: & ponens ibi remedium contra periculum super biæ: deinde seipsum excusans commemorat beneficia Corinthijs impensa.
I gloriari oportet. Cap. XII. non expedit quidem. Veni am autem ad visiones & reuelatio nes domini. Scio hominem in Chri sto ante annos quatuordecim siue: in corpore siue extra corpus nescio de us scit: raptum huiusmodi vsqȝ ad tertium cœlum. Et scio huiusmodi

Actuū. 9.

*Aduerte pleraqȝ
tempore suo occul
tanda: quū opus e
efferri licere etiam
indignantibus per
uersis.*

UPHOLDING THE LAW
Monks, 'secretaries' and writing masters

If you do not know how to write you will consider it no hardship, but if you want a detailed account of it let me tell you that the work is heavy; it makes the eyes misty, bows the back, crushes the ribs and belly, brings pain to the kidneys, and makes the body ache all over. Therefore, oh reader, turn the leaves gently and keep your fingers away from the letters, for as the hailstorm ruins the harvest of the land so does the unserviceable reader destroy the book and the writing. As the sailor welcomes the final harbour, so does the scribe the final line.
MANUSCRIPT OF SILOS BEATUS

These words, written by the scribe in the colophon of a 12th-century manuscript, illustrate the way he himself sees his position: neither an artist in harmony with nature, nor a mystic looking for the hidden face of Allah in a combination of letters, but simply a craftsman.

In Imperial Rome, where form followed function, the calligrapher was mainly a scribe, that is, a copyist. The level and standard of his work was to a large extent dictated by the text: elegant book hands for the copying of literary works which were commissioned by (and sold to) the educated elite, and quick cursive styles for chancery documents, letters, administrative notices and instructions, which served the infrastructure of the huge empire. Calligraphy originated in the first category but flourished greatly when the two styles began to influence each other.

Roman society was highly literate. Excavations in Rome and Herculaneum show library rooms in most houses. There were at one time 26 public libraries in Rome alone (Julius Caesar had planned to establish one shortly before his assassination). The subsequent demand for texts made publishing quite a lucrative business. Competition was keen, if not at times unfair: the edicts of the Emperor Diocletian (301AD) set out the maximum prices to be charged for writing a hundred lines of text in documentary as well as in first- and second-class book hands (DJ; p.43). By the middle of the Imperial period there were two types of scribe: *librari*, copyists who used formal book hands (no doubt those written in a good hand sold better), and *scribae*, personal secretaries and government servants who employed documentary and cursive scripts. But though writing and literacy were considered of great importance (many citizens, especially those belonging to the great and wealthy families were well versed in Latin and Greek), the position of the scribe was often ambivalent. Indeed, in many cases he would be a slave, or a freedman,

and – as one discovers on examining the forms of recorded names – quite often a slave of Greek origin.

The sack of Rome by the Goths in 410AD brought about the destruction of most public and private libraries and resulted in an almost total loss of the existing literary output. Book production and the continuation of literacy (together with that of existing book styles) passed into the hands of the newly emerging Christian Church whose very existence depended on the authority of written Biblical texts. The monasteries which sprang up all over Europe during the later part of the first Christian millennium needed books, but these were in short supply and, to begin with, only available in Rome, from where they had to be fetched (often after a lengthy and difficult journey) and then copied. This need for authentic copies was recognized by the founders of the great monasteries. The rules laid down by St Benedict (c.480–547AD) after the foundation of Monte Cassino (529AD), made it obligatory for monks to set aside certain hours of the day for study and writing. Other monastic houses followed suit and soon all the large monasteries in Ireland, Britain and on the continent of Europe had their scriptoria where books brought back from Rome, or on loan from other monasteries, could be painstakingly copied by dedicated and often gifted monks who worked not only as scribes, but also as illuminators or bookbinders. Those scribes were, however, first and foremost copyists; they were never considered artists, and they became calligraphers because of the subject matter they wrote. Their importance to the monastery lay in the fact that by copying the sacred texts they provided material for study, devotion and (most important) the conversion of heathens to Christianity. As such they were of great value to the community; indeed an Irish law prescribes the same punishment for the murder of a scribe as for a king or bishop (EMB; p.11). Nevertheless scribes had no special status except the one they already held within the monastic hierarchy. If we know their names it is very often because of their place within the community. For example, St Columba (521–597AD), much praised as a scribe, was the founder of Iona, and Eadfrith, who wrote the Lindisfarne Gospels, was also Abbot there.

Talented and willing scribes were not always easy to find and Odo, an 11th-century Abbot of St Martin's at Tourain, wrote that he used to delight in the number of scribes the Lord had given him 'for if you had gone into the cloisters you might in general have seen a dozen young monks sitting on chairs in perfect silence, writing at tables carefully and artificially constructed' (MD; p.8). Monastic scribes worked long hours to make use of the daylight (candles and fires were strictly prohibited for the safety of the manuscripts) and the only interruption in their daily chores were prayers and feast days. Though they wrote in silence they did not always suffer in silence [40]; in the margins and at the end of a good many manuscripts we can find complaints about stiff and frozen hands, a desire for better writing material, or wine ('now I have written the whole thing: for Christ's sake give me a drink'), or even just a good meal, and occasionally also a note stating that the

Galfridus Stukle legauit Conuentui. C. s
Alanus Strayler circa depictione
presentis libri plurimu laborauit. 7
tres solidos 7 iiij. d. sibi debitos p colo
rib; condonauit.

zome pictoris: Alan Strayler licetur
Qui su fine chorus. celestib; associet

40 *Book of the Bene-*
factors of St Alban,
1380AD. The illumina-
tor shows himself in
one of the portraits
which depict the bene-
factors. In an inscrip-
tion next to it he states
that he has laboured
long and hard on the
book and that he him-
self has now donated
the three shillings and
four pence still owed to
him for pigments.
BRITISH LIBRARY,
COTTON MS NERO D.VII,
f.108

completion of the work had to be postponed until the return of the warmer
season. There were, however, also happier moments: a 9th-century Irish
scribe simply wrote in the margin of his manuscript: 'pleasant to me is the
glittering of the sun today upon these margins, because it flickers so' (DJ;
p.70). The scriptorium itself was run by the *armarius* whom a scribe could
summon by hand signals whenever he needed fresh ink, a new pen or
another sheet of parchment. Accuracy was of the uttermost importance; it
not only saved the cost of re-copying but a monastery which became known
for its reliable copies could gain a considerable amount of prestige and fame.
Scribes might occasionally write from dictation but most medieval illustra-
tions show them with an exemplar (the manuscript from which the text is
being copied) on the lectern in front of them. Though they could not boast a
powerful patron saint – the only one known in this connection seems to have
been St Cassien who in the 4th century taught pagan children in Tirol and
was promptly killed by one of them with a pen (one wonders why) – they had
a special 'patron' demon, Titivillus, first mentioned in John of Wales's *Trac-*
tatus de penitentia (*c.*1285AD). His task was to wander around the scrip-
torium looking for errors; if he saw one, he carried it off in his sack so that the
mistake could be held against the unfortunate scribe on the day of judgment
(MD; p.17). But, however arduous the task and however important the work,
pride in one's skill and achievements was rigorously discouraged. Should a
scribe boast about his work, he could be taken from the scriptorium and
given another, more humble task. But sometimes pride would win and a
calligrapher/scribe (or illuminator) would slip in a signature (or a miniature
self-portrait) to establish his claim of authorship [41]. The Eadwine Psalter,

41 *Historia Anglorum*
by Matthew Paris (died
1259), a Benedictine
monk and chronicler.
Though we know next
to nothing about him
as a person his volu-
minous and detailed
writings are an impor-
tant source of informa-
tion concerning events
in Europe between
1235–1259AD. This
page shows Paris
adoring Virgin and
Child.
BRITISH LIBRARY, ROYAL
MS 14.C.VIA, f.6

a manuscript written in 1140 and now in Trinity College Library in Cambridge, has a small portrait of Eadwine, a scribe of Christ Church, Canterbury; around his portrait he proclaims himself a 'prince of writers' adding:

> '...neither my fame nor my praise will die quickly; demand of my letters who I am... Fame proclaims you in your writing for ever Eadwine, you are to be seen here in this painting. The worthiness of this book demonstrates your excellence, Oh God this book is given to you by him. Receive this acceptable gift.' (DJ; p.70)

Something had obviously gone wrong.

After the break up of the highly centralized Roman Empire, Europe disintegrated into a number of small and quarrelsome tribal states with no central cultural impulse except that provided by the Christian Church in Rome. Under the Merovingians, the Franks eventually emerged as a unifying power. As the political situation became more stabilized, government and administration developed a need for clerical skills, which to begin with was supplied by the Church in the shape of the *clericus* or clerk. Merovingian chancery scribes took up the challenge and produced a special cursive script which came to be known as Merovingian minuscule. The unification of Europe was finally brought about by Charlemagne (742–814AD), whose conquest united a large part of Western Europe, though England, Ireland and Spain (and with it many important centres of learning) remained outside his orbit. Charlemagne differed greatly from the preceding Merovingians in that – although illiterate himself – his ambition was to revive culture and learning, and to create a mode of life which combined Christianity with Roman civilization. To this end he surrounded himself with learned men from all over Europe: the historian Paul the Deacon from Italy, the grammarian Peter of Pisa, Theodulf the Visigoth from Spain, and most important of all, Alcuin of York (*see* p.59) whose *turba scriptorum* (crowd of scribes) in the Abbey School at Tours not only copied valuable manuscripts brought from Rome and Monte Cassino, but in addition created one of the finest calligraphic styles, the Carolingian minuscule.

In the 12th century the Church's monopoly on scholarship began to decline, learning ceased to be synonymous with theology, and the clerk was no longer necessarily a *clericus*. This secularization of society, and the influence of Arab, Jewish and Greek scholarship, encouraged the creation of new centres of learning, and led to the foundation of universities without direct links with the Church in places like Bologna (1158), Oxford (1168), Paris (1200), Padua (1222) and Salerno (1224). In consequence the monastic scriptoria ceased to be the main centres for book production; with the spread of wealth and education, the book market (and with it book ownership) increased, catering no longer just for the Court and the Church but also, increasingly, for the needs of students, scholars and the new wealthy mer-

chant class. By 1300 a good many monasteries had stopped producing their own manuscripts and monks began to patronize the commercial bookshops like everybody else. This drastically changed the position of the calligrapher/scribe. His purpose was no longer self-evident; like the copyist (who at first rather benefitted from the new situation) he had to find his own clientele and commercial aspects began to influence him. Lay scribes had worked for hire in cathedral schools side by side with monks since the 8th century, but now scribes had to find customers themselves. Often they would travel the neighbourhood with their sample books to show what they had to offer, or post notices on the doors of inns and churches. In the newly prosperous towns, professional scribes and calligraphers set up workshops and, in order to keep up standards and protect themselves from unfair competition, organized themselves into guilds. Book production now required the co-ordination of a large number of different skills: writers (who produced the main body of the book), limners (who illuminated the pages), tornours (who drew initial letters and borders), rubricators, flourishers, bookbinders and parchmenters, and, most important perhaps in the new climate, stationers and booksellers who acted as middle-men between different workshops or individual craftsmen and the customers who had placed the order. Apprenticeship was strict, usually lasting some seven years; after the 'master piece' had been presented to the master and the warders, the candidate would become a journeyman before settling down to practise his craft (usually well away from the locality in which he had been trained). A scribe was expected to be proficient in a number of different styles to serve the requirements of the text and prevailing fashions. An apprentice would usually perform the more humble tasks of checking the skins when they were delivered by the parchmenter, ruling lines, mulling and grinding colours on a stone slab, and mixing them with the yoke or white of an egg. Writing was done sitting at a desk, a sharpened quill in the right hand, and a pen-knife to hold down the parchment in the left. At the beginning of chapters space had to be left for large letters. Having completed a page the scribe would (with a finer pen and paler ink) scribble instructions in each empty space for the illuminators and rubricators (who filled in the red letters). Mistakes would be erased with a pen-knife; this is relatively easy since skin consists of several layers and the corrections only become visible after dirt has collected in that area. An important task was that of the corrector who indicated errors in the margin. If whole sections were missing they had to be written in the margin, or at the bottom of the page; occasionally, the illuminator/illustrator would paint a little scene which showed the missing sentence being lifted (by, for example, a pulley) into the correct position.

Socially such calligrapher/scribes ranked as craftsmen and their status was on the whole fairly low. Unlike the monks working in their scriptoria the new town scribes had no longer any inbuilt job security. At times contracts contained deadlines with penalty clauses should they fail to deliver; with the

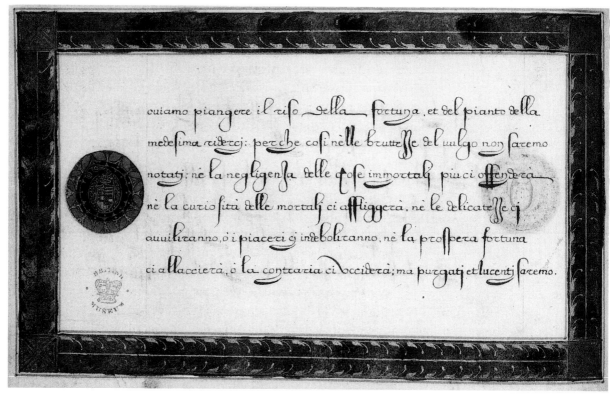

loss of monopoly the power had shifted, decisively, from the producer to the market. Pay itself was frequently late (the pay of a 14th-century scribe was generally the same as that of a common farm labourer, only half that of a carpenter), often it was altogether forgotten, and many a scribe died poor [42]. This was, however, not the whole story. Some calligraphers (and illuminators) were able to attract the attention of rich patrons who provided lifelong and well-paid employment; others, like Christine de Pisan (*see* p.84), managed to earn substantial sums of money by selling their manuscripts to rich members of the aristocracy or the Court.

In the second half of the 15th century the printed book became firmly established. Some enterprising calligraphers accepted the challenge and brought out manuals (*see* p.169) on calligraphy and handwriting, shrewdly using the increased circulation possibilities to further their own ends. Because of such efforts handwriting became formalized and calligraphy merged with the needs of common everyday business. The following centuries saw a steady increase in bureaucracy, which in turn created a need for officials and secretaries who could write in an appropriate manner, and take down dictations at short notice. These new job opportunities gave young men a chance of upward mobility, and also created possibilities for the calligrapher/scribe in the role of the writing master [43]; somebody had to teach all those aspiring young men. Teaching to write, which had up to then occupied a fairly low place on the social ladder (indeed, in Antiquity it had

42 Specimens of Calligraphy, a page from a copy-book by the Italian writing master Petruccio Ubaldini (c.1524–1600). Born in Florence, Ubaldini found employment at the Court of Elizabeth I in a variety of capacities. Despite his many talents and entrepreneurial skills, material success did not come his way, and he frequently needed to be rescued from the debtor's prison by members of the Privy Council. This page (written in Italian) is in a 'Mixed Hand' which represents a fusion between Humanistic and Gothic elements. This example is influenced by the italic mercentile Land.
BRITISH LIBRARY, ROYAL MS 14.A.I. f.23V

43 A writing master at work surrounded by the various instruments of his craft. Woodcut illustration from Urban Wyss, Libellus valde doctus elegans & utilis, multa & varia scribendarum literarum genera complectens, *published in 1549. Wyss, a Swiss, was the author, printer and engraver of this work which became one of the most important manuals of the 16th century.*
VICTORIA AND ALBERT MUSEUM, 86 D.95

mostly been the task of slaves), acquired status. In the late 15th and during the whole of the 16th century the writing master gained in importance; by printing and publishing his copy-books he could extend his influence, attract pupils, win patronage, fame, perhaps even a chance to ensure that his particular style was preserved for posterity. Still, his position was not always easy to determine. Some famous writing masters came from noble families (Sigismondo Fanti, Giovanni Francesco Cresci); others were middle ranking Church men (Vespasiano Amphiareo, Augustino de Siena, or in Spain, Andreas Brun); some advanced to minor titles (Juan de Yciar [44]); others were appointed at Royal Courts (Francisco Lucas, and in France Pierre Hamon). Giovanni Antonio Tagliente was a minor official at the Vatican Civil Service, and Ludovico degli Arrighi was a professional copyist, a scriptor at the Vatican and a master printer; Giovanni Battisto Palatino was on equal terms with the Roman upper circle of diplomats, literary men and Church dignitaries. Finally, in Pedro Madraga's *Libro subtilissimo* (1587) we learn of a writing master who had three cargo ships at sea, which is not altogether surprising since in the same publication we are also told that in Spanish society writing was considered an essential accomplishment of an *hidalgo* (nobleman).

44 *Juan de Yciar*, Arte subtilissima, por la qual se ensena a escrevir perfectamente, *1555. Yciar is generally considered the founder of Spanish calligraphy. The examples in this book have been engraved on wood, some show white letters on black background.*
VICTORIA AND ALBERT MUSEUM: L 412–1895

By the 18th century England had become a great trading nation. Industrialization, overseas trade and colonial expansion created a need for a large army of clerks who were able to write a clear, quick and above all legible hand [45]. The conflict between various styles which had provided previous writing masters with much of their *raison d'être*, encouraging individuality as well as extravagance, was no longer in evidence. In consequence most copy-books now aimed, like George Bickham's *The Universal Penman* [see 176], at teaching a good clerical hand. The new English Round Hand was also taken up by merchants in other countries (France, Spain, the Low Countries, eventually Italy, and in due course also America; *see* p.199) and became

45 *John Bland, An Essay in Writing exemplified in the several Hands and Forms of Business, etc., engraved by George Bickham, London, 1760. This looped, strongly inclined script combined speed and elegance. At first thought more suitable for the female sex it eventually became the preferred Running Hand for clerks and men of business, subsequently influencing developments in America.*

BRITISH LIBRARY, X.425/3011, P.198

Invoice of 1 Bale containing 6 Long Bays shipd on board the Bonadventure Cornelius Nutty Command.r bound for Lisbon Consignd to Mess.rs Aubury & Frome on their proper Acco.t & Risque. Mark'd & Numb.d Viz.

N.o		Ells.
1 Red		100.
2 Sky		101.
3 Poping		103.
4 Mazarine		104.
5 ½ Light ½ da Copper		104.
6 ½ Scarlet ½ White		102.

For 6 Long Bays q.l 614 Ells at 17 p. Ell	43. 9. 10.
Dying 5 Peices at	1. 4. - .
Whitening ½	- . 7. - .
Dying ½ Scarlet	2. 10. - .
Drawing at 8.d	- . 4. - .
Drying	- . 4. - .
The Sworn Measurer	- . 2. - .
Measuring Folding & Tacking	- . 9. - .
Filleting	- . 1. 8 .
Imbailing	- . 9. - .
Cocquet & Searchers	- . 4. - .
Boathire Wharfage Porterage & Carman	- . 3. 6 .
	.5. 18. 2.
£	49. 8. 2 .

London 19 Febry 1728/9

Errors Excepted Bland

Bland Script.

known as *Lettre Anglaise*; in fact only Germany, together with the Austro-Hungarian Empire, continued to prefer styles based on the Gothic script.

This increase in demand – further accelerated in Britain by the new Education Act of 1840 – again changed the position of the writing master. No longer a member of a respected community, or part of a team of sought-after craftsmen, he began to rank somewhere between a law-writing 'scrivener' (tainted in public esteem because of a perceived association with money lending and fraudulent costs) and a mere schoolmaster (never a popular figure), and with this loss of status, the type of scripts he propagated declined. The pedagogic copy-books which flourished during the late 19th

century in Europe and America were largely derived from the examples of Guilantonio Hercolani's manual ([46], published in Bologna in 1574), and those of his successors. They reduced handwriting to almost total mediocrity by confusing pen and burin (*see* p.176). Robert Bridges, a poet who regarded Victorian school copy-books as soulless models, claimed the ultimate degradation of handwriting was to be witnessed in lawyers' offices where clerks 'scrupulously perfect the very most ugly thing that a conscientious civilization has ever perpetuated'. Or, even more damning, we read in George Eliot's *Middlemarch* (1871) that 'at that time the opinion existed that it was beneath a gentleman to write legible or with a hand suitable to a clerk'. Thus the writing master had finally become not only a teacher, but a teacher of those most despised by the snobbish middle-class section of Victorian society – people in trade.

46 Guilantonio Hercolani's work, Lo scrittor' utile', published in 1574, shows how visually effective various hands can be, executed by means of copperplate engraving. VICTORIA AND ALBERT MUSEUM, L412–1895

WOMEN CALLIGRAPHERS

Christianity has always favoured literacy among women. Indeed, many saints, the Virgin Mary and her mother St Anne [47], are portrayed holding a book in their hands. Teaching children how to read and write was one of the parochial duties of the Church and during the middle ages women from noble families were often better versed in Latin and other school learning than boys, whose education centred around hunting, warfare and the courtly arts. The Church encouraged this trend, hoping that a good education would make a woman more suitable for taking up the religious life should her parents decide to dedicate her to a nunnery. As a result a good many nuns, especially those occupying prominent positions in the hierarchy (who, by definition, came from a more privileged background than the working sisters) were often highly literate and able to collaborate with monks who copied and/or illustrated a particular manuscript. Such work was done either in separate communities or in one of the double monasteries founded in Egypt in the 6th century and still quite common in medieval Europe. If we do not know many of them by name it is because their work was, like that of the monks working in the scriptoria, part of their dedication to God and not an exercise in self-expression. The framework in which calligraphy was practised during the middle ages imposed anonymity. Occasionally however this anonymity was breached and we are allowed glimpses of such a collaboration. In an astrological treatise written in Alsace in 1154, for example, we find, on the dedication page, a picture of Brother Sintram (the illuminator) and of Guta, the scribe, who was a Canoness of a sister house in nearby Schwartzenhann (DJ; p.70). But though nuns continued to produce books in collaboration with monks (or on their own) until the late middle ages, nunneries were never major centres of book production. After the 12th century, when the monastic scriptoria made way for scribal ateliers and commercial

workshops (*see* p.77), such a collaboration between men and women was, however, often inevitable; a workshop was in many cases a family business where wives and daughters laboured side by side with the men of the family. Sometimes a woman could be found running such a workshop, but this was usually the result of a wife having lost her husband or a daughter her father; in other words, her position depended – in line with contemporary conventions – more on association than on personal merit.

There were, of course, exceptions. There were women who had, and were able, to earn an independent livelihood through their pen, as, for example, Christine de Pisan (1364–1430AD), who wrote with authority on moral questions, education, the art of government, conduct of war, and the life and times of Charles V. Christine, who is often referred to as the first professional woman writer of Europe, was born in Venice and came to France as a child when her father accepted an invitation from Charles V. Educated by her father (a well-known physician and astrologer) she read French, Italian and Latin. Becoming a widow at the age of 25 she had to support not only herself, but also her three children, her mother and a niece who lived with them. Christine, a poet, author, illustrator and scribe, was soon able to earn a comfortable living by selling her manuscripts to the great ladies and gentlemen of the French Court [*see* PLATE IV].

With the rarest of exceptions women, however, did not feature as writing masters. This was a highly competitive profession, and rivalry could at times become rather acrimonious, if not outright violent. Successful writing masters had to be entrepreneurs with an ability to organize, take risks, look for financial backing, perhaps even own a printing press, or legitimize their authority by being officially employed at a Chancery or at a Court, with the poorer ones being forced to hack their samples around the country or post them on church doors – none of which was easy or even socially acceptable for a woman. Many writing masters, while trying to court women as potential pupils, were rather patronizing about their abilities. In his copy-book, *The Pens Excellencie; or, the Secretaries Delighte* (published 1618), the author Martin Billingsley says soothingly: 'suffer me not to give connivance to that ungrounded opinion of many, who affirm writing to be altogether unnecessary for women... if any art is commendable in a woman... it is this of writing, whereby they,' (qualifying statement) 'commonly having not the best of memories... may commit many worthy and excellent things to writing'. It is however only the Roman Hand which 'is conceived to be the easiest that is written with the pen, and to be taught in the shortest time' which in his opinion and that of other writing masters was 'usually taught to women, for as much as they (having not the patience to take great pains, besides phantasticall and humorsome), must be taught that which they may easily learne, otherwise they are uncertain of their proceedings, because their minds are (upon light occasions) easily drawne from the first resolution.'

But as the Industrial Revolution progressed and women became an impor-

tant source of cheap labour, more and more of them found work in printers'
shops, in factories (making paper, steel pens, etc. [*see* 15]), and eventually
also as poorly-paid governesses and school teachers. By the end of the 19th
century a few women were also employed as 'scriveners' by 'one or two law
stationers' and it seems were even paid the same rate as men, but one
wonders how comfortable they felt in the company of colleagues generally
renowned for their drinking habits (DJ; p.148).

The 19th-century revolt against what was by then considered the negative
spiritual inheritance of the Industrial Revolution (mechanization and the
mass-production of objects without any direct link between manufacturer
and user) brought about a general nostalgia for the past. A positive by-
product of such sentiments was an increased study of medieval art which in
turn created a desire to see, handle, copy and produce manuscripts. A
number of do-it-yourself copy-books appeared; some of them (for the less
talented) gave the outlines of letters which could simply be filled in, thus
creating results which looked reasonable enough even without any real talent
on the part of the would-be calligrapher. Just as industrialization had pro-
vided a work place for poorer women, so it had also created a group of
newly-fashionable ladies of leisure who looked for socially appropriate ways
of spending their time. A good number of Victorian middle-class women took
up the new ideas and wrote and illuminated manuscripts for their own pleas-
ure, or as a suitable gift for their friends, some producing quite respectable
work in the process. Those with less talent (the same who confused canvas
work with embroidery) could at least complete one of the do-it-yourself
manuals, often copying the outlined Gothic letters with a mapping pen before
filling them in with a brush – totally missing the basic point of calligraphy.

The Pre-Raphaelite Brotherhood, and even more so the Arts and Crafts
Movement inaugurated by the work of William Morris (*see* p.183) and his
followers, involved women more actively in their work; women became
painters, embroiderers, designers, and eventually also calligraphers. Some of
Edward Johnston's (*see* p.185) best pupils such as Irene Wellington or Mar-
garet Alexander (who wrote beautiful Rolls of Honour) were women. Indeed
his most famous pupil, who spread his ideas, his style and method of writing
and teaching to the continent of Europe, was a woman, Anna Simons (1871–
1951). Simons had come to London in 1896 to study at the Royal College of
Art, since women were not allowed to train at Art School in her native
Prussia. After her return to Germany in 1905 the Prussian Ministry of Com-
merce arranged a lettering course for art teachers at Dusseldorf, offering the
teaching post to Johnston; it was only after Johnston had refused the offer
that Simons was appointed. During the 20th century women's interest and
participation in calligraphy (including the teaching and commercial use of
calligraphy) has increased progressively. Today women are amongst the
best contemporary calligraphers, either teaching, contributing to journals, or
actively involved in the work of societies designed to further standards.

Arabic calligraphy

At the heart of Arabic calligraphy lies the Koran and the need for its precise and appropriate transmission. According to tradition the sacred text was revealed to the Prophet Muhammad by the Archangel Gabriel over a period of some 23 years. Although in the 7th century AD the Arabs did possess a script of their own, a stiff angular development of Nabatean (AG; p.97) called Jazm, this script was not widely used; indeed the Koranic verses were at first either orally transmitted amongst Muhammad's followers, or recorded on various pieces of material such as wood, paper, parchment, bone, leather or even saddle bags. However, in 633AD, during the battles following the Prophet's death, many of the *huffaz* who traditionally memorized and recited the Koran were killed, and, alarmed at the possibility of losing any part of the revelation, Abu Bakr (reigned 632–634AD), the first Caliph, instructed one of the Prophet's secretaries to compile the text into a book. In 651AD, under the third Caliph Uthman, a collated and codified version was prepared which still forms the authentic basis for every single Koran.

The fact that the Koran had been transmitted to Muhammad in the Arabic tongue gave both language and script a new status. Provisions had to be made to safeguard the Message and to provide it with a vehicle worthy of its divine origin.

The Arabic script, which is written from right to left, consists of 29 letters made up of 17 basic outlines plus diacritical points to distinguish otherwise identical character signs. Short vowels are not included (Arabic is a Semitic language where the root meaning of the word is borne by the consonants, and vowels serve mainly to fashion grammatical forms), but they can be indicated by vowel marks written above or below the consonant preceding the vowel. Some letters can be joined to their neighbours, either on both sides, or on one side only; if this happens their shape is modified. Thus, despite the fact that the Arabic script has more or less the same number of characters as the Roman alphabet, the variations in which individual characters can be written provides the calligrapher, from the very outset, with a wider range of possibilities than the largely self-contained Roman letterforms.

The earliest copies of the Koran were written in calligraphic variants of Jazm named after the towns in which they had originated, such as Anbari (after Anbar), Hiri (Hirah), Makki (Mecca), or Madani (Medina). None of them was well defined and available evidence points to the existence of only three definite styles, known in Medina as Mudawwar (rounded), Muthallath (triangular) or Ti'm (a combination of both). Only two of them were maintained: Mudawwar, curved and easy to write, and Mabsut, more angular and straight lined (YHS; p.9). These features dominated the development of the early Meccan–Medinan scripts and led to the formation of several further styles, the most important ones being Ma'il (slanting) [48], Mashq

48 A double-page opening of a Koran copied on vellum in Ma'il script; Mecca or Medina in the early part of the 8th century. Supposed to be one of the two oldest extant Koran manuscripts, it is devoid of any diacritical marks other than an occasional letter-pointing indicated by short strokes.
BRITISH LIBRARY, ORIENTAL AND INDIA OFFICE COLLECTIONS, OR.2165, ff.67V/68

(extended) and Naskh (inscriptional). In addition, another style developed in the newly conquered territories of Kufah and Basra which was to have a profound effect on the future of Arabic calligraphy. This was Kufic [49], a bold, elongated and straight-lined script of great distinction which for the next 300 years became the sole hieratic (sacred) script for copying the Koran. In early Korans this script is large, sometimes with as few as three lines to the page. The manuscripts themselves are often oblong in shape which adds emphasis to the impression of a line of characters moving with dignity and

49 A page from a Koran copied on vellum in black Kufic script in the 9th century AD, probably in North Africa. The vowels and the hamzah are indicated by red and green dots respectively, according to the system of Abu l-Aswad. Short diagonal strokes in black are used for letter-pointing, according to the system of al-Hajjaj.
BRITISH LIBRARY, ORIENTAL AND INDIA OFFICE COLLECTIONS, OR.1387, f.15V

strength from right to left. To no other style does the Arabic term for calligraphy, *handasat al-khatt*, that is, 'geometry of line' ('line' meaning 'letter' and 'writing') apply more aptly.

At the beginning of the 9th century Kufic began to attract non-figurative illuminations to mark title-pages, chapter headings and verse divisions; eventually the letters themselves took on ornamental forms: foliated, floriated [50], plaited, knotted, or animated, with individual characters taking

the shape of animals [51], or human heads and figures (YHS; p.12). Ornamental Kufic became an important feature of Islamic art, not only for Koranic headings but also for numismatic inscriptions and major commemorative writings; it was also (and still is) used with great effect in architecture [*see* PLATE IX] and on objects of everyday use.

By the late 10th century two distinct forms of Kufic emerged: Eastern (sometimes also called 'bent') Kufic [*see* PLATE VII; 52], which first developed in Persia, was an elegant, graceful script, its most beautiful variation being the so-called Qarmatian style; and Western Kufic [53], which originated around Tunis and became responsible for the development of the various scripts of North and West Africa, and of Andalusia, the Islamic part of Spain. After the 13th century Kufic went out of gerneral use and became predominantly a decorative element contrasting with those scripts which had superseded it.

50 Two lines of Ornamental floriated Kufic script, from a manuscript now in the Topkapi Museum, Istanbul, Turkey. PHOTOGRAPHED 1991

51 At times Islamic calligraphers tried their hands on more fanciful styles giving them names such as 'flame script', 'crescent script' or 'bride's tresses', though the more orthodox disapproved of such practices. The three letters (aliph, lam *and* nun*) shown here are written in Taus, the 'peacock script'.* PHOTOGRAPHED 1991

52 A double-page opening of a Koran in Eastern Kufic of a style known as Qarmatian, copied in the 11th or 12th century in Iraq or Persia. BRITISH LIBRARY, ORIENTAL AND INDIA OFFICE COLLECTIONS, OR. 6573, ff.210V/211

53 A double page opening in a Koran copied in Maghribi script in 1701/2AD in Morocco. The sura *headings are in ornamental Western Kufic, with palmettes of gold open-work arabesque outlined with blue and with blue finials. An inscription in gold ornamental Maghribi script, in which the eyes of the letters are filled in with red, is placed at the foot of the (left) page indicating the end of the Koran.* BRITISH LIBRARY, ORIENTAL AND INDIA OFFICE COLLECTIONS, OR. 13382, ff.284V/285

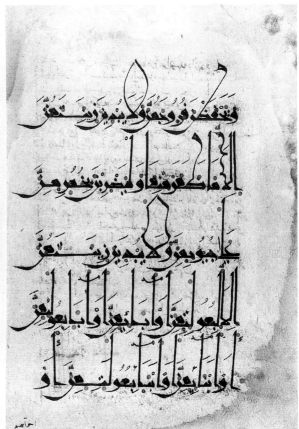

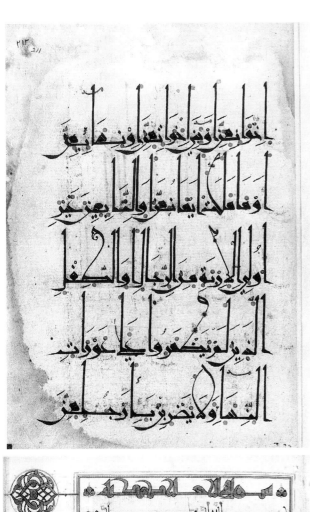

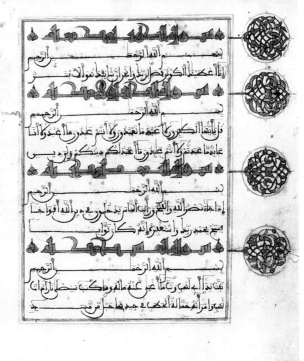

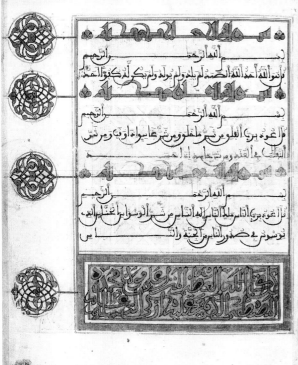

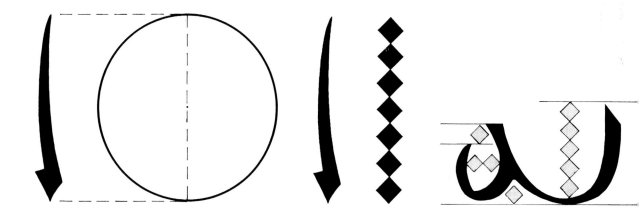

Besides the elongated and straight styles to which Ma'il and Kufic belong, more rounded, cursive scripts had been used since early times for personal correspondence, and to meet the needs of commerce and administration within the rapidly expanding Muslim empire. Unfortunately, few calligraphic specimens from this period have survived, since, after the fall of the Umayyid dynasty (661–750AD), the Abbasid Caliphs (750–1258AD) destroyed most previous records. Early attempts at improving the cursive scripts had led to the creation of some 20 different styles, many of them localized and short-lived, all of them lacking the elegance of good Kufic and much in need of discipline. Discipline was eventually provided by Ibn Muqlah (886–940AD), an accomplished calligrapher from Baghdad, who set himself the task of radically redesigning the cursive scripts so as to make them suitable for the writing of the Koran. He laid down a comprehensive system of calligraphic rules [54] which included a definite methodology of measurements based on the 'rhombic dot', the 'standard' *alif*, and the 'standard' circle. The 'rhombic dot' is formed by pressing the pen diagonally on paper so that the length of the dot's equal sides are the same as the width of the pen. The 'standard' *alif* is a straight vertical stroke measuring a specific number of 'rhombic dots'. The 'standard' circle has a diameter equal to the length of the 'standard' *alif* and provides the proportional grid for all letters. Thus the various cursive styles are ultimately based on the width of the pen used by the scribe and the number of dots chosen to fashion the 'standard' *alif*; those can be five to seven in number. This was a formula of great simplicity, successfully balancing dynamism against restraint and giving a creative tension to Arabic calligraphy. It also made it the most mathematically exact form of calligraphy which well befits a people who have always excelled in this science.

Ibn Muqlah's reform (his method of writing is referred to as *al-Khatt al Mansub*) was successfully applied to the *sittah*, the six major styles. They are: Thuluth [55], a static monumental style which was often used for

54 In the 10th century the great reformer and calligrapher Ibn Muqlah laid down a comprehensive system of rules based on the rhombic dot (formed by the pen being pressed diagonally on paper): the standard alif (made up of a specific number of rhombic dots), and the standard circle (which has a diameter equal to the standard alif). The size of the rhombic dot varies from style to style and depends on the width of the pen.
YHS, P.18

55 Page from a Koran, copied in Egypt in Thuluth script in 1304AD. BRITISH LIBRARY, ORIENTAL AND INDIA OFFICE COLLECTIONS, ADD. MS 22406–13, f.89V

اللَّهُ وَأُخْرَى كَافِرَةٌ يَرَوْنَهُم مِّثْلَيْهِمْ

رَأْيَ الْعَيْنِ وَاللَّهُ يُؤَيِّدُ بِنَصْرِهِ مَن يَشَاءُ

إِنَّ فِي ذَلِكَ لَعِبْرَةً لِّأُولِي الْأَبْصَارِ

زُيِّنَ لِلنَّاسِ حُبُّ الشَّهَوَاتِ مِنَ النِّسَاءِ

وَالْبَنِينَ وَالْقَنَاطِيرِ الْمُقَنطَرَةِ مِنَ

الذَّهَبِ وَالْفِضَّةِ وَالْخَيْلِ الْمُسَوَّمَةِ

56 A Koran copied in Naskhi script in the late 17th century AD in Persia. The sura heading is in white Thuluth on a gold ground. The verse counts are in marginal medallions in Thuluth, gold on blue for five verses and blue on gold for ten, inscribed over floral sprays of red and light blue. There is an interlinear Persian translation in small red Nasta'liq script dated 1728AD.
BRITISH LIBRARY, ORIENTAL AND INDIA OFFICE COLLECTIONS, OR. 13371, ff.313V/314

57 A double-page opening of a Koran copied in Muhaqqaq script, probably 14th century AD, from Egypt. The verse divisions are small gold and blue rosettes with a larger one at every tenth verse.
BRITISH LIBRARY, ORIENTAL AND INDIA OFFICE COLLECTIONS, OR. 1401, ff.64V/65

58 A miniature octagonal Koran in Ghubar script, with a heading in Riqa, copied in 1543AD in Shiraz. The maximum text width is only 4.5 cm, c.1¾ in. BRITISH LIBRARY, ORIENTAL AND INDIA OFFICE COLLECTIONS, OR.2200, ff.91V/92

decorative purposes in manuscripts and inscriptions; Naskhi [56], the most popular form of writing in the Arab world, it became (after 1000AD) the standard script for the copying of the Koran; Muhaqqaq [57], characterized by extended upward strokes, shallow downward strokes and sweeping sublinear flourishes, the favourite script for large Korans throughout the Islamic east; Rayhani, another popular Koran script, with strokes and flourishes ending in sharp points and diacriticals written with a smaller pen, sometimes in coloured ink; Riqa, smaller and more rounded than Naskhi and Thuluth from which it is derived, with short horizontal lines and a convention by which the centre of the loops of letters is filled in (mostly used for personal correspondence and secular manuscripts it was one of the favourite scripts of the Ottoman calligraphers and one of the preferred forms of handwriting in the Arab world); and Tawqi, with lines thicker than Riqa and letters more rounded than Thuluth, it is a large and elegant script usually reserved for important occasions.

According to tradition four more cursive styles have a status similar to that of the six *sittah*: Ghubar [58], a diminutive script which shared certain characteristics with Thuluth and Naskhi, originally used for writing messages on tiny pieces of paper to be sent by pigeon post, but later also for copying the Koran; Tumar, a large and heavy script, one of the earliest Arabic styles, which lost much of its static character under the reforms brought about by Ibn Muqlah and his followers, and acquired an elegance similar to that of

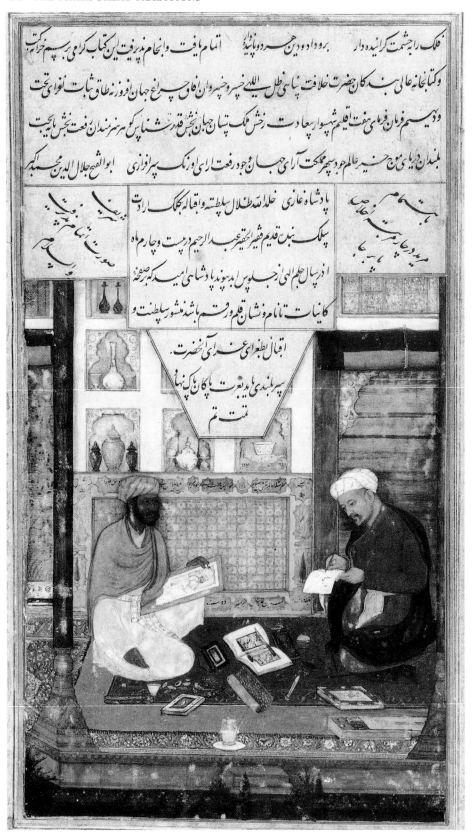

59 In Mughal India calligraphers were highly regarded and at times their portraits were included in the manuscripts they copied. In this folio of the Persian poet Nizami's Khamseh, dated c.1610AD, we see the miniature painter Daulat and the calligrapher Abd ar-Rahim (who had been given the title Ambarin Qalam – 'Amber-pen') at work surrounded by the tools of their trade: pen-box, ink pot, a roll of gold sprinkled paper, brushes and pots of paint. The text is written in Nasta'liq.
BRITISH LIBRARY, ORIENTAL AND INDIA OFFICE COLLECTIONS, OR.12208, f.325V

Thuluth; and the two most important scripts, which will be discussed later, which are Ta'liq (or Farisi) and Nasta'liq [59, 60].

These cursive scripts were further perfected by the two famous Arab calligraphers Ibn al-Bawwab (died 1022AD) (*see* p.102), whose formulation of Naskhi elevated the latter to a major script worthy for copying the Koran; and Yaqut (died 1298) who gave prominence to Thuluth, and also perfected a special oblique cut of the reed pen which increased the aesthetic dimension of his calligraphy.

As the sphere of Muslim influence extended – in the course of time Islam dominated an area from Spain to the Philippines, from Central Asia to Tanzania – several regional styles developed. The Maghrib, the western part of the Islamic empire (which includes all the Arab countries west of Egypt and until 1492 also parts of Spain), evolved its own distinct form of Islamic art and, with it, calligraphy. The most important centre for the development of Western Kufic, and subsequently the style referred to as Maghribi [*see* PLATE VIII], was the city of Kairouan (now in Tunisia) which had been founded by

the Arabs in 670AD; between 800 – 1200AD it became an important cultural and religious centre, where, in the school attached to the great mosque, Korans were copied by accomplished calligraphers. The distinguishing features of Western Kufic are a rounding of rectangular angles into curves and semi-circles, especially in the final flourishes of letters. These flourishes, extended into the sublinear area, are a distinct feature of Western Kufic; later, in the Maghribi script, they sometimes touch other letters in adjoining words, giving the whole page a new element of integration and coherence. Maghribi spread from Kairouan and became the most widely used script of North-West Africa and Muslim Spain.

 Ibn Muqlah's system never found much favour in the Maghrib where the purity of style was safeguarded by copying acknowledged masters, rather than through the application of definite rules. This encouraged conformity but it did not prevent the development of some regional styles. The four most important variations were: Qayrawani, the earliest style, which soon gave way to Fasi; Andalusi, a fine, delicate script which originated in Cordoba and established itself throughout Muslim Spain, eventually reaching Morocco;

61 Koran written in Sudani style Maghribi script, with letter-pointing and full vocalization, copied in northern Nigeria in the early 19th century AD. BRITISH LIBRARY, ORIENTAL AND INDIA OFFICE COLLECTIONS, OR.74.D.23, ff.LV/2

and finally Sudani. Sudani [61] was first used in Timbuktu (founded in 1213AD, the town eventually became the most important Islamic centre in the sub-Sahara region), from where it spread throughout the Islamic countries of Africa; it is a heavier, less disciplined script, with thick lines, irregular strokes and densely written letters.

Both Persia and Turkey (where, after the acceptance of Islam, the Arabic script was adopted for the writing of the vernaculars) made definite contributions to calligraphy. In the 16th century, Persian calligraphers developed and formulated an already existing style called Ta'liq (the Persian language belongs to a different linguistic system and requires the adding of diacritical marks to certain letters) which was to become the most influential style of the eastern part of the Islamic world. It gained favour not only among Persian but also Indian and Turkish Muslims. *Ta'liq* means 'suspension'. A later development of the same style was Nasta'liq (the term is a compound from Naskh and Ta'liq), a more fluid and elegant variation. Both scripts have certain features in common, such as a lack of pointed elevations, frequent filling-in of centres of the loops of letters, and thin pointed endings in the case of many unjoined letters. Neither of them was much used for Koranic copies, but in the field of secular literature Nasta'liq [60] soon replaced Naskhi. In the middle of the 17th century there developed in Herat a variation of Nasta-'liq called Shikasteh, a 'broken form', characterized by an exaggerated density, closely connected ligatures, low inclined verticals and no vowel marks; in due course this script became the preferred vehicle for Persian and Urdu commercial and personal correspondence. A larger variation, Shikasteh-amiz, usually written on illuminated or coloured paper, served as Chancery script. Persian influence and Persian calligraphers also brought Nasta'liq to India and Afghanistan. During the 14th century a minor Indian style called Bihari [*see* PLATE X], often written in multiple colours, developed, which is characterized by wide, heavy horizontal lines, sharply in contrast with the thin, delicate verticals (YHS; p.28). Chinese Muslims usually adopted (for religious purposes) the calligraphic styles current in Afghanistan, but, in addition, a special script called Sini, with fine lines and exaggerated roundness, was used for writing on ceramics and china.

Soon after the defeat of the Mamluks in 1517, Turkey began to extend its dominion over most of the Arab world. From then on Islamic art and Islamic calligraphy became increasingly associated with the Ottoman Turks, who not only accepted (and excelled in) most existing calligraphic styles, but were prolific in producing some highly effective scripts of their own, the most important being Diwani and Jali. Diwani has its roots in Turkish Ta'liq; refined and restructured, it became the main script of the Ottoman Chanceries. It is difficult to read, excessively cursive and superstructured, with undotted letters unconventionally joined together, and no vowel marks. An even more ornamental variation, full of embellishments and decorative devices, is known under the name of Diwani Jali.

62 *A fine example of mirror writing atop a line of Ornamental Kufic, at a wall inside the Great Mosque in Bursa built by Sultan Beyazit in 1396AD, Turkey.*
PHOTOGRAPHED 1991

The Turks also excelled in the art of mirror writing [62], a technique by which the left reflects the writing on the right. Another style, Siyaqad, already in existence at the time of the Turkish Seljuks of Asia Minor, combines complexity of line with elements of cryptography, and was used to communicate important political information within the same department. An impressive device is the Tughra [63], an elegant, elaborate ornamental design, based on the names and titles of the reigning Sultans which served as a signature legitimizing official degrees. Over the following centuries Turkish calligraphers produced large numbers of illuminated Korans and thousands of calligraphic secular manuscripts; in addition mosques [64], public buildings and schools were richly decorated with calligraphic inscriptions in a profusion of different and well executed styles [*see* PLATE IX].

Outsiders often speak of the abstract beauty of Arab calligraphy but, from the Islamic point of view, calligraphy has nothing to do with art or abstraction. It is at the very centre of the spiritual and political life of the people. In the Koran the word of Allah is revealed through the Arab language written down in Arabic characters. Calligraphy is thus part of a sacred bureaucracy designed to impress on society a political order based on the Koran.

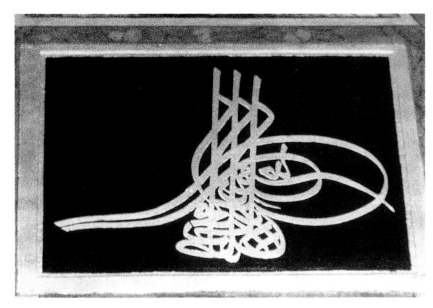

63 (a) A Tughra out-
side the mosque
entrance inside the
Topkapi Palace in
Istanbul;
(b) The Tughra of
Sultan Ahmet II
(1693AD). The actual
origin of the Tughra is
unknown; according to
one opinion it comes
from a previous habit
of dipping the hand
into red ink and press-
ing it on paper in place
of a signature; Timur
(1330–1405AD), for
example, is supposed
to have signed docu-
ments in this way. In
time Tughras became
exceedingly more com-
plex to safeguard
against forgery and
any unauthorized use
carried the death
penalty.
PHOTOGRAPHED 1991

64 'Hua', He (ie God);
written on an outside
wall of the old mosque
built by the renowned
architect Sinan (died
1578) between 1569–
75AD for Sultan Selime
II, Edirne, Turkey.
PHOTOGRAPHED 1991

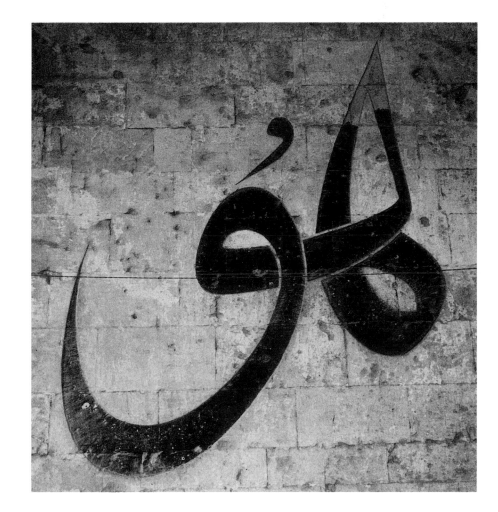

GUARDING THE REVELATION
Caliphs, mystics, statesmen and scholars

The foundation of the art of writing is the practice of virtue.
SULTAN ALI MASHHADI, 15TH CENTURY

As a result of its close connection with the Koran, calligraphy has always been held in high esteem by Muslim society and in consequence gifted calligraphers had possibilities for advancement not open to others. But becoming a good calligrapher (a *khattat*) was no easy matter. It involved not just learning how to read and write (a skill taught to most upper- and middle-class children) but a long period of training under an established master who might, under certain circumstances, be a member of one's own family – the profession being more often than not hereditary. Students started young, usually at the age of eight. Those who succeeded were not expected to receive their *ijaza* (from Turkish *icazet* 'permission', to sign copies of their work) before they were well into their twenties, though especially gifted pupils were sometimes allowed to do so while still in their teens. Like the Sufis, with whom they have close connections (both claim descent from the Prophet's cousin Ali ibn Abi Talib), calligraphers placed a high value on the relationship between master and disciple which was thought to provide the essential spiritual chain of initiation (*silsila*) between a pupil and the founder of a particular style; indeed the imitation of models written by the founder was an important feature of a calligrapher's training. At times the identification between master and disciple went so far that a master specially satisfied with his pupil might, as a mark of appreciation, put his own *kataba* (signature) to the latter's work; in the same way a pupil might sign an exceptionally good piece of his own work with the master's name. Teaching methods varied. In the eastern part of the Muslim world the master would instruct the students letter by letter (each letter had to be endlessly repeated and rehearsed), but in the Maghrib (*see* p.95) pupils were taught straightaway how to write whole words. Students spent all day practising their craft, either squatting, or sitting on their heels, holding the paper in the left hand, or on the knees (this was thought to enable them to learn writing curves more easily than on the hard surface of a table). After graduation (an occasion for celebration amongst friends and family members) the newly qualified calligrapher would try to earn his livelihood, either in an independent position, or by joining a profession where the ability to write well held prospects of advancement. Talented young men were usually anxious to obtain a position at Court, either as teachers in the Imperial school or at a *madrasa* (theological college), or they would seek employment within the religious or secular administration. Most coveted were posts in a Royal (or at least one of the

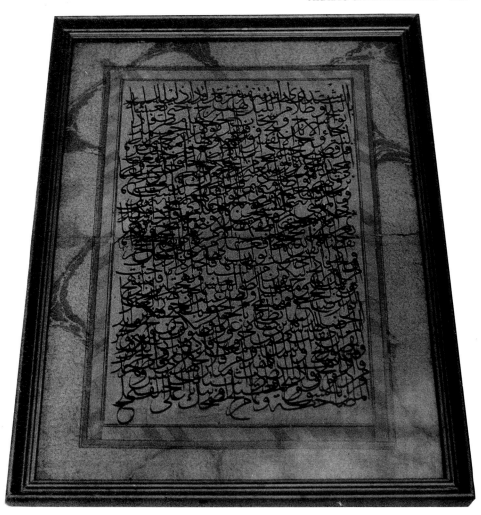

princely) libraries, but few were able to realize such an ambition. Patronage was of the greatest importance and could quickly advance the prospects of a good calligrapher however humble his background. The profession was not entirely free from snobbery, however, and occasionally we come across pointed remarks about a master who had originally been a cook or the son of a saddler (AS; p.52). Patronage could at times also be a mixed blessing since it obliged the calligrapher to share the misfortune of his patron should the latter fall on hard times.

Whatever the prospects for advancement, the life of a calligrapher was not necessarily always an easy one. For one, he could never allow himself to stop practising [65] because, as the 16th-century calligrapher Mir Ali wrote, 'if one sits leisurely for a moment without practising, calligraphy goes from one's hand like the colour of henna'. Copyists (the lowest rank) were expected to produce large quantities of well-written pages if they wanted to support themselves in a reasonable manner. One such copyist is reported to have finished 100 pages in 24 hours. But even good calligraphers worked at considerable speed. We are told that Muhammad Simi Nishapuri, one of

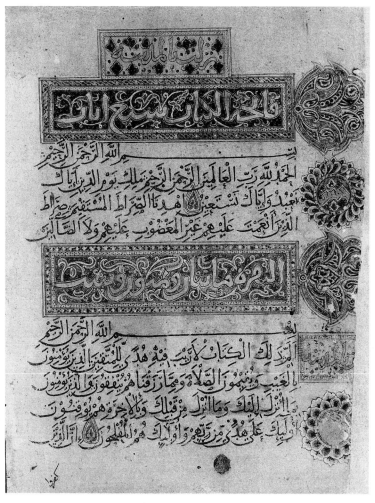

Baysonghur's (died 1433) calligraphers, produced 3,000 lines of poetry in 24 hours, neither eating nor sleeping until he had completed his task (AS; p.57). Even the famous Yaqut wrote two Korans in one month; and we are told that the equally renowned Ibn al-Bawwab (*see* p.00) is supposed to have completed 64 Korans during his lifetime [66].

Ibn al-Bawwab's biography provides a good illustration of the ups and downs calligraphers might have to undergo during their lifetime. Born in Baghdad as the son of a doorkeeper, he started his career as a house decorator but later became a manuscript illustrator, and eventually a calligrapher, studying, according to some sources, either with or under the daughter of Ibn Muqlah (*see* p.90). As a young man Ibn al-Bawwab used to preach in the al-Mansur mosque in Baghdad where he came into contact with the Vizier Fakhr al-Mulk; when the latter became Governor of the city he admitted him into his inner circle. For some time Ibn al-Bawwab seemed to have been in charge of the Buwayhid Baha'ud-daula library in Shiraz where, so the story goes, he accidentally stumbled across a nearly complete Koran written by none other than Ibn Muqlah himself. Unable to find the rest of the pages Ibn

al-Bawwab asked for permission to complete the Koran by writing the missing portion in Ibn Muqlah's hand. The prince was much impressed and promised a reward of 100 dinars should he find it impossible to recognise the forgery; but princes being notoriously fickle he promptly forgot his promise. Eventually Ibn al-Bawwab asked for some cut pieces of Chinese paper which were kept in the library; the wish granted, he was at least able to continue writing without having to buy paper for several years (DSR; p.81). Despite his fame Ibn al-Bawwab never achieved material success, a fate he shared with many other calligraphers. Yet even those who managed to obtain high offices of state were not immune from misfortune, as the life of the great script reformer Ibn Muqlah shows. Having served as Vizier under three Abbasid Caliphs, Ibn Muqlah had his right hand cut off and his tongue torn out, and eventually died in prison.

Others were more fortunate. At the Mughal Court in India exceptional calligraphers could gain lavish rewards and were also often given high sounding titles ('Model of Scribes'. 'Jewel Letters', 'Amber Pen' and so on). The Mughals were great patrons of calligraphy and during their rule Persian poets, miniature painters and calligraphers migrated to India to try their luck. Master calligraphers could find wealth and fame, and receive special honorary titles; some had their portraits included in the manuscripts they copied [94]. About 50 such calligraphers are known to us by name on the basis of their signed works. The most successful calligrapher at the Mughal Court was without doubt Abd al-Haqq (died 1645) of Shiraz who designed the calligraphy for the Taj Mahal. Having come to India from Persia in 1608 he entered the employ of Jahangir (reigned 1605–1627AD) and was immediately commissioned to compose, in Thuluth and Nasta'liq, a Persian anthology for the gateway of the late Akbar's (reigned 1556–1605AD) tomb at Sikander. Jahangir remained well pleased with him and six months after the work on the Taj Mahal commenced Abd al-Haqq was raised to a fairly high level of Mughal nobility and awarded the title Amanat Khan [67]. He certainly did not die poor: his last work was extensive calligraphic decoration on a *karavansarai* he built from his own funds, a day's journey outside Lahore (WEB; p.16).

Unlike in the West, calligraphy was never an anonymous art form in the Muslim world. The names, dates and achievements of famous calligraphers have been carefully recorded and handed down since the 7th century. The first calligraphers are thought to have been some of the Prophet's companions skilled in the art of writing, who took down the text of the Koran at the Caliph's order. Caliphs and rulers were known for their beautiful calligraphy. The fourth Rashidun Caliph Ali ibn Abi Talib (died 661AD) was much praised for his beautiful handwriting; Mu'awiya (reigned 661–680AD), the founder of the Umayyid house, was a good calligrapher and it is said that the Prophet himself gave him instructions about how to write the *basmalah* [68]. Some of the rulers of Iran, India and Ottoman Turkey were not only

patrons of calligraphy but also very often personally skilled in the art of fine writing. Timur (reigned 1370–1405AD) and his descendants excelled in it; the Mughal Emperor Babur (reigned 1526–1530AD) is said to have invented his own style referred to as *khatt-i Baburi*, and sent the copy of a Koran he had written in this hand to Mecca. Akbar, who attracted many master calligraphers to his Court, was in fact the only Mughal Emperor who remained illiterate. Jahangir, another member of the Mughal family, was an expert in Nasta'liq [*see* 60] and, in Turkey amongst the Ottomans, almost every Sultan was a known calligrapher. The Arabic historian Ibn Khaldun (died 1406AD) praised Cairo as the centre of civilization and calligraphy; the same was said, with even greater justification, of Istanbul from 1500 onwards (AS; p.72).

67 A portrait of Amanat Khan (Abd al-Haqq, died 1645AD) who designed the calligraphy for the Taj Mahal. Not only Amanat Khan himself (the title was given to him by the Mughal Emperor Jahangir) but several other members of his family held positions of influence at the Mughal Court. He is here shown together with his brother and son.
BRITISH LIBRARY, ORIENTAL AND INDIA OFFICE COLLECTIONS, ADD. OR. MS 3129, f.25V

68 The basmalah written in the form of a hawk and dated 1915. The sacred formula 'in the name of God, the Compassionate, the Merciful' is widely used not only before chapter openings in the Koran but also on the walls of mosques or on tombstones. It appears written in a variety of styles and on a variety of materials: carved in wood, cast in metal, embroidered on cloth. BRITISH LIBRARY, ORIENTAL AND INDIA OFFICE COLLECTIONS, ADD. OR. MS 4621

But calligraphy was not just an elite art form, it was deeply rooted in the consciousness of the people, irrespective of whether they themselves were skilled in it. There are frequent references to calligraphy in that compendium of Arab folk tales, the *Arabian Nights*. Thus the story of Asma'i and the three girls from Basra stresses the importance of writing, and of writing with 'erect *alif*', 'swelling *ha*' and 'well-rounded *wa*'; and another story, that of the First Qalander, tells of the monkey who wins the king's heart because of his elegant calligraphy.

Writing and Islam were from the beginning a powerful combination. The Koran is the revealed word of the hidden God – revealed in Arabic and written in Arabic – which raises both language and script to the level of a divine gift. According to Abu al-Abbas Ahmed al-Bhuni the Arabic letters arose from the light of the Pen which inscribed the Sacred Tablet; after wandering through the universe the light became transformed into the letter *alif* from which all other letters arose (KHA/MS; p.32). Being so close to the centre of reality imposes its own demands. Ultimately the calligrapher must be worthy of his task; apart from ability and dedication he is expected to have a sweet and unassuming disposition, and since he is writing the name of God, he is not supposed to be unclean for a single hour. To this day calligraphers (and girls who embroider the golden texts of tomb clothes) perform *ghusl*, the major ritual ablution, every morning before starting their work (AS; p.37). Copying the Koran is an act of merit, an essential part of propagating the message. The calligrapher was therefore never an anonymous servant, but a guardian of the faith, a man in harmony with the purpose and the will of God. An often quoted *hadith* (Prophetic tradition) says that he who writes the *basmalah* well will obtain innumerable blessings and enter Paradise. The story goes that after his death the famous calligrapher Imaduddin ibn Afif (died 1336AD) appeared to a friend in a dream and told him that he had been forgiven all his sins because he had always written the *basmalah* so well.

WOMEN CALLIGRAPHERS

Islam neither denied women literacy nor did it object to women as calligraphers. Indeed in the Maghrib women were told that they would have to write at least one Koran before they could hope to make a good marriage (AW; p. 23). Tradition tells us that one of the Prophet's wives could write – an important role model. (The Prophet himself was of course *ummi*, unlettered, since to receive the revelation his mind had to be pure, just as the body of Mary had to be pure, to receive Christ.) Muslim ladies from noble families were often highly educated and skilled with the pen [69] but slave girls too could be literate, become scribes and obtain important positions because of their ability to write a fine calligraphic hand. More orthodox members of the community did at times have certain misgivings about this and one can appreciate their point when listening to the poet Hamza al-Isfahani (died 961) who waxes lyrically about a girl scribe, comparing her writing to the shape of her figure, her ink to the blackness of her hair, her paper to the skin of her face, her pen to one of her fingers, her style to the magic of her eye, her penknife to her flirtatious glances and her cutting board to the heart of her lover. Similar remarks abound throughout the following centuries and eventually an 18th-century Turkish treatise on calligraphy says rather sternly 'do not allow them (*i.e.* the women of the family) to come down to the public sitting rooms, and do not teach them how to write', obviously sensing some connection between the two. One contemporary Turkish lady, who is literate herself, explained that while it is right for women to be taught how to read (they should after all be able to study the Koran and convey its message to their children), it was perhaps less prudent to teach them how to write, since they might use such skills to compose love letters – to others than their lawful husbands (AS; p. 172).

But the role of women calligraphers was more important than those frivolous remarks suggest. Some Muslim ladies achieved a high level of competence and were widely renowned for their work. We know that the Mughal Emperor Aurangzeb's daughter Zebunnisa (died 1701AD), who was a great patron of poets, scholars and calligraphers, was able to write three different calligraphic styles with equal skill. The Lady Malika Jahan, probably the wife of the Sultan Ibidem II Adilshah of Bijapur (reigned 1580–1626AD) wrote at least one Koran (in unusually bold and colourful letters) which can now be seen in the Chester Beatty Library in Dublin. In the 18th century some Turkish women produced such excellent pieces of calligraphy that examples of it are still kept in the mosques of Istanbul; one of them is reported to have received her *ijaza* in the year 1756, well before reaching puberty, and she also wrote a book of calligraphy at the age of 12. The famous calligrapher and script reformer Ibn Muqlah, after having lost his right hand, taught his art to several pupils, among them his own daughter with whom Ibn al-Bawwab is said to have studied. The school of Ibn al-Bawwab did in turn continue in

69 A Muslim lady holding book and pen. Miniature from an album assembled in Delhi by Dara Shikoh, the eldest son of the Mughal Emperor Shah Jahan, between the years 1633–43AD, probably as a present for his wife Nadira. BRITISH LIBRARY, ORIENTAL AND INDIA OFFICE COLLECTIONS, ADD. OR. MS 31129, f.25V

Baghdad, and one of the best exponents of his style was again a woman, Zaynab Shuhda al-katib (died 1178) from whom a direct chain of transmission goes to the third great calligrapher, Yaqut.

Chinese calligraphy

*The forms of the characters must seem to sit, to walk, to
fly, to stir, to set out, to return, to sleep, and to wake.
They must appear sorrowful and joyous; they must be
like the seasons; they must peck like birds and devour
leaves like silkworms; they must be as sharp as the blade
of a dagger-axe; and taut as a bow with its arrow set;
they must be like water or fire, mist or cloud, sun or
moon; they must reflect every image in the world. Only
then may they be called calligraphy.*
CAI YONG, 133–192AD

Chinese calligraphy begins with the Chinese brush and the Chinese script.
Unlike other writing systems, the Chinese script does not primarily represent
the sounds of a particular language but the concept by which language as
such can be represented. Many of the characters (words) have their roots in
pictures derived from nature, and this pictorial origin is very often still clearly
visible [95 c]. Unlike systems based on the Phoenician consonant script
(such as the Arabic and Roman alphabets), Chinese characters do not repre-
sent meaningless sound units, but words, and with it, by implication, ideas.
Such a script does by necessity need a large number of signs (2,000–4,000 for
everyday use, some 50,000 for the reproduction of classical literature) and, in
consequence, the calligrapher finds himself in a position where he is able to
manipulate a wide range of variants. This range is further increased by the
fact that a Chinese character is formed by a variable number of strokes (up to
37), all executed in strictly defined order, which allows for a certain amount
of individualism in the choice of shape, thickness of line, and overall compo-
sition. Ultimately, two factors dominate Chinese calligraphy: the nature of
the Chinese script, and its identification with visual art. Not only does the
calligrapher use the same tools as the painter, they both abide by the same
aesthetic principles. In China, calligraphy is part of the 'three perfections',
the others being painting and poetry. It is the most prestigious of the three:
Chinese artists would rather be remembered for their calligraphy than their
painting.

The earliest extant examples of Chinese writing can be seen on animal
bones (*gu*) and tortoise shells (*jia*) used for the purpose of divination. This
'shell and bone script', Jiaguwen [70], which was discovered at the beginning
of the 20th century in the province of Henan, has until very recently been
dated to the Shang period (*c.* 1766–1122BC) [71]. In 1987, however, scholars
from the Institute of Archaeology at the Chinese Academy of Social Science in
Beijing announced that similarly inscribed bones, found during the previous
year in Sian, had been dated 3000–2500BC (FWM/HC; p. 19). So far some 2,000,
largely pictographic, signs have been identified; they are predominantly

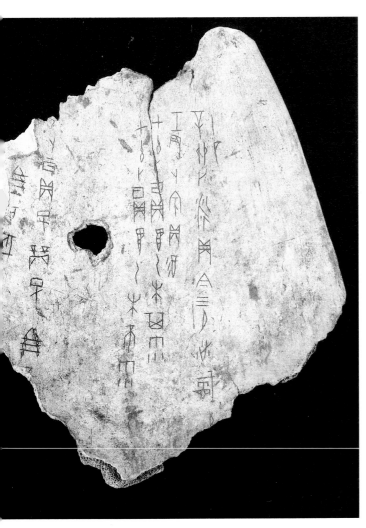

70 *Inscribed ox spatula, 12th century* BC, *from Anyang, Henan province. The characters, in early Jiaguwen script, have been incised with a sharp instrument, by the diviner who interpreted the cracks caused by a hot poker applied to the reverse side of the bone.*
BRITISH LIBRARY, ORIENTAL AND INDIA OFFICE COLLECTIONS, OR.7694/1511

71 (a) *Chinese oracle bone from the Shang period (1766–1122* BC); *the characters have been incised with a sharp instrument in the rough surface of the bone. Compare this to* (b), *the essay flow of line when characters are executed with a brush on the smooth surface of a wood slip dating from around the 1st century* BC.
BRITISH LIBRARY, ORIENTAL AND INDIA OFFICE COLLECTIONS, OR.7694/1554 AND OR.8211/2

72 Gu wen qu zi, *manuscript copy of the first part of a dictionary of unusual Great Seal Script forms, 19th century.*
BRITISH LIBRARY, ORIENTAL AND INDIA OFFICE COLLECTIONS, OR.2282, ff.30–31

古子字象在褓　籀文子字从己象兒囟未合形

裸戴髮出手形　从儿从母體中始生如相背也

俱古籀子字

筆體小譌

古孫字子也　俱鍾鼎文子

古女字未嫁者之稱　字取象互異

蔽其面厂象擁蔽之物也下文未詳疑或譌誤　俱鍾鼎文子

之子也　象形古者女子出門必擁　孫字

女字　兒字　俱古

古軍字兵卒也　俱鍾鼎文

象介胄之形　俱古　軍字

古腰字身之中畔也

linear in appearance, and, though not yet completely uniform, the variations are not fundamental. It thus seems that the Chinese had a well-developed writing system some 5000 years ago, and, what is more, that since then the script has changed relatively little.

The next recorded style, referred to as Jinwen zhongdingwen [*see* 8], reaches us mainly in the form of inscriptions inside ritual bronze vessels belonging to the Zhou period (late 11th century BC). The characters retain the general principle of the oracle bone script but are more elaborate and aesthetically more pleasing; they have also been well planned to harmonize with the decorative elements on the outside of the vessels. This style was eventually supplanted by the Great Seal script, Dazhuan [72], which flourished from 1700–800BC. Invented, according to tradition, by a Recorder at the Zhou court, this style was more a synthesis of previous ones than a totally new development. The number of characters had by now greatly increased and individual characters show much higher levels of sophistication; inscriptions preserved on stone have lines of equal thickness, but the line work is still limited to the use of centre brush (*see* p.33). The most famous examples of this style so far discovered are the so-called Stone Drum Inscriptions (8th century BC) found in the Shaanxi province; some of the Confucian classics were perhaps also originally written in this script.

73 Standard Chinese characters give the impression of having been written within an imaginary, subdivided square. Balance and space are among the most important elements of Chinese calligraphy. When a text is prepared for engraving and printing the calligrapher will first rule a blank sheet into columns and spaces with a centre line in the lead column known as variegated space (hua ko) to use as a guide for writing the characters within each space in a balanced arrangement.
FWM/HG, P.12

In the 3rd century BC China was finally united under the first Qin Emperor Shi Huang Di (259–210BC) who, we are told, instructed his Prime Minister Li Si (221–107BC) to collate the existing writing systems and design a new script capable of meeting the growing demand for documented records. This new script, Xiaozhuan, Small Seal script, remained in general use until the 3rd century AD. Its 10,000 characters were to provide the basis for future developments; in later calligraphy they are often used for their balance and beauty, especially for seal engraving. Xiaozhuan, written with the tip of a long-haired brush, mainly on bamboo slips and wood, shows certain characteristics which differ from those of the early bone and bronze scripts. Though lines are still of even thickness, they are more curved, and individual characters have a more defined and harmonious appearance. Each character (word) seems to have been executed within an imaginary square [73], and these squares are neatly arranged in columns (from top to bottom) and rows (from right to left).

Unfortunately for a script primarily designed to aid the demands of administration, Xiaozhuan had one serious shortcoming: it could not be written with speed. What the new unified Empire needed was a quick, easy-to-write and easy-to-read clerical script, which could be used for the preparation of Government records, and also for the execution of official inscriptions on stone monuments. Such a script, Lishu (official or clerical script [74]), is traditionally held to have been invented by Cheng Miao (240–207BC), an official at the court of the first Qin Emperor. At one point in his career Cheng Miao seems to have offended the Emperor, who sent him to prison for 10 years. Cheng Miao spent his enforced confinement designing a new script which not only facilitated speed but also had possibilities for further developments.

Lishu began as a simplified variation of the Small Seal script. At first written on bamboo with a thicker brush, it came into its own with the introduction of paper when the instruments for writing were greatly refined. It has no circles and very few curved lines, the circles having been turned into squares and the curved parts having become more angular; short straight lines, vertical and horizontal, are mainly used. Because of the speed with which the

74 An 18th-century rubbing of Xioa jing xu, *a preface to the* Classic of Filial Piety *composed by the Xuanzong Emperor and written in fine Lishu script; this inscription, dated 745AD, can be found in the Temple of Confucius in Xian, Shaanxi province.*
BRITISH LIBRARY, ORIENTAL AND INDIA OFFICE COLLECTIONS, 15300.B.12

brush could move over the smooth surface of paper an even thickness of line could no longer be enforced. As the thickness of individual lines began to vary, the calligrapher could concentrate on giving them artistic shape and expressions. Between 200–400AD three new variations of Lishu came into existence: Caoshu (*fl.* 200–400AD), Xingshu (*fl.* from the 3rd century AD to the present), and Kaishu (which originated in about the 4th century AD and is still the standard script for writing the Chinese language). The most important variation was undoubtedly Kaishu [75], the standard or 'regular' script. This was the 'proper style of Chinese writing' used for government documents, for public and private correspondence dealing with important mat-

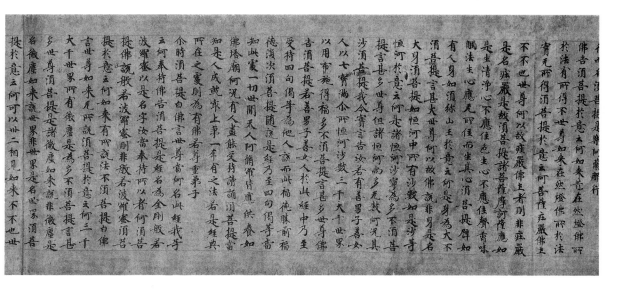

75 Chinese translation of the Vajracchedika-prajnaparamitasutra, *written in fine, fully developed Kaishu script; the scroll is dated 700AD; Dunhuang, Gansu province.*
BRITISH LIBRARY, ORIENTAL AND INDIA OFFICE COLLECTIONS, OR.8210/S.87

ters and, eventually, also for printed books. The regulations for the Civil Service examinations, enforced during the Tang period (618–907AD), stipulated that each candidate must be able to write a good hand in the regular style, and, in consequence, every Chinese who wanted to become a scholar and enter the Civil Service (one was dependant on the other), took care to perfect his mastery of that style; despite the fact that the examinations were abolished in 1905, Kaishu is still the standard script.

In Kaishu the individual characters changed their sideways compressed rectangular form and became almost perfect squares. It is a style which allows for a maximum of individuality. Each line, square or angle, each dot, the structure and composition of the characters, can be shaped according to the will of the calligrapher. The greatest exponents of Kaishu were Wang Xizhi (321–379AD; 303–361 according to some sources) and his son Wang Xianzhi (344–388AD) who have influenced Far Eastern calligraphy ever since. Few original pieces of their calligraphy have survived but, in keeping with tradition, examples had been inscribed on stone tablets from which rubbings were later made, and many famous calligraphers have tried to imitate their style. Wang Xizhi relaxed the tension in the arrangement of

strokes and allowed the brush to trail downwards to the next character. By doing so he created two more styles: Xingshu, and Caoshu.

Xingshu, the running script ('as if the hand were walking fast while writing') encouraged ease of brush movements, some modification of characters and their structure, and an absence of rigid angularity. It lent itself easily to an inventive use of brush and ink, thus allowing the calligrapher more artistic freedom. The second style to develop from Kaishu, Coashu [76], or 'grass script', takes its name from its appearance: 'as if the wind had blown over the grass in a manner both orderly and disorderly'. Originally intended as a quicker version of Lishu it was soon favoured for its artistic impression. The characters no longer conform to the invisible square grid; they can be linked, visibly or invisibly, with each other as the brush moves downwards. Abbreviations and distortions are common and characters are often greatly simplified when compared with Kaishu. Invented during the Han period, Caoshu reached its *apogee* during the Tang dynasty when it was preferred for literacy compositions, especially for poems and for poetic inscriptions on paintings. The rapid way in which this style is executed allows the calligrapher great individual freedom, but it also produces characters which are difficult to read by anybody not familiar with the practice of calligraphy.

76 An important fragment of a Tang period (618–906AD) copy of the pieces Zhan jin tie *and* Long bao tie, *by China's most famous calligrapher, Wang Xizhi (321–379AD) written in Caoshu; from Dunhuang, Gansu province.*
BRITISH LIBRARY, ORIENTAL AND INDIA OFFICE COLLECTIONS, OR.8210/ S.3753

Chinese calligraphy depends on skill, imagination and, above all, on training. Like the painter, the calligrapher learns his art by carefully and patiently copying the ancient masters, and by following the instructions of his own master. This eventually enables him to write with speed and without hesitation; a line once drawn cannot be retouched or corrected. The inspiration for the calligrapher, as for the painter, comes from nature: each stroke, each dot suggests a natural object. Su Qianli (596–658AD), a Tang calligrapher, wrote:

> 'of the wonder of *shu fa* (the art of writing) I have seen many and many a one... I have seen flocks of queen swans floating on their stately wings, or a frantic stampede rushing off at terrific speed. Sometimes in a line a flaming phoenix dances a lordly dance, or a sinuous serpent wriggles in speckled fright, and I have seen sunken peaks plunging headlong down a precipice, or a person clinging to a dry vine while a whole valley yawns below. Some strokes seem as heavy as the falling banks of clouds, others as light as the wing of the cicada.'

Two keynotes dominate a piece of good calligraphy: the stimulation of a well executed line held in balance by the dynamic equilibrium of the final structure.

KOREA

When the Chinese (Han) Emperor Wu Di conquered much of the northern part of the Korean peninsula in 109AD, the area which today constitutes modern Korea was ruled by several small independent states. During the following centuries three important kingdoms emerged: Koguryo in the north, Silla in the south-east and Paekche in the south-west. Contact and a steady cultural exchange (by land to Koguryo and by sea to Paekche from the southern coastal areas of China) introduced, in due course Buddhism, Confucianism, and the Chinese system of writing. By the time of the unification of Silla in 668AD Chinese characters had become the official script of the Court and were used as such by the educated, powerful elite. But the basic unsuitability of the Chinese script for transcribing the very different grammatical features of Korean soon led to repeated attempts to devise more acceptable alternatives. The first experiment of this nature was a system that represented Korean words by Chinese characters having the same sound. Later, similar schemes using Chinese characters to convey Korean words of identical meaning were used, but the issue remained problematic until the reign of the great reforming monarch of the early Choson dynasty, King Sejong (reigned 1418–1450AD). In 1446 a simple alphabetic script called *Hangul* was promulgated, an event of enormous importance which is still remembered in Korea by the celebration of Alphabet Day on 9 October of each year.

77 Hunmin chongum, *King Sejong's explanation of his script. The new signs, simple and angular in shape, have been designed on the bases of phonetic principles. The individual consonants are graphic representations of the way the organs of speech are used in articulating them; the vowels consist of different arrangements of one long line joined at right angles by one or two shorter lines. Syllables are formed on the basis of consonant plus vowel plus consonant. Modern facsimile of a blockprint.*
BRITISH LIBRARY, ORIENTAL AND INDIA OFFICE COLLECTIONS, 16509.A.4

Hangul [77], consisting basically of 11 vowels and 17 consonant signs, met considerable resistance from the aristocratic Confucian scholars of the time who opposed the extension of literacy and education to commoners as fiercely as they revered Chinese language and culture. Thus the new script did not supplant, but rather complemented the use of Chinese writing, and was used side by side with Chinese characters as an aid to pronunciation, for grammatical terms or to clarify ambiguities, in a similar way to the Japanese use of syllabic *kana* signs (*see* p.120). Indeed, as in Japan, the ability to read and write Chinese continued to be a highly esteemed sign of social and intellectual superiority; popular literature, novels written in the Korean script, were thought suitable only for consumption by women or people of low rank. During the Japanese occupation between 1940–45, when the Japanese authorities tried to encourage the use of their own language as the publishing medium of first choice, *Hangul* became a nationalist issue. Today a mixed script (Chinese and *Hangul*) is still employed in the south; in the north of the country all writing is done in *Hangul*.

78 An 8th-century AD rubbing of an inscription with calligraphy by Ouyang Xun (557–645AD), found in a booklet (the earliest of its type surviving) which was discovered at Dunhuang, Gansu province.
BRITISH LIBRARY, ORIENTAL AND INDIA OFFICE COLLECTIONS, OR.8210/ S.5791

Korean calligraphy has a long and distinguished tradition but few written examples have survived the many foreign invasions and internal conflicts. In the 1590s the invasions launched by the Japanese army of Toyotomi Hideyoshi caused particular damage to cultural objects and historical monuments, and only some 20 calligraphic fragments pre-dating this period, have survived. Fortunately, the practice of stone engraving has (as in China) left us with additional information. In fact the first surviving evidence of calligraphy on Korean soil is examples of Chinese writing on a number of stone monuments from the time of the Three Kingdoms (*c.* 57BC–668AD). The following period, under the Unified Silla dynasty (668–935AD), was much influenced by the culture of Tang China. Contemporary Korean calligraphers, such as Kim Saeng (*fl. c.*800AD) and Ch'oe Ch'i-won (born 857AD), based themselves on Chinese models, especially the style of Ouyang Xun (557–641AD) [78] and You Sinan (558–638AD). This was a square, angular script which continued throughout the time of the Koryo dynasty (918–1392AD) until around 1350, when the style of yet another Chinese calligrapher, Zhao Mengfu (1254–1322AD) [79] came into fashion. The new *zhao* style, more graceful, rounded and fluent, remained an enduring influence on Korean calligraphy.

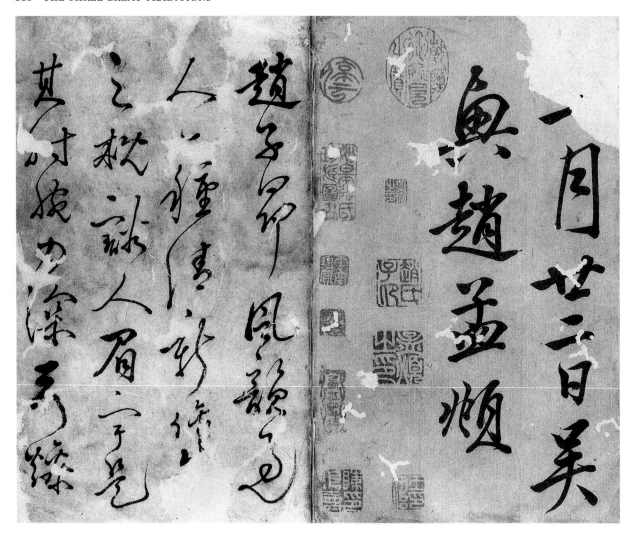

The early rulers of the Koryo period reinforced the Chinese practice of holding Civil Service examinations which (as in China) put stress on an applicant's ability to write a good hand, thus providing the upper classes with a stimulus for improving their handwriting. In addition, Buddhism flourished as the state religion and a good many more objects which have survived from this period (tombstones, woodblock prints, fragments of handwritten copies of the Buddhist *sutras*, epitaphs on memorial stupas) allow us to judge the standard of contemporary calligraphy. The best calligraphers of this period are generally thought to have been Yi Am (1297–1364AD), Yi Che-hyon (1287–1367AD) and Han Yun.

During the early part of the succeeding Choson (Yi) dynasty (1392–1910AD), Korean calligraphers followed the elegant *zhao* style; indeed Prince Anp'yong, also known as Yi Yong (1418–1453AD), the third son of King Sejong, the creator of the *Hangul* script, was considered a great expert in this

79 Opening from an album with calligraphy attributed to, and certainly in the style of, two famous calligraphers: Zhao Mengfu (1254–1322AD) and Dong Qichang (1555–1630AD). Note the seal impressions of previous owners.
BRITISH LIBRARY, ORIENTAL AND INDIA OFFICE COLLECTIONS, OR.8625

style. Another well-known calligrapher was Han Ho (1543–1605AD) whose devotion to the Chinese master Wang Xizhi did however prevent him from fully developing a style of his own. At the beginning of the 16th century a more mannered and less imaginative mode of writing began to dominate, and overall Korean calligraphy entered a period of sterility. But in the 19th century [see PLATE XI] individual styles emerged again; most of them looked for inspiration to the Chinese calligraphers of the 16th and 17th centuries. This new trend evolved as a result of Korea's closer cultural contact with Qing China, a contact ardently pursued by Korean intellectuals and scholars who looked for role models to solve social and political problems.

The most famous calligrapher of the later Choson period was Kim Ch'ong hui (1786–1856AD), a member of a group which called itself 'School of Practical Learning' (*Sirhak*), who invented a new style called *ch'usa* (so named after the king's *nom de plume*). Though he derived his calligraphy from (Chinese) Lishu, Kim Ch'ong hui showed great originality in the powerful execution of his strokes, and the harmony he was able to create within asymmetrical compositions.

After the Second World War traditional calligraphy, based mostly on Choson models, temporarily lost its importance and calligraphy itself became a minor art form. But the 20th century saw the emergence of two new trends. One, the influence of Japanese calligraphy from 1920 onwards, was again derivative. The other, which has gained momentum since the 1960s, is based on the calligraphic exploitation of the Sejong's Korean alphabet [80]. It represents, for the first time, an attempt to create a genuinely indigenous form of calligraphy.

80 An example of the work of the contemporary Korean calligrapher, Kim Ki Seoung (see also 161).

JAPAN

Do not think that calligraphy is simply the copying of Chinese characters.

THE MEIJI CALLIGRAPHER NAKABAYASHI GOCHIKU, 19TH CENTURY

Japan came into contact with the more advanced Chinese civilization, and the Chinese form of writing, through the intermediacy of Korea. No definite records exist as to when exactly the Japanese first began to use Chinese characters but in 307AD Japan invaded Korea and successfully held some of the newly acquired territories until 562. In consequence, the so-far tentative contacts between the three countries (Japan, Korea and China) increased. In the middle of the 6th Century Buddhism became the official religion of Japan, and from then on Japanese scholars went regularly to China for further studies. With no script of their own, the Japanese accepted the Chinese (concept) script, Chinese writing techniques (brush, ink and ink-stone) and, after 600AD, the use and manufacture of paper (*see* p.39). Since there exist, however, hardly any similarities between the agglutinative, polysyllabic Japanese and the largely monosyllabic Chinese language, the adoption of the Chinese script did present serious problems. This situation was resolved, successfully, in a number of ways. At first the Chinese characters (in Japanese referred to as *kanji*) were simply read in Japanese, but, since Japanese syntax is vastly different from Chinese, special notations were needed to indicate the order in which the individual characters had to be read. A solution was eventually found by the addition of simplified Chinese characters used in a syllabic manner. The next step was the modification and simplification of these phonetic Chinese characters to form a systematic syllabary (*kana*) with fixed phonetic values. Between the 8th and the 10th centuries two such syllabaries evolved: *katakana* (formed from isolated parts of Chinese characters) and *hiragana* (derived from the cursive form of whole Chinese characters). Japanese could now (and still can) be written in more

than one way: in Chinese characters, in syllabic characters specially designed to represent the Japanese language, and in a combination of both. This multiplicity of forms greatly increased the range of calligraphic possibilities and allowed for the creation of uniquely Japanese elements.

Japanese calligraphy begins noticeably in the Nara period (710–794AD). A good number of Chinese monks who came to live and work in Japan were not only sound Buddhist scholars but also accomplished calligraphers; their work inspired the new converts who tried to emulate them. As a result, many Japanese, including some early Buddhist emperors, became masters of *kanji*. The style of writing which consequently developed was largely based on Tang models and on the calligraphy of such renowned earlier Chinese masters as the 'two Wangs' (*see* p.131) and Ouyan Yun. A leading role in the development of the new art form was played by the Japanese monk Kukai (in Japanese, Kobo daishi, 774–835AD) who, after studying in China, not only brought back important calligraphic specimens, mainly in the style of Yan Zhenqing (709–785AD), but also succeeded in establishing an awareness of the theoretical aspects of calligraphy as a major art form. Another important early stimulus was no doubt the practice of *sutra*-copying which was introduced from Korea when Buddhism was embraced by the ruling family of Japan. In 673AD the entire Buddhist canon was systematically copied by Japanese scribes and in 728 a special *sutra*-copying bureau (*Shakyopo*) was established in Nara by Imperial order. Scribes employed there had to pass a test for accuracy, style and clarity and were paid per sheet copied; a certain sum was deducted from their pay if they made a mistake. This office stayed open until 794 and was probably a contributory factor to the sudden (if short-lived) burst of printing activities [81] soon afterwards. *Sutra*-copying, as an act of merit, is still practised and even after the development of more indigenous Japanese calligraphic traditions, Buddhist literature continued to prefer the *kanji* styles such as Kaisho, Gyosho and Sosho. The *sutras* themselves were, and are, usually written in Kaisho, in a manner largely devoid of

82 Japanese calligraphic styles are based on Chinese models. The most important are: (a) Tensho (based on the Chinese Seal Scripts); (b) Reisho (based on Chinese Lishu); (c) Kaisho (based on Chinese Kaishu); (d) Gyosho (based on Chinese Xingshu); and (e) Sosho (based on Chinese Caoshu).

individual interpretation, since in this type of literature written characters are looked upon as manifestations of the Buddha, and are not meant to provide the calligrapher with a means for self-expression.

In the course of time a variety of styles using *kanji* developed, all of them based on earlier Chinese counterparts. The first one, already in vogue during the Nara period, was Tensho (based on Dazhuan, the Great Seal script) with Kukai as its most famous exponent [82, a]. Another style, Reisho (the scribe's script based on Lishu and used mainly for official documents), evolved in the Muromachi period (1392–1573AD) and found much appreciation during the Edo period (1603–1868AD) when the calligrapher Ishikawa Jozan (1583–1672) used it with great skill [82, b]. Other such styles were Kaisho (the block script based on Kaishu [82, c], a popular style with easily recognizable characters, also used for modern movable type), Sosho (based on the Chinese grass script, cursive, with linked characters [82, e]), and Gysho (the 'running script', written with quick brush movements and, often running together the

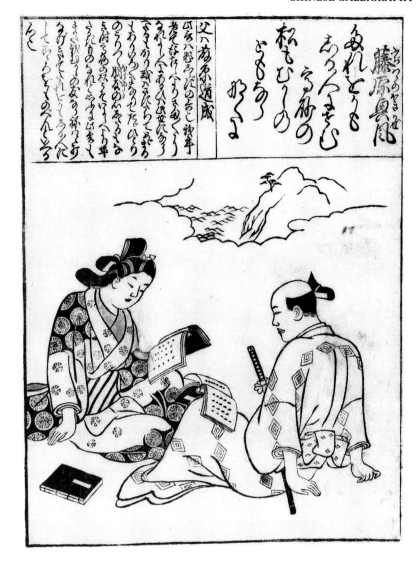

strokes within certain characters) which was used mostly for informal writing [82, d].

This Chinese-based tradition (*karayo*) monopolized Japanese calligraphy until the Heian period (794–1185AD); it produced many outstanding examples but, compared with Chinese originals, most lacked distinction. The three great masters of this era were the monk Kukai, the Emperor Saga (786–842AD) and the courtier Tachibana no Hayanari (died 842AD) who eventually became known as the *Sampitsu*, the 'Three Brushes' of this period. At the end of the 9th century Japan officially terminated the embassies to China and a period of 'Japanization' commenced. Calligraphers began to interpret Chinese models instead of simply imitating them, and, by doing so, became more inventive. The final break was brought about by Kozei (972–1029AD) who perfected a new Japanese (*wayo*) tradition and established

models which were followed by courtiers and calligraphers for the rest of the Heian period.

The time of the Heian dynasty was a period of great sophistication and artistic refinement which saw the development of a number of highly original trends including Waka poems and novels written by women writers. Translations of literary works like Murasaki's *Tale of Genji* (*see* p.136) and Sei Shonagon's *Pillow book* allow us glimpses of a courtly society where the lives of a small number of men and women seem to revolve almost exclusively around the planning and execution of love affairs, the composition of music, poetry [83], and above all, calligraphy. While serious matters of state and religion were conducted by men who continued to write in *kanji*, or *onokode* (men's writing), women composed their novels, poems and the all-important love letters in an elegant and graceful *hiragana* which was known as *onnade* (women's writing) [84].

Hiragana calligraphy became one of Japan's great artistic achievements. It introduced a number of new and highly effective elements. Whereas in *kanji*

each character seems to be written within an imaginary square, *hiragana* characters are usually written in connected form. Lines are irregularly positioned and blank space is used to give the effect of a painting. This creates a beautiful feeling of freedom, a trend especially noticeable in Heian calligraphy. The two most noted styles of this genre are Remmen-tai, where the *hiragana* characters are continuously connected without break. Another such style is Chowa-tai; here *kanji* characters, written in Kaisho, are interchanged with *hiragana*. This style was popular for letters and poems, which, for heightened effect, were often written on coloured or decorated paper. The individual lines on a page can be of different length, the strength of the ink may vary, and a variety of brush strokes can be employed.

At first sight these two styles seem to resemble Caoshu, the Chinese grass script, but they are in fact easily distinguishable from it. In Caoshu individual words retain their regular spacing within the imaginary square, but *hiragana* cannot be spaced so evenly. In consequence a piece of Remmen-tai looks like a 'bundle of beautiful silk strings hanging down in artistic confusion', apparently arranged without conscious effort on the part of the calligrapher. Characters cascade over the page, individual dots and strokes have no distinct shape but join others in the next character. Unlike the strokes in Chinese characters, *hiragana* strokes are not meant to recall the shape of living things; they are also not of even thickness, though they must be spaced in a manner designed to avoid confusion. Such a piece of calligraphy has to be executed with great speed; to achieve this much training and artistic insight is needed.

The Heian mode of calligraphy, developed by Kozei, retained its dominant position throughout the Kamakura period (1185–1333AD) when it became known as the Sesonji style, after the temple associated with Kozei. It was eventually monopolized by Kozei's family and handed down by his descendants. This led to a growing mannerism during the following Muromachi period (1333–1568AD), and, already at the beginning of the 14th century, a decline becomes noticeable in Japanese calligraphy. In the 16th century the *wayo* tradition seems to have stagnated altogether as changes in the economic condition of the country forced members of the once privileged classes to sell their calligraphic skills for writing documents, letters, merchants' inventories and trade signs. The 16th century also saw an increase in Chinese influence; the establishment of the Obaku sect of Zen Buddhism in Uji in 1661 once more encouraged closer contacts with the mainland. New waves of Ming-dynasty styles (1368–1644AD) were taken up by men of letters, and the *karayo* style managed to overshadow *wayo* from the late Edo to the Meji period (1868–1912AD). A century later the pendulum swung back and Japanese calligraphy received a new orientation, largely through the three masters of the Kan'ei period (1624–1644AD): Hon'ami Koetsu, Shokado Shojo and Konoe Nobutada. This movement coincided with the re-unification of Japan under the first Shogun, Tokugawa Ieyasu, in 1600, an event which

greatly reawakened national self-confidence. Ieyasu, who was a great patron of the arts, made substantial land grants in the north of Kyoto to Hon'ami Koetsu (1558–1637AD). An artists' colony grew up there which became (and still is) a cultural centre where calligraphy based on the Heian style has been able to blossom.

Apart from the *wayo* tradition Japan can boast another, highly original and individualistic style of calligraphy. This form of writing traces its origin back to the 13th century when Chinese Chan Buddhism was introduced to Japan, and an established Zen Sect was formed by the monks Eisai (1141–1215AD) and Dogen (1200–1253AD). In the newly-founded Zen monasteries a special type of calligraphy developed, referred to, especially after the 14th century, as Bokuseki (traces of ink); it greatly differs from other styles of Japanese calligraphy.

Bokuseki calligraphy has connections with the aesthetics of the tea ceremony; a hanging scroll with a choice example of calligraphy, written perhaps by the host's own master, forms a focal point in the environs of the actual ceremony. It was an important part of Zen literary tradition and artistic movements of the Muromachi period. A young monk, anxious for promotion within the monastic community, had to be a poet and calligrapher and many prominent Zen monks, such as Muso Soseki (1275–1351AD), Sesson Yubai (1290–1346AD) and Zekkai Chushin (1336–1405AD), to name but a few, were indeed leading calligraphers. Their scrolls became prized possessions of their communities and in time highly valued collectors' items. The Zen calligrapher does not adhere to traditional aesthetic values, but places the ability to communicate an inner state of mind above mere technical considerations. Zen calligraphy is not an accomplishment but an essential part of life. In the training halls attached to Zen monasteries the students are taught calligraphy, swordsmanship and *zazen* (seated meditation), each discipline complementing the others. The work of the Zen calligrapher is illuminated by the overwhelming force of enlightened vision. This force is *kiai,* and the essence of the cosmos, *ki,* is incorporated in it; in the ink it is *bokki* which reveals the calligrapher's inner light. Without *ki* in the *bokki* his work may well be brilliant but it will remain essentially lifeless. When the brush is fully raised it should be rooted in *konton kaiki* 'pristine existence', the state before the separation of heaven and earth, before there was differentiation between things and essence. It is the place from which all things emerge. The strokes of the calligrapher originate there and return to it, they arise from nothingness which is gathered in his brush.

In Japan *shodo* (the way of writing), is not just a means to communicate verbal information. A piece of calligraphy is an event which exists in its own right. The merit of the content does not improve bad writing. To a large extent the content is immaterial. Calligraphy opens a direct channel between the writer and the onlooker; it must be contemplated, not just read. It thus allows visions far beyond the mere corporeal.

A MARK OF DISTINCTION
Courtiers, warriors, priests, poets, and painters

*When you have no intention to make your calligraphy
good, then it is good.*
SHU SHI, 1036–1101AD

Throughout China's history the Chinese script, representing sense elements rather than linguistic units, has been a major unifying factor; indeed the political and administrative hegemony of China (a vast country inhabited by people speaking many different dialects) largely depended on it. Under those circumstances the ability to write (and write well) has always held central stage in Chinese thinking. Already in the 12th century BC during the Zhou period, writing was a basic element of formal education. The *Rites of Zhou* states that the sons of aristocratic families must be taught how to write Chinese characters from the age of eight (no mean feat if one considers the nature of the Chinese script); writing was part of the 'six arts': rites, music, archery, charioteering, writing and mathematics.

Much has often been made of the fact that in China calligraphy was not a profession one entered for gain but an essential means of self-expression (albeit self-expression within strictly prescribed boundaries). Indeed, during the Han period, which saw the flowering of Chinese calligraphy, its best exponents were aristocrats: philosophers, priests, scholars, monks, nuns, statesmen, courtiers, princes and princesses, emperors, and warriors. Calligraphy was an art practised by the elite for the elite; the artist was in most cases not a paid artisan, he (or very occasionally she) belonged to the same social circle as the audience, and audience and performer were in fact often interchangeable. The lifestyle of literary men had for long centred on such culturally acceptable activities as writing poems, playing chess, drinking wine, and, most important, using the brush for painting and calligraphy. Their environment reflected this attitude: there were tasteful gardens, libraries, books, paintings, and (last but not least) there were examples of calligraphy displayed in every room [85]. Their writing implements were well made; some (such as the often expensive and always beautiful seal stones) could become collectors' items. Calligraphy greatly stimulated the intellectual life, and its appreciation contributed in no small way to the development of art criticism. When in 320AD the Lady Wei Shao (*see* p.33) wrote her treatise on calligraphy she laid down aesthetic norms which are still honoured today. Essays on the theory of calligraphy continued to be composed; in 849AD, for example, a 10-volume encyclopaedic compilation of such writings entitled *Fahu Yaolu* appeared which included all relevant

works composed between the time of the Later Han and publication.

Calligraphy was also instrumental in the development of art markets. Already during the time of the Eastern Han (25–220AD) the occasional notes of accomplished calligraphers were considered valuable collectors' items. In 316AD, when the capital of the Western Jin dynasty was besieged by invading nomads, the Prime Minister fled south to safety across the Yangtze River carrying in the folds of his garment his most prized possession: the calligraphy of Zhong Yu (c.170–230AD). The Emperor Wu (reigned 502–490BC) of the Liang dynasty was probably the first Chinese ruler to collect the calligraphy of old masters in a systematic manner; carefully mounted they became part of his private collection and it is said that he took great pleasure in discussing their artistic merit with his friends at court. Many Chinese Emperors and dignitaries were not only accomplished calligraphers but also well-known collectors. Sometimes they would write a note in the colophon of a particular work praising its excellence (or employ an established calligrapher if they did not have sufficient confidence in their own handwriting); nearly always they would add their own personal seal next to those of previous owners, thus providing us with a valuable record of a particular work's provenance. The value of Chinese calligraphy was well recognised in neighbouring countries. During the Tang period, envoys from the Courts of Korean kings travelled to China to acquire the works of famous calligraphers in an attempt to stimulate the development of calligraphy in their own country. One reason why (certainly nowadays) painters and calligraphers want to be remembered for their calligraphy rather than their painting is perhaps not totally unrelated to the fact that calligraphy fetches (and fetched) much higher prices.

But apart from being an art practised by the elite for the elite, entirely for art's sake, writing and calligraphy without doubt also had practical uses. Indeed, the teachings of Confucius (died 479BC), which became the official orthodoxy during the Han period, included calligraphy as one of the basic skills taught in childhood. Students learned how to write beautifully by studying and copying the work of famous masters. The political and administrative developments which accompanied the unification of China in the 3rd century BC created a need for documents and archives; a prince enfeoffed as a feudal lord was given land, slaves, goods – and also books and scribes. During the Han period, writing a good calligraphic hand in the established clerical style (*see* p.193) became an essential prerequisite for young and talented men (including those of a quite modest family background) who wanted to enter the Civil Service. A good hand could ensure advancement. After all, handwriting was thought to reflect a man's character, and for many families the aim of educating a son was to make him fit for Government service. The office of Court historian or scribe was usually hereditary and a number of modern surnames still relate to this profession: Shi (scribe), Dong (custodian) or Jian (tablets) and so on (DK; p.8).

85 Portrait of the Haiku poet Kyokusui (died 1720AD) with one of his poems written in a flowing cursive style. From Yahanjo *by Yosa Buson (1716–1783). 18th century.*
BRITISH LIBRARY; DEPARTMENT OF ORIENTAL AND INDIA OFFFICE COLLECTIONS, 16099. f.27.

86 Chinese students of calligraphy spent much time practising characters; an example from Dunhuang, Gansu province, 9th century AD.
BRITISH LIBRARY, ORIENTAL AND INDIA OFFICE COLLECTIONS, OR.8210/ S.5657

The training of the calligrapher was the same as that of the painter: years of studying under a master, years of copying the style of the master (and his master), and years of practising. Like his Islamic counterpart the Chinese calligrapher continuously practised his art [86], not only from fear of losing his skill, but because he was simply unable to do otherwise. In his *Random Notes on Calligraphy*, the Emperor Goazong (reigned 1127–62AD) wrote: 'since my youth I have liked to pick up my brush to do calligraphy. I cannot pass a single day without doing so, except when I must tend to the offices of State'; and the Song artist Mi Fu (1051–1107AD) agrees, 'I cannot pass a single day without doing calligraphy, otherwise my thoughts would dry up' (LLC/PM; p.1). One story tells of a painter who for many years diligently practised writing his name before he felt the result was good enough to serve as signature for his work. Calligraphy is (like painting) a highly disciplined art form, and originality comes, if at all, only after long and careful study. The preparation for work is equally important. The calligrapher must consider the mood of the moment – the same piece of calligraphy executed again at a different time of the day will differ considerably from the first one (even the great Wang Xizhi found it impossible to make an exact copy of his *Lang ting xu* the day after the Spring Festival). In order to succeed the calligrapher must try to attain a state of harmony with nature: the sound of the leaves in the spring wind, the fragrance of the blossoms – all these will influence his calligraphy. Then comes the rubbing of the ink stone (a time for reflection), followed by contemplation of the quality and the tone of the ink. Finally, he will concentrate on the piece of writing he has planned, visualize it, and complete it in his mind, before the brush touches the paper. Having reached this state of inner calm he will execute the first line, decisively and in one swift movement, because once done no correction is possible. As Wang Xizhi put it, 'only if the thought precedes the brush does one write calligraphy'.

A rich and extensive collection of biographies and anecdotes has been handed down about famous calligraphers [87] which demonstrates not only their social position (some rose to high office), their background (many belonged to ruling clans) and the esteem in which they were held by their contemporaries, but also the sometimes almost supernatural power of their calligraphy.

Many stories surround the most famous and influential of all Chinese calligraphers, Wang Xizhi [88], a member of the Jin dynasty (265–386AD), and his seventh son; together they were known as the 'two Wangs', *wang* meaning king, a reference to the excellence of their calligraphy. One day, so a certain story goes, Wang Xizhi visited a pupil who proudly told him that he had just made a table, asking whether the master would like to see it. Wang Xizhi agreed and, impressed by the craftsmanship, took out a brush and wrote some poems on it. When the two men went next door the pupil's father came into the room and, shocked to see the newly-made table covered with ink, he tried to shave off the top. But such, we are told, was the power of Wang

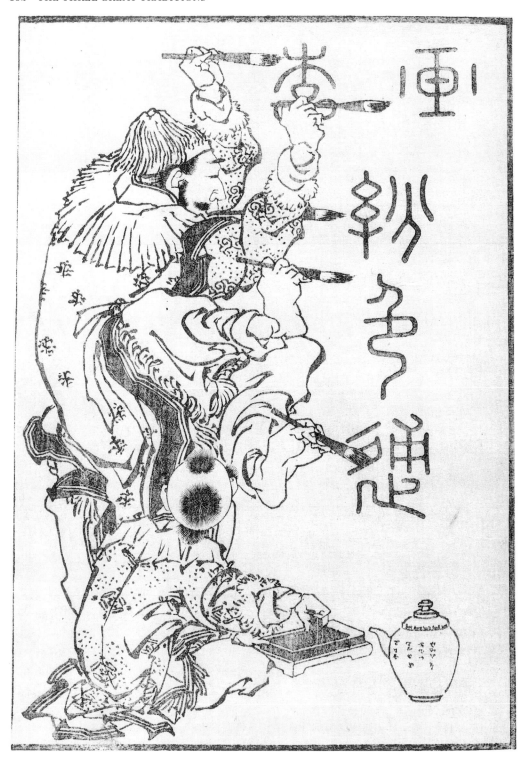

87 Frontispiece of Hokusai's Ehon saishiki-tsu *('Mastering Painting in Colours'), Edo, 1848. Caricature of an enthusiastic painter and calligrapher inscribing the title of his book with hands and feet (or as the book puts it 'all four paws'), watched by an admiring apprentice.*
BRITISH LIBRARY, ORIENTAL AND INDIA OFFICE COLLECTIONS, 16112.A.12

Xizhi's calligraphy that he was unable to remove any of the writing.

The monk Kukai (*see* p.121), who played such an important part in the establishment of Japanese calligraphy, once received a commission to inscribe a plaque for the temple of Otenmon. As the plaque was just about to be raised to the lintel of the gate he noticed that a crucial dot was still missing from one of the characters. Quickly Kukai filled his brush with ink, threw it into the air, and to everybody's amazement it landed just on the right spot to make the missing dot.

Zhao Mengfu (1254–1322AD), who was widely admired not only in China but also in Korea (*see* p.117) and Japan was a distant descendant of the Song Emperor Taizu and one of the most accomplished calligraphers of the Yuan period (1260–1368AD). Born in the province of Zhejiang, he had completed

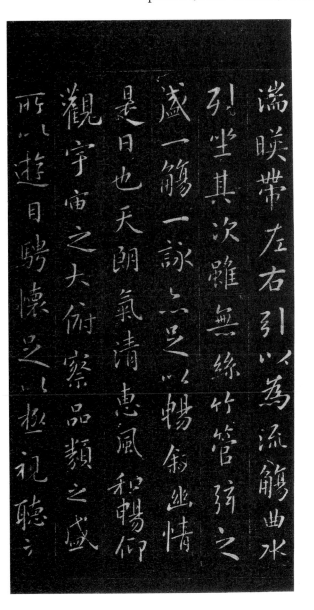
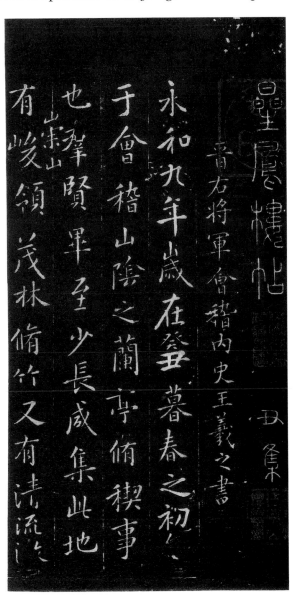

his education and been appointed an Imperial guard by the time the southern Song dynasty fell to the Mongols in 1279. In 1287 Cheng Jufu, a censor from the Yuan court in Beijing, discovered him and recommended him as one of the 'eight talented young men of Wuxing' (Zhao Mengfu's birth place) to the Emperor Kublai Khan (reigned 1260–93AD). Zhao Mengfu's talent in administration and art quickly brought him to the Emperor's attention and before long he became a favoured official.

One of the leading calligraphers of his century was Song Ke (1327–87AD). Born into a wealthy family in the cultured city of Suzhou he showed an early talent for painting, calligraphy and literature. His knowledge of strategy gained him the position of 'military advisor' in Hebei at the end of the Yuan period. Having travelled widely he returned to Suzhou in 1356, where, as a result of his literary activities, he became known as one of the 'Ten Friends of the North Wall', a group which included many famous poets and painters. During Zhang Shicheng's occupation of the city, Song Ke shrewdly kept well away from any political involvement, concentrating instead on his poetry and calligraphy. His prudence paid off and eventually, during the early Ming period (1368–1644AD), he became Calligrapher-in-waiting at Beijing Hanlin Academy, and later Deputy Prefect of Fengxiang in Shaanxi.

In Japan, excellence in calligraphy was an important requirement for monks anxious to rise within the hierarchy of their Zen monastery, just as it was an essential accomplishment for members of the upper classes, especially the gentlemen and ladies of the court. In 10th-century Japan, at the Heian Court, the way a person handled the brush was considered a better guide to his breeding, character and sensibility than what he or she actually said or wrote. To write a poor hand, and to be indifferent at poetry spelled social ruin and set the victim up for ridicule and contempt. In her *Pillow book*, Sei Shonagon gleefully, and with a good deal of satisfaction, describes an episode when a young official from the Ministry of Ceremonial boasts that he can write a poem on any subject:

> 'Hearing the boast the Empress herself proposed a subject, at which Nobutsune promptly took his leave saying: 'Dear me, how frightening! I'd better be off'. 'He has an appalling hand,' somebody explained after he had left the room. 'Whether it's Chinese characters or Japanese script, the results are equally poor. People are always laughing about it. That's why he had to escape.' One day when Nobutsune was serving as Superintendent in the Office of the Palace Works he sent a sketch to one of the craftsmen explaining how a certain piece of work should be done. 'Kindly execute it in this fashion,' he added in Chinese characters. I happened to notice the piece of paper and it was the most preposterous writing I had ever seen. Next to his message I wrote, 'If you do the work in this style, you will certainly produce something odd.' The document found its way to the Imperial apartments and everybody who saw it was greatly amused. Nobutsune was furious and after this held a grudge against me.'

One can hardly blame him.

89 *The Japanese calligrapher and painter Uchida Gentai (1749– 1822AD) persuaded a number of friends to contribute drawings and calligraphy in celebration of his 70th and 71st birthdays. Such 'communal albums', privately printed and with the seals of the various artists affixed to their work, enjoyed considerable popularity and at times introduced as yet little-known artists to a wider audience. The above opening from* Sho-meika shoga-fu *('An Album of Calligraphy and Paintings by various Masters') shows a composition of pomegranates and iris with a poem written (in square Chinese characters) and composed by Uchida Gentai, and a eulogy (in a more cursive style) by another artist/calligrapher, Nanpo, on the right. Probably Edo, 1819AD.* BRITISH LIBRARY, ORIENTAL AND INDIA OFFICE COLLECTIONS, OR.81.C.25

In China (and in the countries of the Far East which follow Chinese traditions) calligraphy was never just a leading visual art form; it was, and is, the most important of the 'three perfections' – poetry, calligraphy and painting. To be a 'master of the three perfections' has always been the mark of a truly cultured, truly educated, indeed truly superior human being. Being a medium of direct communication between performer and onlooker it allows deep insight into the personality of the practitioner. A single character, a single stroke, indeed a single dot can reveal the calligrapher's inner spirit (his 'breath'), insight, learning and talent. In Japan, to praise a person for his beautiful handwriting is tantamount to calling him graceful and endowed with inner beauty [89]. The calligrapher is thus in many ways a role model. He is part of an elite because of personal inner merit and not simply as the result of inheritance or birth.

WOMEN CALLIGRAPHERS

In the Far East women calligraphers have always been accorded serious consideration. The first Chinese treatise on calligraphy, published in 320AD, which established definite criteria for writing and for the appreciation of calligraphy which are still valid today, was written by a woman, the Lady Wei Shao, and it is thought that none other than the great Wang Xizhi himself was one of her students. Calligraphy was an essential accomplishment for ladies of noble birth and during the Han period, when calligraphy flourished and developed, the cultural elite which practised and understood this art form included women, from aristocratic ladies to Buddhist nuns, as well as men. Even though for a woman calligraphy was in many ways more an accomplishment than a source of power and influence, it did enable her to gain 'promotion' within her own sphere of activity: a more advantageous marriage, a better position at Court.

A similar situation prevailed in Japan during the Heian period. In the sophisticated atmosphere of the Imperial Court, calligraphy and the art of writing poems (naturally in a fine calligraphic hand) not only occupied a special place but constituted a form of everyday communication. A fine calligraphic hand came close to being considered a moral virtue, and being a mirror of a person's inner self, it also played an essential part in the complex games of courtship which occupied so much of the leisure time of the people of Heian. Often it was the sight of a lady's (or gentleman's) handwriting which first gave rise to romantic speculations and the desire to meet the writer in person. Calligraphy was a powerful aphrodisiac and during the initial stages of a love affair both partners awaited the first written communication from the other with a good deal of apprehension, since an indifferent hand would invariably have meant the end of the affair before it had even started. Sending a letter was therefore an act of great (and dangerous) importance and surrounded by strict conventions. First the right paper had to be chosen; size, thickness, design and colour had to harmonize with the time of day, the season, and the weather, so as to evoke the desired mood in the recipient. The handwriting was if anything more important than the actual message, which usually took the form of a poem. After the letter had been completed the paper had to be folded in one of the prescribed styles – ignorance or lack of sophistication could betray itself at any one of these stages.

At one point in Murasaki's *Tale of Genji*, Prince Genji receives a letter from a lady he had known in Akashi. His favourite companion, Murasaki, is consumed with anxiety, not about the contents of the letter, but about the lady's handwriting. When she finally manages to catch a glimpse of it she at once realizes 'that there was a great depth of feeling in the penmanship. Indeed it had style that might give pause to the most distinguished ladies of the Court', accepting sadly that it was 'small wonder that Genji felt about the girl the way he did'. Years later Genji takes the 13-year-old Princess Nyosan as his

official wife and again Murasaki waits anxiously for the first glimpse of the girl's handwriting, knowing that her own future might depend on it. But this time the handwriting turns out to be unformed and childish, and both Genji and Murasaki are embarrassed that somebody of the princess's rank could have reached this age without developing a more polished style. Tactfully Murasaki, who wrote a fine hand and was also a scholar,

> pretended not to have noticed and made no comment. Genji also kept silent. If the letter had come from somebody else he would certainly have whispered something about the writing, but he felt sorry for the girl and simply said, 'Well now you see that you have nothing to worry about'.

Not only calligraphy, but also the implements connected with it, the way they were kept, and the whole process of writing, all mirrored the owner's

90 Japanese writing box. A woman with a girl attendant is writing the characters koi-o-shinobu *(perseverance in love) on a screen by ejecting black tooth stain (black teeth were considered a sign of beauty) from her mouth. Early 19th century.*
VICTORIA AND ALBERT MUSEUM, W.309–1916

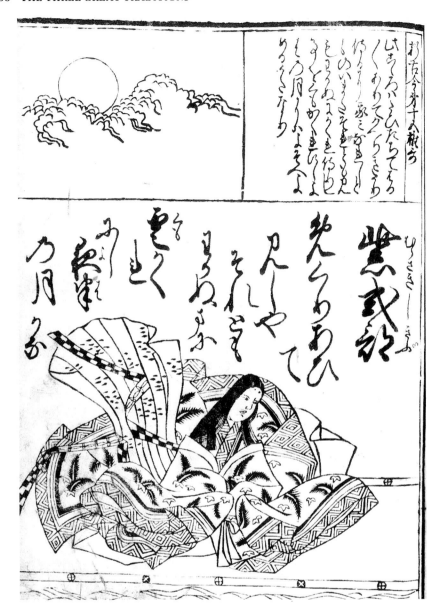

personality and offered important clues to character. Murasaki's contemporary, the Lady Sei Shonagon, ever critical, writes with distaste:

> I hate seeing a dusty, dirty-looking ink stone with an ink stick that has been used in a slovenly way so that it is rubbed down on one side only . . . one can judge a woman's nature by looking at her mirror, her ink stone, or any other belongings of that kind.

And later, reflecting on some love affair which had obviously gone awry: 'I find it painful to be scolded by someone when I have been peeping at his calligraphy', adding wistfully, 'this sort of thing does not happen with a man one loves'.

91 The author of The Tale of Genji, *the lady Murasaki Shikibu. In* Kashiragaki esho hyakunin isshu, *Kyoto, 1673.*
BRITISH LIBRARY, ORIENTAL AND INDIA OFFICE COLLECTIONS, OR.75.H.3

四德と
仁義
礼智と
仏ぬて
のかな
みくも
讀て
初べ〜

92 Two Japanese girls learning the 'four virtues' from books written in kana. Jido kyokun iroha uta *('The Iraho syllabary taught Children'), Kyoto, 1775.*

It is perhaps no accident that during the Heian period two styles were in use: one, *onokode* (men's writing) using *kanji* (Chinese characters) and the Chinese language was considered suitable for administration, scholarship, religion and the execution of power in general; the other was *onnade* (women's writing) written in *hiragana*, the phonetic script, and it was in this style that women authors wrote their novels. In other words, the indigenous, Japanese language and script was more or less used mainly by women. To write in Chinese, using Chinese characters, was indeed deemed highly unsuitable for ladies, and those who had somehow acquired such knowledge, like Murasaki [91] who came from a family of scholars, took great care not to emphasize this fact.

93 Portrait of a
kyoka, *poetess, with*
one of her comic
poems, written in
cursive calligraphy.
Michinoku-gami
kyoka awase, *Edo,*
1793.
BRITISH LIBRARY, ORIEN-
TAL AND INDIA OFFICE
COLLECTIONS, 16099.C.90

The ability to write beautiful calligraphy was an essential part of a woman's sexual attraction and those responsible for her upbringing took great care to foster it. (A 10th-century Fujiwara statesman to his daughter: 'first you must study penmanship'.) Women were valuable objects of barter in the political power game; it was through the advantageous marriage of one of their daughters that a family could hope to reach the highest circles (a daughter married to an Imperial prince might even give birth to the future emperor). To make such a marriage possible a girl had to be well-versed in the prescribed accomplishments which included music, poetry, the ability to fold and choose the right kind of paper and, of course, calligraphy; an indif-

94 *Japanese print by Utamaro (1753–1806AD) from the* Twelve Hours of the Gay Quarters. *This is the Hour of the Dog: a courtesan writes the obligatory morning-after letter to a client, attended by an apprentice. The ink-box, with the stone for rubbing down the ink stick into the water, is on the floor.*
BRITISH MUSEUM, DEPARTMENT OF ORIENTAL ANTIQUITIES, 1906–1230–341 (B27)

ferent hand would indeed have quickly disqualified her whatever her other charms might have been. This attitude to calligraphy remained the same throughout Japanese history, drawing different parts of society into its fold. Women of all classes [93] continued to compose poetry and write their letters and notes in a fine calligraphic hand. Seven hundred years after the Heian ladies had written their love letters, the great courtesans of 'Floating World' were just as carefully trained in music, calligraphy and conversation. An essential part of their daily duties was the writing of love letters to their clients the morning after, and a special hour of the day, the 'Hour of the Dog', was set aside for this task [94].

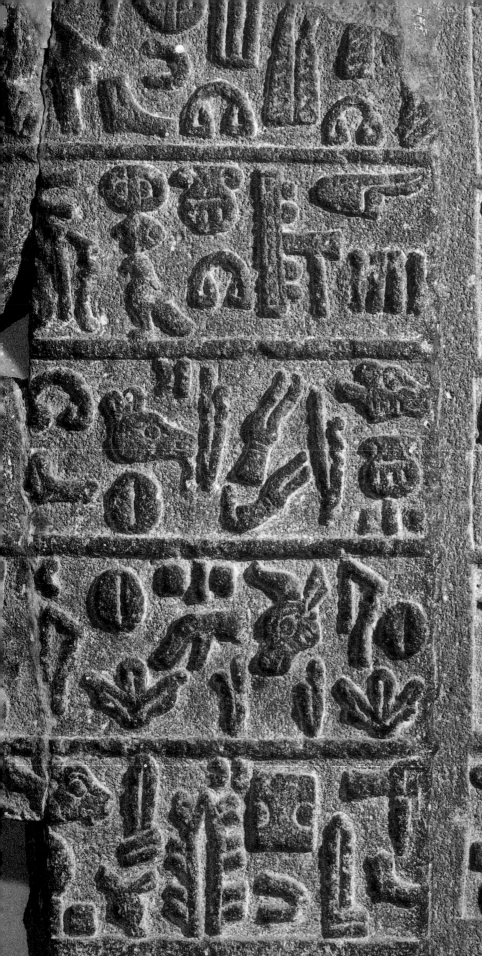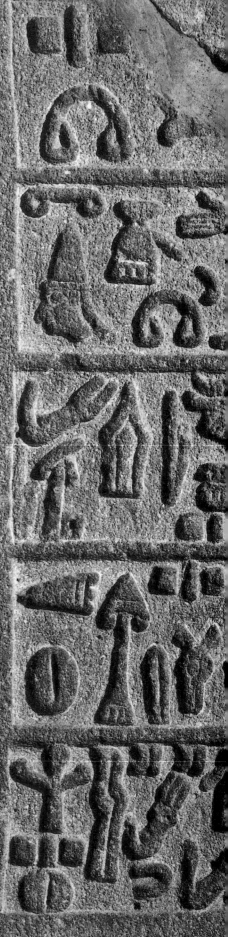

'BEAUTIFUL WRITING'

The term 'calligraphy' derives from the Greek words *graphein* (to write) and *kallos* (beautiful). However, fine writing, even the development of distinct styles, is not necessarily calligraphy. A number of definite elements must combine before true calligraphy can develop. One is the availability of tools which allow for a swift movement across an even surface – such as pen and brush together with parchment and paper. Calligraphy did not develop wherever the script was incised with a stylus or knife into materials such as palm-leaves (South and Southeast Asia), clay bricks (ancient Mesopotamia and Crete), or bone (early China). Although stone itself is not the best medium it is well suited to receive and preserve calligraphic copies; indeed Western calligraphy can be said to trace its roots to Roman stone inscriptions (such as, for example, those on Trajan's column) but such inscriptions were, no doubt, first composed on perishable material. Very much the same holds true of wood, especially in relation to block printing in the Far East (*see* p.164). The second vital factor is motivation, and the attitude of society to writing. In the case of Islam it was revelation and conquest; in the Far East artistic sensibility and political hegemony; and in Western Europe, both secular and religious legality and a stress on (letter) form and function. The third element, which invariably distinguishes calligraphy from 'beautiful writing' is the existence of definite, often mathematically based rules which guide the construction of letters and the relationship between line and space. Calligraphy may be defined as harmony between script, tools, text and cultural heritage. 'Beautiful writing' on the other hand is an expression of spontaneous individuality; it is not rooted in a generally accepted knowledge and technique, and it can therefore develop under a variety of circumstances, either because of individual effort or because it is connected with a certain sphere of the cultural or religious life of a particular community. Finally, if all the right elements combine, beautiful writing can move towards calligraphy.

An intimate relationship exists between picture and script [95, 96]. Both are visual means of communication and information storage. Indeed most scripts known to us started in the form of pictures – Egyptian hieroglyphs, early Sumerian writing, the Indus Valley script, the pre-Columbian scripts of Central America. In the case of the Chinese script, this pictorial origin is often still clearly visible. A letter of the alphabet may not be a picture in the sense of representing a known object, but it is still a visual sign. Representation is not

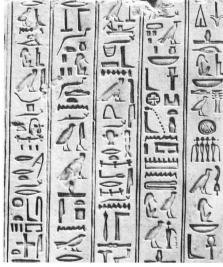

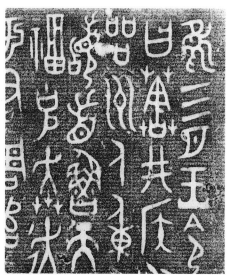

96 Pictures can be part of the script, indeed the script itself: (a) Moso script of the Naxi people of south-western China; 19th century. BRITISH LIBRARY, ORIENTAL AND INDIA OFFICE COLLECTIONS, OR. 11508 (b) Egyptian hieroglyphic inscription from Thebes; c.2100BC. BRITISH MUSEUM, DEPARTMENT OF EGYPTIAN ANTIQUITIES, 614 (c) Chinese bronze vessel from the Western Zhou period (1050–771BC). The inscription in sunken charcaters in the Jinwen zhongdingwen style was cast into bronze by inserting a section in the mould on which the characters were shown in relief. BRITISH MUSEUM, DEPARTMENT OF ORIENTAL ANTIQUITIES, 1936–11–8–2 (11) (d) Maya script of Central America, Codex Madrid; c.1300–1500AD. BRITISH MUSEUM, MUSEUM OF MANKIND (e) Carved bone from Monte Albán, Mexico, engraved with pictorial signs relating to ritual and calendrical calculations; 700–1000AD BRITISH MUSEUM, MUSEUM OF MANKIND, 1949, AM.16–57 (f) Sumerian script from Mesopotamia; c.3000BC. BRITISH MUSEUM DEPARTMENT OF WESTERN ANTIQUITIES, 19124–21–4

an essential element of visual art, for an abstract painting is no less a painting (or less valuable) than a representative one. The way the text forms a pattern on the page is again purely visual. When in the 19th century a number of new scripts were invented in Africa, America and Asia (either by indigenous people who had so far been without a script of their own, or by missionaries working among them) most of them were initially pictorial (AG; pp.130–4); this despite the fact that the inventors were usually familiar with alphabetic writing.

In calligraphy the pictorial element retains a dominant position. Indeed in the Far East painter and calligrapher are considered not only intimately linked but more or less identical. Writing informs us about content in a verbal manner, calligraphy communicates something beyond the mere verbal. For example, by drawing out the lines of the Arabic letters in Kufic [*see* 87] to make them move across the page in relentless pursuit of an ultimate truth, the calligrapher appeals to a deeper level of consciousness.

There are various calligraphic devices which increase the pictorial impact. Texts can be written to form pictures, the shape of the picture being deter-mined by the subject matter of the writing itself [97]. Such text-pictures are generally referred to as calligrams, a term first used by the French poet

98 *'Tout terriblement'*, *a calligram in the shape of a horse from Guillaume Apollinaire's* Calligrammes *published in 1918. Appollinaire (born Wilhelm Appollinaris de Kostrowitzki) was involved in nearly all the avant-garde literary and artistic movements which flourished in France at the beginning of the 20th century. In his poetry he often used indigeneous typographic arrangements to make his calligrams designs as well as poems.*

99 *An invocation (in Persian) to the Prophet Muhammad written in the Arabic script in the shape of two horses.* BRITISH LIBRARY, ORIENTAL AND INDIA OFFICE COLLECTIONS, ADD. MS5660 F, f.27

Guillaume Apollinaire (1880–1918) to describe his own work, published in 1918 [98]. But the convention itself is much older. It can in fact be traced back to the Greek poet Simias, who, in the 4th century BC, wrote poetry in the shape of an egg, a double axe, and the wings of a bird. Simias was not the only Greek poet who used this art form; the tradition continued and was eventually introduced into Christian Europe in the 6th century, by a Bishop of Poitiers, Venatius Fortunatus, who wrote his poem *De Sancta Cruce* in the form of a cross. Text-pictures remained popular throughout the middle ages and the Baroque period. In more recent times artistic groups such as the Dadaists (*see* p.187), and individual poets like George Herbert, Hans Arp, Dylan Thomas, or Robert Herrick have repeatedly made use of them. In the 1960s, the Concrete Poetry Movement greatly revived and popularized the tradition.

Though Islam does not look with favour on the visual representation of living forms, calligraphers (especially in Turkey) have been skilful in using the Arabic script to form pictures of animals [99], human faces [100], birds, or flowers, to write down invocations, sacred words, or even the *basmalah*. The *basmalah* ('In the name of God, the Compassionate, the Merciful', a formula which opens each *sura* of the Koran) holds an important place in Islam and he who writes it beautifully obtains great blessings, if not Paradise itself (*see* p.68). Other popular motifs for Islamic text-pictures are lamps

100 *A human face made up of the names of Allah and Muhammad, and those of the first three Imams: Ali, Hasan and Husain. Under certain circumstances the tendency to equate figures to letters, or compose figures or faces from sacred words, names or formulas, developed naturally out of the concept of the hidden meaning within calligraphy.*
PHOTOGRAPHED 1991

101 (BELOW) *A short text in Arabic written in square Kufic in the form of a mosque. Pictures of sacred buildings were often constructed from such formulas or from the profession of the faith. (See also 80)*
PHOTOGRAPHED 1991

102 (OPPOSITE) *The goddess Annapurna giving rice to the mendicant Siva. The picture is composed of repeated invocations written in Bengali script (mid-19th century AD). Tantric Hinduism holds that the non-dual Supreme Reality has two aspects: Siva (male) and Sakti (here in the form of Annapurna – female). Tantrism is associated with a number of highly unconventional practices and insists on the efficacy of mystical diagrams (sometimes formed by written passages) and mantras made up of mystic syllables (as for example the* siddham *seed syllables (see 111). In Tantrism, Buddhism and Hinduism overlap and after the 8th century AD Tantric practices spread from India to Nepal, Tibet, Southeast Asia, China and eventually also to Japan.*
VICTORIA AND ALBERT MUSEUM, D.422–1889

created from letters (to remind the faithful that God is the light of heaven and earth), or architectural features such as mosques [101].

A special form of picture writing is micrography, where the script is reduced to minute size: the whole Koran, amounting to 77,934 words, has been written on the shell of a single egg (YHS; p.30). In addition, individual lines of writing can be used to 'draw' a picture. Micrography is known in most parts of the world – in the Far East, Southeast Asia, India [102], and in Western Europe; some of the most splendid examples can be found in

103 Pentateuch with Masorah; notes to the masoretic texts written in a variety of phantastic animal shapes at the bottom or in the margin of the page; early 14th century AD. The Masoretic Bible is the result of painstaking work done by certain Jewish scholars known as the Masorets between the 6th and 10th centuries at Talmudic academies in Babylon and Palestine. Their aim was to reconstruct, as far as possible, the original text of the Hebrew Old Testament.
BRITISH LIBRARY, ORIENTAL AND INDIA OFFICE COLLECTIONS, ADD.21160

Hebrew manuscripts, especially in connection with the representations of the so-called masoretic notes [103].

Apart from micrography no calligraphic traditions exist within Hebrew writing. As a result of the political situation created by the Diaspora, the Jews did not have religious or secular institutions such as monasteries, *madrasas*, or princely courts to provide patronage, stimulus and scriptorial authority.

There was, however, a large body of highly literate users, many of them producing their own manuscripts without any editorial guidance. This situation created a demand for good reliable copyists but not for calligraphers. In addition, the correct reproduction, and the legibility of words and letters had in any case always been considered of greater importance than their visual impact or the question of exact (mathematically defined) measurements. An exception is made in the case of the *Sefer Torah* used in the Synagogue, which has to be written (on skin) by a scribe observing special rules. For this text the parchment is prepared with great care, the quill is cut from a turkey feather, and only the square Hebrew script can be used. Particular care is taken with letters of similar appearance (to avoid confusion), and though Hebrew is written from right to left, for this particular text each individual character is written from left to right. Definite rules govern the space between the letters and words: a nine-letter space between portions of the text, a gap of four lines between each of the five books, and so on. When writing, the scribe omits the name of God, which can only be written after special purification; this the scribe performs once the whole text is complete and then proceeds to fill in the appropriate blank spaces.

Unlike the Romans, the Greeks did not develop a distinct tradition of calligraphy. The earliest surviving documents of alphabetic Greek writing so far discovered date from the 8th century BC. They are for the most part epigraphic in nature, showing a predominantly monumental style of often well-executed stone majuscule [104] which do not, however, quite match the mathematical precision and the grandeur of early Roman *capitalis*. Greek inscriptions were not vehicles of imperial power but a means of communication between free men, enabling them to take part in the democratic process. More rounded letterforms were employed when writing with brush or reed pen (a Greek invention; *see* p.24) on papyrus, leather, or, later, parchment;

105 Codex Sinaiticus. *The Bible written in Greek Uncials, middle of the 4th century* AD. BRITISH LIBRARY, ADD. MS 43725, f.260

though one must remember that surviving examples of book hands (documents mostly written on papyrus) between the 2nd century BC and the 5th century AD are still rare and come mostly from Egypt where the climate favoured their survival. During the later part of this period an Uncial type of script [105] developed and remained the preferred book hand until the 9th century AD. This hand was eventually replaced by various more cursive forms, in particular a minuscule script [106], which became the true Greek parchment script of the middle ages. But for the whole period a remarkable uniformity persisted throughout the Greek dominated regions; no sharply

106 Pantocrator Lectionary with text written in the shape of a cross; Greek minuscule, 11th century AD
BRITISH LIBRARY, ADD. 39603, f.1V

differentiated regional or national styles arose (as in the Western part of Europe), nor did form and function exercise the same decisive influence on the various book and documentary hands. Writing remained a means of communication and information storage; it never quite managed to make an aesthetic or socio-historical statement about the Greek world in the way that the Roman script did.

Calligraphy played no major role in South Asia before the establishment of Islam after the 12th century AD; neither the tools nor the writing material (palm-leaves and stylus), nor the socio-religious attitude was congenial to its

development. Although a knowledge of writing had been introduced to the Indian subcontinent by Semitic traders as early as the 7th or 6th century BC, Hinduism, the major religion of that area, was decisively hostile to it. The memorizing and recitation of the sacred Vedic hymns which ensured the well-being of the community and the continuation of the universe, were the carefully guarded property of certain Brahmanical sub-groups whose power and status depended on their ability to maintain this monopoly; low caste people were not even permitted to listen to such recitations. It was only after a point had been reached when the innumerable commentaries and sub-commentaries began to outstrip human memory that texts were written down. But even then the grammarian Panini (c.400BC) says grudgingly that 'things from books are not as good as things from the living and abiding voice', thus endorsing the superiority of oral tradition over written texts. Buddhism too (especially of the original austere Theravada persuasion), though not overtly hostile to writing, placed the importance of the text above its visual representation. Monks should not take delight in visual beauty [107]. In consequence the vast majority of South Indian and Sri Lankan palm-leaf manuscripts are at best only adequately, and indeed often indifferently written.

This, however, does not mean that no fine manuscripts were produced in South Asia. In the northern part of the Indian subcontinent most writing was done on palm-leaf or birch bark (later on paper), with reed pen and ink and, judging from the few remaining examples, beautifully written manuscripts, often meant for royal or temple libraries, or for rich patrons, seem to have been plentiful. In Tibet, where writing was introduced from India together with Buddhism in the 7th century AD, good writing was taught in the monasteries as part of the curriculum. Soon a number of definite styles developed: book hands (*dbu-can*) mainly for printing Buddhist texts with wooden blocks; cursive scripts (*dbu-med*) for everyday use [108], or for official documents ('bam-yig); decorative scripts ('bru-tsha); and a special style called *lentsa* based on the ancient Gupta characters which could be used for seed syllables and titles of texts.

Fine writing also played a major part within the complex and esoteric world of Hindu Tantras, popuar Daoism [109] and in Tantric Buddhism, and in the case of the latter, beautiful writing, combined with other elements, did eventually move towards calligraphy. The script which underwent this transformation was *siddham*, an Indian syllabic form of writing going back to the Gupta script [110] of the 4th century AD. The Gupta era (320–647AD) has often been called the golden age of Indian Buddhism; it boasted a definite style of art and flourishing monasteries where writing was taught to young monks and many outstanding literary works were composed and copied.

According to Tantric Buddhism the *siddham* letters 'exploded' out of emptiness (Buddhist philosophy rejects the concept of first causes) and were taught by the Buddha but kept secret until the Indian saint Nagarjuna

107 An 18th-century Sinhalese palm-leaf manuscript from Kandy. Theravada Buddishm (which is closer to the original austere teaching of the Buddha) does not encourage visual beauty since it might delight the senses and distract the attention of the monks from the actual text. The wooden covers of manuscripts, however, were the work of lay craftsmen, not bound by such restrictions, who used certain sets of illustrations, mostly without much regard for the text.
BRITISH LIBRARY, ORIENTAL AND INDIA OFFICE COLLECTIONS, OR.6600.71

108 (a) Formal Tibetan script, dbu-can, with headmarks; a folio from the first volume of the Tibetan Buddhist cannon Kanjur, 18th century AD. (b) Cursive headless Tibetan script, dbu-med, from a manuscript about the history of the Sakya tradition of Tibetan Buddhism, 15th century AD.
BRITISH LIBRARY, ORIENTAL AND INDIA OFFICE COLLECTIONS, OR.6724 AND OR.11374, f.1

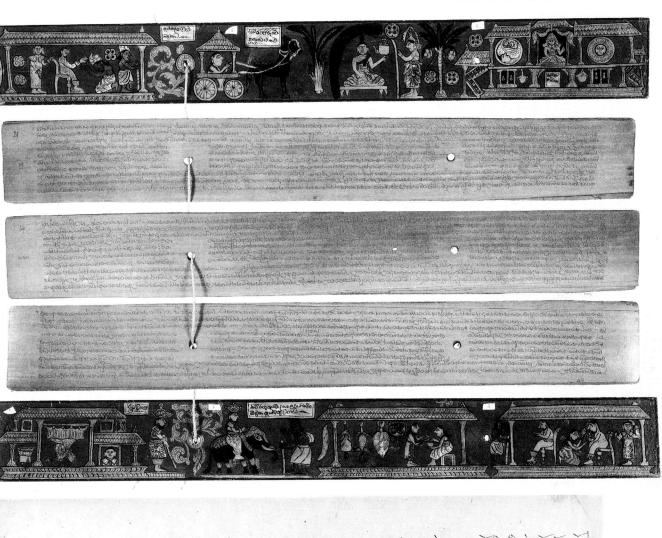

*109 In the field of popular Chinese religion calligraphy could become endowed with super-
natural powers. Popular Daoists would make talismanic diagrams with calligraphic
elements, paste them on walls, burn them to send messages to the spirit world, or fashion
them into pills to be used as medicine. Copy of a Chinese secret society magic banner on
silk with tiger and talismanic drawing.*

BRITISH LIBRARY, ORIENTAL AND INDIA OFFICE COLLECTIONS, OR.11549

110 Sadharma pundarika sutra. Fragment of a manuscript from Gilgit (Kashmir) written in Central Asian upright Gupta on birch bark, 7th–8th century AD. Variations of the Gupta script (eventually known as siddham*) reached China together with Buddhism. By using the Chinese brush and applying definite rules of measurement and composition* siddham *became a special branch of calligraphy which today is still actively practised in Japan.*
BRITISH LIBRARY, ORIENTAL AND INDIA OFFICE COLLECTIONS, OR.11878A

111 Siddham seed syllables: (a) The syllable ha *representing Ksitigarbha Bodhisattva, the Bodhisattva of the Underworld, and the patron of gamblers, travellers, lost causes and the dead. (b) The syllable* yu *representing Maitreya Bodhisattva, the Buddha of the future. (c) The syllable* sa *representing Avalokitesvara Bodhisattva, the Bodhisattva of great compassion. (d) The syllable* mam *representing Manjusri Boddhisattva, the Bodhisattva of wisdom, learning and enlightenment.*

(*c.*200AD) revealed them to his disciples. From the 7th century onwards *siddham* letters were mostly used for the representation of 'seed syllables' within *mantras* (sacred diagrams), each letter personifying a different cosmic force of the Buddha [111]. Awareness of emptiness, so the teaching goes, is transformed into a seed syllable, from the seed develops the Buddha, who may be portrayed by an icon (in this case, the seed syllable); contemplation of the icon unites the devotee with the seed and returns him to emptiness.

Buddhism brought Sanskrit texts, mainly written in Sanskrit in the *siddham* script, to China. Unlike India, China had always given much importance to the written word since within its realm the large number of different dialects made oral communication difficult. In keeping with this attitude Chinese Buddhists paid great attention to the form and the correct construction of *siddham* characters. Once the pen had been replaced by the Chinese brush, *siddham* became a special branch of Chinese calligraphy connected with sacred writing. From China Buddhism brought the *siddham* script to Korea and in the 9th century two Japanese monks, Kukai (773–835AD) and Saicho (767–822AD), who had both studied in China (*see* p.121), introduced it to Japan where it soon gained great popularity within certain circles. Both the Heian (794–1185AD) and the Kamakura period (1185–1333AD) produced a number of well known *siddham* masters. After a period of decline *siddham* calligraphy re-emerged in the 17th century. It is still an important calligraphic style (*see* p.208) and indeed has experienced something of a renaissance (SO; pp.12–40).

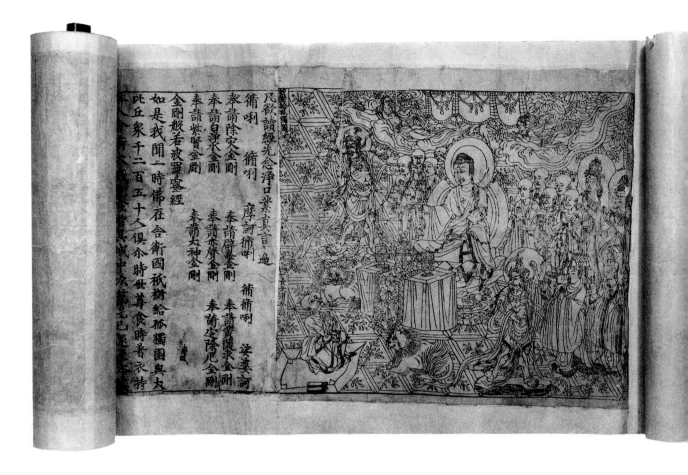

PRINTING AND CALLIGRAPHY

112 *Chinese transla-*
tion of the Diamond
sutra, *a Buddhist work*
originally composed in
Sanskrit. The scroll,
dated 868AD, is gener-
ally considered the
oldest complete and
dated printed book in
existence. Printed from
wood blocks on seven
sheets of paper glued
together, the script
(kaishu) and illustra-
tion show a high level
of sophistication which
testify to a lengthy
printing tradition.
BRITISH LIBRARY, ORIEN-
TAL AND INDIA OFFICE
COLLECTIONS, OR.8210
P.2

Does printing invariably spell the end of calligraphy? Perhaps we should first ask ourselves the question: what exactly is printing, and what is the main difference between printing and writing? Basically, printing is the multiplication of graphically stored information by mechanical means. Texts can of course be copied manually, but a text copied mechanically remains the same as the original; scribes could (and often did) alter a text while copying it, but the printing press can do no such thing. Printing therefore introduces (apart from mass-production) an element of authenticity while at the same time limiting the creative process.

Printing goes much further back than Gutenberg's Bible [*see* PLATE V] which appeared in Mainz in 1455AD, or even than the Diamond sutra [112], a Chinese translation of a Sanskrit text, printed in 868AD in the Far East. The first mechanical copying of graphically stored information known to us occurred in the 3rd millenium BC in Mesopotamia when property was stamped with seals. By intent, as well as in practice, a seal performs exactly the same function as the printing press: it reliably copies and multiplies information by mechanical means – in this case information about ownership. Such information could already be fairly sophisticated; it could consist of a picture, one or a number of single signs (movable type), or a text (block print) [113].

This leads us straight to the two main (traditional) possibilities of printing: block printing, and printing with movable type. In the case of Chinese and other Far Eastern block printing [114], the text is first written on a thin sheet of paper by a professional calligrapher. The sheet in question is then attached, face down, to a wooden block, over which a thin layer of rice paste has been spread and left to dry. The upper surface of the paper is carefully rubbed off and oil is applied to make the rest transparent, enabling the engraver to see the inscribed area more clearly. The wood surrounding the characters is cut away, and, once the block is dry, ink is applied with a brush. Then paper, which had been kept moist for several hours, is placed on the block; the actual impression of the imprint is obtained by rubbing the paper with a tool made for this purpose. The technique of the wood block, which has been the principal vehicle of printing in the Far East, has changed little since it came first into use. The point worth noting is the close connection between writing and printing. The original text could be (and in many cases was) written by a renowned calligrapher; thus the final printed page had two

messages: the actual information contained in the text, and the calligraphy of
a particular master.

In the case of Western printing from movable type, letter fonts (originally
made of soft metal) were produced by a process of replica-casting from mat-
rices which assured that in one and the same font the same letters were
identical with each other, and that all letters could be set, evenly, on the level
bed of the press so as to provide an absolutely flat printing surface. The ink
applied to this surface had to be oil-based (unlike the water-based ink used
for block printing) to enable it to adhere to the metal type [115]. Both, print-

113 (OPPOSITE) In 1908 the so-called Phaistos disc (now in Athens) was found in an out-building of the Minoan palace at Hagia Triada in Crete. The disc, dated as not later than 1700BC, contains what appears to be a text made up of about 45 different pictorial signs impressed with wooden or metal punches into soft clay. It consists of, altogether, 241 signs arranged in groups (words?) divided by vertical lines, and runs in a spiral either to or from the centre; the individual signs bear no resemblance to any ancient pictorial scripts used in this area at the same time and nothing similar has so far been found. BRITISH MUSEUM, DEPARTMENT OF GREEK AND ROMAN ANTI-QUITIES

114 (RIGHT) Two Japanese wood blocks for printing title-page and one page of text. Woodblocks not only allowed a closer connection between calligrapher and printer, they were also more economical to prepare than the thousands of different characters (see 116) required by movable type, they could be stored more easily, edited for errors, repaired if damaged and re-used for hundreds of years. BRITISH LIBRARY, ORIENTAL AND INDIA OFFICE COLLECTIONS, OR.14566

¶ Mors resecat/mors omne necat quod carne creatur ¶ Nobiliũ tenet imperiũ nulli reueretur
Magnificos premit ꝛ modicos/cunctis dominatur. Tam ducibus ꝗ̃ principiꝰ cõmune habetur.

¶ Nunc ꝟ̃i ius/ꝟ̃i lex/ꝟ̃i vox/ꝟ̃i flos iuuenilis/hic nisi pus/nisi fex/nisi terre precio vilis.

¶ Le mort ¶ Le mort
¶ Venez danser vng tourdion ¶ Sus auant vous ires apres
Imprimeurs sus legierement Maistre libraire marchez auant
Venez tost/pour conclusion Vous me regardez de bien pres
Mourir vous fault certainement Laissez voz liures maintenant
Faictes vng sault habillement Danser vous fault/a quel galant
Presses/ꝛ capses vous fault laisser Mettez icy vostre pensee
Reculer ny fault nullement Comment vous reculez marchant
A louurage on congnoist louurier. Cõmencement nest pas fusee

 ¶ Les imprimeurs ¶ Le libraire
¶ Helas ou aurons nous recours ¶ Me fault il maulgre moy danser
Puis que la mort nous espie Je croy que ouy/mort me presse
Imprime auons tous les cours Et me contrainct de me auancer
De la saincte theologie Nesse pas dure destresse
Loix/decret/ꝛ poeterie/ Mes liures il fault que ie laisse
Par nr̃e art plusieurs sont grans clers Et ma boutique desormais
Releuec en est clergie Dont ie pers toute lyesse
Les vouloirs des gens sont diuers Tel est blece qui nen peult mais.

6

ing from the wood block and printing with movable type, depend on paper (not only because of its flat surface but also because of expense: the great printed vellum Bibles of Gutenberg's time required as many as 300 sheep skins for a single volume). Indeed, without the invention of paper in China, and its eventual ready availability in Western Europe, printing would probably not have been able to succeed so quickly in quite the same way. The important difference, as far as calligraphy is concerned, lies in the fact that in the case of typography there is no longer any direct contact between writing and printing. To begin with, printers did try to produce pages which resembled those of manuscripts, and letter fonts were (and often still are) designed by calligraphers, or at least by craftsmen proficient and knowledgeable in the art of letterforms. But the input is no longer immediate and direct, and the calligrapher (if consulted at all) is further restricted by the fact that letters have to be designed in isolation, one by one; the easy flow, the inspiration which comes from seeing them emerge as part of the text across the page, is lost.

Far Eastern block printing

In China printing, as a serious technique, began during the Tang period (618–906AD), at a time when calligraphy had already reached a high level of perfection and (in the right circles) popularity. Contemporary calligraphers, such as Ouyang Xun (557–641AD), Liu Gongquan (778–865AD) and Yan Zhenqing (709–785AD), dominated the artistic scene, and though they themselves did perhaps not write texts for transfer to the woodblock (at least nothing of this kind has survived), calligraphers writing in their style did (FMW/HC; p.13).

The idea, and the practice, of making mechanical multiplication of texts does however go back much further. The use of stamping seals cut in relief, and the practice of obtaining duplicate inscriptions from moulds or matrices, were already in evidence during the 1st millennium BC. Especially in China, the personal seal, bearing the owner's name, has always been used as a signature and/or a mark of ownership (*see* p.79); in the case of a painting or a piece of calligraphy the seal was (and is) an integral part of the whole composition [163]. By the 2nd century AD all the enabling ingredients for the development of printing were in place: paper, ink, the ability to carve a text in relief on to a flat surface. There existed further a tradition by which the calligraphy of noted writers, important politicians and ritual statesmen (sometimes also lengthy texts such as the Confucian classics) were carefully traced on a smooth stone surface and engraved; from it relatively accurate copies could then be made by rubbing or ink squeeze. Such duplications were thought necessary, either because of the calligraphic significance of the inscription, or

115 La grande danse macabre *Lyons, 1499AD.* This is the earliest known representation of a printing shop. On the left of the picture Death is leading off a compositor and two pressmen. The compositor holds in one hand a composing stick in which he is just about to arrange types taken from the compartments on the trestle table in front of him. On the bench beside him is a two-page forme which he is setting up. The forme would be inked by the man with ink-balls in the background. On the right side of the illustration is a cubicle built into the main room where the finished books are stored and sold over a counter. Indeed William Caxton's (1422–1491AD) own shop may have looked exactly like this.
BRITISH LIBRARY, IB 41735

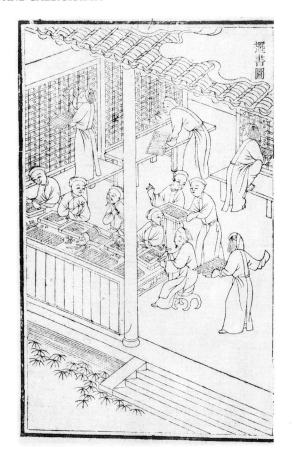

because of the importance of the text itself. In fact nearly all samples of calligraphy from the Han period have reached us in this form.

By the 6th century this method of multiplication by transfer was greatly perfected and copies of high quality, and (even more important) complete fidelity, could be made from inscriptions engraved on stone, wood, metal or baked clay. Since repeated copying was inclined to damage the original the next step was to prepare, on wooden blocks, a faithful copy of it, at first in negative characters, and later in positive ones cut in relief. The result was black script on white paper – a print. The new craft quickly gained in popularity and by the end of the Tang period printing was not only widely used throughout China, it had also been introduced to Korea (where it took root) and Japan (where, after an initial burst of activity it lay dormant until the 16th century). One by-product of printing in the Far East was the gradual change in the shape of the book imposed by the practical limits of the wood block: the scroll format gave way to thin folded double pages, stitched together in a way at least superficially similar to a Western codex. Wood blocks retained their popularity throughout the centuries; even in today's People's Republic of China, political and social messages are often printed in this fashion.

*117 From a collection of Japanese Nô plays, printed with movable type at the Saga press, c.1605–1610*AD.
BRITISH LIBRARY, ORIENTAL AND INDIA OFFICE COLLECTIONS, OR.74.C.I.

The credit for the invention of typography [116] too goes to the Far East. Available evidence suggests that in about 1313AD a Chinese magistrate by the name of Wang Zhen had some 60,000 characters carved on movable wooden blocks to print a treatise on the history of technology. Between 1441–48AD the alchemist Bi Sheng produced movable type made of clay and glue hardened by baking. For printing they were placed side by side on an iron plate coated with a mixture of resin, wax and paper ash; once the print had been made the type was detached and re-used. In Korea typography goes back as far as the first half of the 13th century when it was taken up and soon flourished under the patronage of the Royal Court. In 1403 King Htai Tjon ordered a set of 100,000 pieces of type to be cast in bronze; by 1516 nine more sets had been made, at least two of them pre-dating the European discovery of typography. Movable-type printing reached Japan, almost simultaneously, in the later part of the 16th century from Korea and from Portugal. Although the use of the new technique was short-lived, lasting no more than some 50 years (from 590–1650), during this period Japanese printers produced exceedingly fine work in some of the most difficult calligraphic styles [117]. However, in the 17th century, typography all but disappeared in the Far East, to be re-introduced from Europe in the 19th century.

豆久邇伊多流伊知遅志麻美志麻邇
豆多布都奴賀能迦邇余許佐良布伊
歌曰許能迦邇夜伊豆久能迦邇毛毛
獻於是天皇仕令取其大御酒盞而御
其女矢河枝比賣[命]令取大御酒盞而
家侯待者明日入坐故獻大御饗之時。
理。此音二字恐之我子仕奉云而嚴餝其

118 Kojiki. Ancient history of Japan, completed in 712AD, the first work of native Japanese literature. This copy was printed from wood blocks in 1803. The pronunciation is indicated by kana signs alongside the Chinese characters. BRITISH LIBRARY, ORIENTAL AND INDIA OFFICE COLLECTIONS, 16047.B.10

There were several reasons why movable-type printing did not establish itself easily and permanently in the Far East. One was the nature of the Chinese script itself. In the West, the limited number of characters in the alphabet made typography cost-effective, less labour-intensive. The sheer multitude of Chinese character-signs – and the additional difficulties which arose when Chinese characters were used for Japanese [118] – offered no such incentive. But there was also the Far Eastern attitude to calligraphy and fine writing. To the true connoisseur (and there are still many in the Far East) typography impairs calligraphic standards; block-printing is preferred (even today) for the reproduction of a calligraphic specimen. Thus, throughout the history of Far Eastern block-printing, the calligrapher and the printer continued to be partners. Printing remained a craft, never wholly becoming a mere industry as in the West; it neither marginalized calligraphy nor did it divorce itself entirely from the manuscript book.

Western typography

This work is fashioned and by diligence finished for the service of God, not with ink and quill nor brazen reed but with a certain invention of printing and reproduction by John Fust, citizen of Maintz, and Peter Schoeffer of Gernsheim, 17 December 1465AD.
STATED IN THE COLOPHON OF THE FUST-SCHOEFFER PSALTERIUM CUM CANTICIS

In the beginning, printers tried to imitate the written page as closely as possible. Books printed between 1450–80 are almost indistinguishable from manuscripts of the same period [*see* PLATE X]. Gutenberg himself cut as many as 300 fonts of individual letters and abbreviations, and together with his contemporaries often left space for the illuminator/illustrator to insert block-printed or handwritten capitals in order to create the impression of a manuscript text. Moreover, in those early years, virtually the whole range of scripts prevalent in Western Europe was used for book production. After 1480, however, printers became increasingly more aware of the intrinsic autonomy of their craft. There were two main reasons for this change in attitude. One was the fact that in the West printing has from the beginning been a commercial venture (you find out what the market wants and what is likely to expand the market, and you provide it); the other contributory factor lay in the nature of the alphabetic script itself, which, by its numerical limitations, encourages standardization and uniformity, both elements conducive to the spread of printing and the expansion of the market. The two styles on which printers

Aue maria
grã plena
dominus
tecũ bene
dicta tu in mulierib'
et benedictus fruct'
uentris tui : ihesus
christus amen.

Gloria laudis resonet in ore
omniũ Patri genitoqȝ proli
spiritui sancto pariter Resul
tet laude perhenni Labori
bus dei vendunt nobis om
nia bona. laus:honor virtus
potẽtia: ȝ gratiax actio tibi
christe. Amen.

Viue deũ sic ȝ vines per secula cun/
cta. Prouidet ȝ tribuit deus omnia
nobis. Proficit absque deo nullꝰ in
orbe labor. Illa placet tellꝰ in qua
res parua beatũ. Ode facit ȝ tenues
luxuriantur opes.

Si fortuna volet fies de rhetore consul.
Si volet hec eadem fies de cõsule rhetor.
Quicquid amor iussit nõ est cõtẽdere tutũ
Regnat et in dominos ius habet ille suos
Vita data ẽ vt ẽ data ẽ sine fenere nobis
Mutua: nec certa persoluenda die.

Usus ȝ ars docuit quod sapit omnis homo
Ars animos frangit ȝ firmas diruit vrbes
Arte cadunt turres arte leuatur onus
Artibus ingenijs quesita est gloria multis
Principijs obsta sero medicina paratur
Cum mala per longas conualuere moras
Sed propera nec te venturas differ in horas
Qui non est hodie cras minus aptus erit.

Non bene pro toto libertas venditur auro
Hoc celeste bonum preterit orbis opes
Precaueris animi est bonis veneranda libertas
Seruitus semper auaris quoque despicienda
Summa petit liuor perflant altissima venti
Summa petunt dextra fulmina missa iouis
In loca nonnunqu am siccis arentia glebis
Be prope currenti flumine man at aqua

Quisquis ades scriptis qui mentem forsitan istis
Ut noscas adhibes pronus istud opus
Nosce: augustensis ratdolt germanus Erhardus
Litterulas istos ordine quasqȝ facit
Ipse quibus veneta libros impressit in vrbe
Multos ȝ plures nunc premit atqȝ premet
Quique etiam varijs celestia signa figuris
Aurea qui primus nunc monumenta premit
Quin etiam manibus proprijs vbicunqȝ figuras
Est opus:incidens dedalus alter erit

Nobis benedicat qui ẽ trinitate vivit
ȝ regnat Amen: Honor soli deo extribuendũ
Aue regina celox mater regis angelo
rum o maria flos virginum velut rosa
vestitum o maria : Tua est potentia tu
reginx domine tu es super omnes gen
tes da pacem domine in dieb' nostris
mirabilis deus in sanctis suis Et glori
osus in maiestate sua orb panthon kyr

Quod prope sacce diem tibi sum conuiua futurus
forsitan ignoras at fore ne dubites
Ergo para cenam non qualem stoicus ambit
Sed lautam sane more carenaco
Namque duas mecum florente etate puellas
Adducam quarum balsama cunnus olet
Vernula sola domi sedeat quam nuper habebas
Si nondum cunnus vepribus horruerit
Sunt qui insimulent ȝ auari crimen amici
O bicant facto ruinor ut iste cadat Hec Philelphus

Hunc adeas mira quicunqȝ uolumina queris
Arte vel ex animo poeta fuisse tuo
Seruet iste tibi:nobis iure sorores
Incolumem seruet usqȝ rogare licet

Est homini uirtus fuluo preciosior auro: ænæas
Ingenium quondam fuerat preciosius auro.
Miramurqȝ magis quos munera mentis adornãt:
Quam qui corporeis emicuere bonis.
Si qua uirtute nites ne despice quenquam
Ex alia quadam forsitan ipse nitet

Nemo suę laudis nimium lętetur honore
Ne ullis factus post sua fata gemat.
Nemo nimis cupide sibi res desiderat ullas
Ne dum plus cupiat perdat & id quod habet.
Ne ue cito uerbis cuiusquam credito blandis
Sed si sint fidei respice quid moneant
Qui bene proloquitur coram sed postea praue
Hic erit inuisus bina qȝ ora gerat

Pax plenam uirtutis opus pax summa laborum
pax belli exacti precium est precuiumque pericli
Sidera pace uigent consistunt terrea pace
Nil placitum sine pace deo non munus ad aram
Fortuna arbitrius tempus dispensat ubi
Ista rapit iuuenes illa ferit senes

κλίω τευτερπη τε θαλεία τε μελπομένη τε
περ ψιχορη τερατω τε πολυμνεία τουρανιη
τε καλλιοπη θεαδη προφερεϲατη εϲιναϲα
ϲαωμ ιεϲουϲ χριϲουϲ μαρια τελοϲ.

Indicis charactex diuersax mane/
rierũ impressioni pararatũ: Finis.

Erhardi Ratdolt Augustensis viri
solertissimi:preclaro ingenio ȝ miri
fica arte:qua olim Venetijs excelluit
celebratissimus. In imperiali nunc
vrbe Auguste vindelicox laudatissi
me impressioni dedit. Annoqȝ salu
tis.M.CCCC.LXXXVI.Kalẽ.
Aprilis Sidere felici compleuit.

eventually settled at the beginning of the 16th century were the Humanistic scripts and the local forms of Gothic [119].

A certain amount of controversy exists about how far (or indeed whether) the wood block played any significant part in the development of Western printing. Most scholars deny the existence of genuine 'block books' prior to Gutenberg's Bible. Block printing was certainly practised in the first half of the 15th century, but mostly in the form of single sheets (the earliest dated wood-block print being the Buxheimer St Christopher, which bears the date 1423AD) or in the form of chiroxylographic books which mixed printing of illustrations with handwriting of the text.

Western typography established itself rapidly within a few decades and before long it began to affect the position of the scribe, especially the scribe who earned his living as a copyist. The printing press could produce more accurate copies more quickly, and in addition more cheaply. As early as 1480 Antonio Sinibaldi, a distinguished member of the profession (forced into a new form of competitiveness, calligrapher/scribes had long shed their anonymity), complained when completing his tax form that he had lost so much copying work on account of the new invention that he was barely able to clothe himself (DJ; p.109). At first gifted calligraphers tried to counteract the threat to their livelihood by concentrating their efforts on the production of luxurious manuscripts exclusively meant for wealthy patrons. Especially in Italy, Humanistic masterpieces (using Roman as well as Italic hands) were produced, sometimes on richly coloured paper (or parchment) to attract the attention of rich and discerning customers. Chancery scribes were in a better position since their products were by nature 'one offs' which had no need for mass-duplication. In the 16th century a new calligraphic style developed in this area: Cancellaresca (a chancery cursive going back to the papal scriptorium of the previous century). It responded well to differently cut nibs and different speeds of writing, and, as a book and documentary hand, soon gained popularity as the script of Christian learning.

The increase in literacy which contributed to and was brought about by the mass distribution of mechanically reproduced texts rapidly enlarged the size of the reading audience. This created new opportunities and some enterprising calligrapher/scribes were quick to exploit the situation: not only did more people want to be instructed in writing (and calligraphy), but by using the new means of mass-production, calligraphers who were able and willing to instruct them, could win for themselves a much larger audience, and with it an increased share of the steadily growing market. In 1522, the Roman calligrapher and printer Ludovico degli Arrighi (*fl.* 1510–1527) published a small booklet entitled *Operina da imparare di scrivere littera cancellaresca* which gave simple instructions, illustrated with wood-cut examples, about how to learn the author's favourite Cancellaresca style in 'a few days'. His publication is widely held responsible for the creation of a new profession: that of the writing master.

120 *Some writing masters were highly accomplished, and not only in calligraphy. Geoffroy Tory (c.1480–1533AD) was a publisher, printer, orthographic reformer and engraver. He was largely responsible for the French Renaissance style of book decoration and for popularising the Roman letters against the then prevailing Gothic hand in France. His most famous work was* Champfleury, *published in Paris in 1529. This page gives examples of Lettre Bastarde.*
BRITISH LIBRARY, 60.E.14

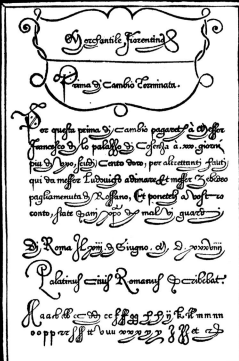

121 *A work by Giovanni Battista Palatino,* Libro nel quale s'insegna a scrivere ogne sorte lettere, *Rome, 1548AD (a reissue of a work first published in 1545). Palatino's manuals enjoyed great popularity. Relatively little is known about his life, but we know that in 1538 he acquired Roman citizenship, a fact he proudly announces on this page.*
BRITISH LIBRARY, 52.D.23

Two years later, the Venetian chancery scribe, Giovanni Antonio Tagliente (*fl.* 1491–1531) brought out (after many long years of teaching) his *Presente libro*; and in 1540 Giovanni Battista Palatino's *Libro nuovo d'imparare á scrivere*, the most widely disseminated copy-book of the 16th century, appeared in Rome [121]. Other professional calligraphers, who had seen their livelihood threatened, were quick to follow suit, and over the next fifty years a host of similar manuals appeared in print: in Germany those of Johann Neudoerffer (1538), Caspar Neff (1549), and Jonathan Sautter (1555); Clement Perret (1569) and Jan van den Velde (1605) in the Netherlands; Juan de Yciar (1548) and Francisco Lucas (1577) in Spain; Gerard Mercator (1540) in Holland; and Geoffroy Tory [120] (1525), Pierre Hamon [122] (1561), Aert van Meldert (1585) and Guillaume Le Gangneur (1599) in France.

123 A letter written by Elizabeth I (1533–1603AD) to her brother, King Edward VI (1537–1553AD), on 20 September 1552. Elizabeth wrote an elegant Italic hand (in preference to the still customarily used 'Secretary' hands – see 124) which had been taught to her by Roger Ascham who, as John Strype wrote in his Life of Sir John Cheke published in 1702, 'for his exquisite hand was the person appointed to teach the Lady Elizabeth to write so that fair writing and good learning seemed to commence together'.
BRITISH LIBRARY, HARL. MS 6986, f.23

Cancellaresca, the Italian Chancery hand, which in the second half of the 16th century became the script most favoured in Court circles and among Humanistic scholars, was introduced to England by the Hugenot scribe Jean de Beauchesne (c.1538–1610) and John Baildon in 1570 (*A Book Containing Divers Sortes of Hands*); it was soon widely accepted. Not only did Elizabeth I [123], amply instructed by Roger Ascham [125], and her contemporaries make use of this style, but it also served for school books and daily correspon-

124 Drake's Treasure. When Sir Francis Drake returned to England in 1580 from his voyage round the world, Elizabeth I suggested to the Spanish Ambassador that his conduct should be investigated, and if misconduct could be proved, he should be punished and the treasure returned; but six months later she knighted him on the deck of his ship. This warrant to the master of the Jewel House and the Mint is dated 26 April 1584, just three years after the ceremony. It is a good example of the contemporary 'Secretary' hand; Elizabeth's own signature has remained remarkably consistent throughout her reign, as can be seen when compared with 123.
BRITISH LIBRARY, HARL. MS 6986, f.37

125 A letter by Philip II of Spain and Mary Tudor to Pope Marcellus II (Hampton Court, 4 May 1555AD), written by Roger Ascham who was Mary's Latin Secretary and as such responsible for the official correspondence of the State. Ascham had already been Secretary to Henry VIII and his son Edward VI, and it was because of the excellence of his pen that the Catholic Mary overlooked his nonconformity in religious matters.
BRITISH LIBRARY, COTTON MS VESPASIAN F.III, f.47

dence on a wider scale. In addition, educated Europeans continued to write Black Letter Secretary [124] and at times (together with Shakespeare) made light of the new 'sweet Roman hand'. Indeed, in the German-speaking countries, a cursive version of Gothic survived as the only script of correspondence and government business until the middle of the 20th century. The principal French style of this period was a national Black Letter cursive called *Lettres Françoises* (or *finançieres*) for everyday and business affairs, and the more

Endeavour continuallie to secure every moment of time to a prudent, commendable, and honourable Imployment, the advantageous improvement thereof being of grand concernment, and an argument of abundance of wisdome in all.

Aa m b me m d me m f m g m h m i m k m l m n m o m p m g m r m s m s m t m v m r m u m r m x m y m z &

Cocker.

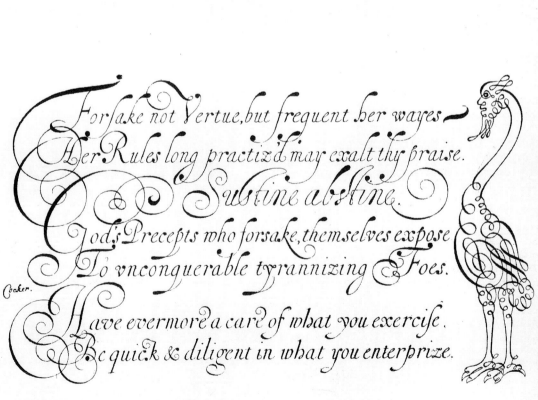

Forsake not Vertue, but frequent her wayes
Her Rules long practiz'd may exalt thy praise.
Sustine abstine.
God's Precepts who forsake, themselves expose
To unconquerable tyrannizing Foes.
Have evermore a care of what you exercise.
Be quick & diligent in what you enterprize.

Cocker.

126 *Edward Cocker*
The Pen's Triumph:
being a Copy-book
containing a variety of
Examples of all Hands
practised by this
Nation according to
the Present Mode
adorned with incom-
parable Knots and
Flourishes, *London,
1660. Though Cocker
could produce simple
and pleasing styles he
shared the contem-
porary taste for dazz-
ling his audience with
decorative 'strickings'
or 'flourishes' done in
the 'command of hand'
which demonstrates
how intricate lines
could be drawn with-
out lifting the pen.*
BRITISH LIBRARY, X425/
3011, P.184

aristocratic Italian Bastarda, a compromise script which mixed common Gothic cursive with the more fashionable Italic, going back to a manual (*Opera nella quale si insegna a scrivere*) published by Vespasian Amphiareo (died 1563) in 1554. Bastarda (still rather an ornate script) was introduced to Britain under the name of 'new mixed current' through Edward Cocker's (1631–1676) copy-books (1661/1668/1672) [126]. Cocker, who engraved his own work, was the most prolific and best known English writing master of his time, much admired for his calligraphy and his exuberant flourishes. By the beginning of the 18th century a more simple and businesslike script had developed from it, originally propagated by John Ayres (*fl.* 1608–1705) [127] and his contemporaries, to serve commercial demands.

In the long run, printing did bring about a progressive decline in the level and importance of calligraphy. As the 17th century drew to its close, and during the whole of the following century, calligraphy was beginning to lose most of its impetus in Western Europe, and the purpose of writing moved increasingly towards utilitarianism. A noteworthy exception were the manuscripts produced from the French Court of Louis XIV, especially those associated with the name of Nicolas Jarry (*c.*1615–1670) and the Court school of calligraphy under his influence. At the same time an enormous number of copy-books flooded the market, with Italian writing masters declining in favour of northern scribes. The fact that more people wanted, and were able, to write brought about a levelling down of standards. The writing master's

127 *John Ayres*, A
Tutor to Penmanship;
or, the Writing Master,
*London, 1698AD.
Ayers, who was one of
the best-known writing
masters of his time,
was a great protagon-
ist of the Round Hand,
though he could (as he
confidently announced)
command 'all the
variety of penmanship
and clerkship as now
practised in England'.
There are two interest-
ing variations of decor-
ated initials on this
page, one a plain
Roman letter over an
architectural drawing
and the other executed
in elegant and finely
drawn lines.*
BRITISH LIBRARY X425/
3011, P.93

position also declined (*see* p.81); he was no longer a calligrapher or even a craftsman, but a mere teacher. As the market grew more and more competitive some tried to attract pupils by ever more fanciful letter shapes, baroque decorations, and elaborate flourishes. But by the 18th century the accelerating demands of commerce, trade and colonial administration, especially in England, had created a need for a clear and fluent hand which was easy to read and easy to write (unlike the rather difficult 'Secretary hands' which had in the past been used for public and private documents). The main aim was no longer the development of an aesthetically pleasing, or even eye-catching style, but legibility. The growing importance of the commercial sector had in some way been foreshadowed in Arrighi's second publication *Il modo de temperare le penne* (1523) which had set out separate models of scripts for merchants, notaries, scribes designing apostolic briefs, and so on. Arrighi's publication also included two pages of type specimens [128], an illustration of a role writing masters added to their brief: that of the type designer.

The writing master/calligrapher acting as printer and type designer was to wield considerable influence. Originally masters such as Arrighi, Tagliente, Palatino (even Giovanni Francesco Cresci, despite his criticism of their work) had used the wood block to print calligraphic examples, but in 1571–74 Guilantonio Hercolani opened up a new controversy by using copperplate engravings for his *Essemplare utile di tuttu le sorti di lettere cancellaresche correntissime, et altre usate*. Though Hercolani himself employed this method with restraint, his decision had far-reaching consequences. The main tool for engraving is the burin, a short piece of sharpened steel which is held almost stationary while the copperplate itself is moved by the engraver's left hand; thick and thin strokes are the result of downward pressure. This method could imitate the extremely fine hairlines and elaborate flourishes, so cherished by writing masters anxious to impress prospective pupils with their virtuosity, much better than the wood block, and before long handwriting began to imitate printed models. Differentiations between thin and thick lines could now be achieved by varying the pressure of the nib and, if necessary, a line could be retouched and built up by a number of disjointed strokes. During the following century the new method was widely exploited; it became the inspiration for copperplate writing of the 18th century, and in due course the preferred script of the ever increasing army of clerks working in government offices and commercial houses. As a style it lacked individuality and character (though it looked pleasant enough), and in the opinion of many, copperplate writing, with its rigidity and lack of originality, bears much responsibility for the final decline of Western calligraphy.

It is also worth remembering that the calligraphy so avowedly propagated by the various writing masters in their copy-books was very often not their own true handwriting. Writing masters such as Urban Wyss, George Bickham and the above-mentioned Edward Cocker, who could double as master engravers, were the exception rather than the rule. Indeed, quarrels between

128 Janiculo's typesheet of the second Italic type of Ludovico degli Arrighi, which was engraved after his design by the goldsmith and medallist Lautritio di Meo Rotelli of Perugia; Italy, c.1529AD. Rotelli enjoyed a great reputation as a seal maker, a work which prepared him ideally for the cutting of metal punches (type); indeed Johann Gutenberg (c.1400–1468AD), widely credited with the invention of printing in the West, at one time was a goldsmith.

writing masters and engravers were exceedingly common and many copy-books are full of complaints about the way the author's style has been perverted by the engraver. This difficulty was inherent in the conventions of Western printing. Unlike in Chinese wood-block printing (*see* p.159), the author's calligraphy was copied rather than transferred, introducing problems of interpretation and ability between the writing master and his printed copy-book.

In the 19th century universal literacy became the aim and during that largely optimistic century its achievement seemed within reach. School-teaching was considered the proper way towards it and copy-books were now used in schools. This meant a further loss of individuality and even greater uniformity. The new Education Act of 1840 spread literacy to an increasingly wide cross-section of society and copy-books, teaching largely the same plain and rather dull script, became that thing so beloved by well-meaning Victorians: a tool for self-help and self-improvement. What those manuals taught was, however, no longer calligraphy but simply writing. In England the establishment of examinations for Government posts in 1855 led to a recommended 'Civil Service' style of writing based on what was com-

monly taught in schools; in America business schools sprang up (*see* p.199) designed to teach the best (that is, the simplest) type of script at the greatest possible speed.

But then calligraphy had always been largely utilitarian in the West, never a major art form which justified its own existence, bestowing status on those who had mastered it. Right from Roman times, and throughout the Middle Ages, calligraphy had served a practical purpose – either that of the Roman laws, as a mark of identity in the case of the newly emerging nation states after the collapse of Rome, and eventually as an aid to the apostolic mission of the Christian Church. With printing dominating the market, the overriding purpose of writing became commerce, and the achievement of happiness through acquisition. There was, in fact, no break but just a natural progression. To use a modern term, calligraphy, being no longer cost-effective, had simply been phased out.

The rise of computers

Technical conditions and pretended usefulness alone
never create humane forms.
JAN TSCHICHOLD, DIED 1975

This brings us to the most recent, non-traditional mode of printing: printing by computer, and with it the possibility of producing letterforms by electronic means.

When computers were first introduced in the 1940s they were hardly more than efficient instruments for manipulating numerical data, admittedly at an up-to-then unheard of speed. As the new information technology advanced, computers grew more and more sophisticated, storing a vast amount of information and providing them on request in an orderly, 'intelligent' fashion. By the 1970s, with the development of pattern recognition (the ability of the computer to correlate data in its memory bank to a given situation) and expert systems (the use of what is referred to as an artificial intelligence) computers began to play an increasingly more important role in practically all spheres of life, and in consequence they were soon considered the panacea for a vast host of problems. Just as printing had replaced the manuscript, so computers, it was thought, would soon replace not only writing but also printing; and, in addition, with the ability to design one's own alphabet, every user could become his or her own type designer and somehow also his or her own calligrapher [129]. By the end of the 1960s there was enthusiastic talk about the 'electronic knowledge warehouse' (that is, library), the 'paperless' office and with it the rise of a new 'bookless' society; indeed the

129 Desktop publishing invades the scriptorium. A Christmas card (CARE) produced in aid of 20 charities.

Canadian Marshall McLuhan (1911–1981) not only confidently forecast the end of the book but named 1978 as the year of its final demise.

In the meantime, however, realism has set in. Despite the advances of desktop publishing, the printed book is still very much with us, as is paper; the electronic warehouse, even if technically possible, is financially far beyond everybody's means (especially if this would mean retrospective conversion of large library stock). Moreover, the artificial intelligence of the computer has its own limitations; so to be one's own calligrapher with the use of a computer, one must first of all be a calligrapher oneself.

Desktop publishing which was to revolutionize book production by enabling everybody to be his own publisher (managing not only the text but also the layout of the page and updating the electronic book as the need arose instead of producing new and expensive editions) is indeed within the reach of every computer-literate user who owns the appropriate appliance. Computers, even quite simple word processors, provide furthermore a choice between a number of different alphabets; as far as the actual print-out facilities are concerned great advances have been made since the early dot-matrix, grid-based alphabets. Indeed, more sophisticated machines allow users to design their own letterforms and to create typefaces based on personal handwriting [130, 131]. It is, however, here that the difficulty arises.

Western calligraphy and good typography have to a large extent always been based on an awareness, and successful manipulation, of letterforms. Since little importance is accorded to the study of letterforms in today's primary and secondary education, an appropriate knowledge, let alone the ability and the necessary training, is not likely to be found among the bulk of

aa aa aa
aa aa aa
aa aa aa
aa aa aa
aa aa aa

130 Computers have reduced the cost of developing new typefaces. Thirty primary Multiple Master fonts, from which almost infinite variations can be created. REPRODUCED WITH PERMISSION FROM ROSEMARY SASSOON'S *COMPUTERS AND TYPOGRAPHY*

Typeface for first reading books

h u y g b f v t i e

k p r copyright R. Sassoon 6.3.85

He was right out of the water and away from the waves and he lay still. He rolled on to his back, and lay very still. He lay there for a long time. He blew and puffed, and lay there on the sand. And as he lay there, the wind blew more softly and the clouds began to blow away. There was a little blue sky. The sun began to shine a little.

computer users. Moreover, to produce, write and design letters is not a natural ability nor something that can be simply acquired, it demands flair, talent and training. In other words, while everybody can learn how to write, not everybody can become a calligrapher. While everybody can learn how to use a computer, one has to be taught, and have the ability, to become a type designer. Without good type designing, computer printouts cannot hope to rival good printing, let alone calligraphy. This of course does not mean that an excellent calligrapher cannot hope to produce good calligraphy with the aid of a continuously improving computer technology and disseminate his or her work through desktop publishing in the way writing masters once used printing to propagate their craft.

131 Rosemary Sassoon's Primary Type (now widely used for school books), from the first sketch to a final text sample. Since most typefaces are designed for adults, children were asked which special letterforms and what spacing they preferred and found easier to read. REPRODUCED WITH PERMISSION FROM ROSEMARY SASSOON'S *COMPUTERS AND TYPOGRAPHY*

132 *An example looking back to uncial and half-uncial letter forms of earlier centuries* from Feder und Stichel: Alphabete und Scriftblaetter in zeitgemaesser Darstellung, Geschrieben von Hermann Zapf. In Metal geschnitten von August Rosenburg. *Frankfurt, 1949.*
VICTORIA AND ALBERT MUSEUM, L 24422–1955

In der still zurückhaltenden/
edel.durchgebildeten/aufs tiefste
in jeder bewegung erfühlten schriftform
suchen wir uns und unser zeitgefühl.
auszudrücken

Rudolf Koch

133 *Hermann Zapf's final design for his typeface* Civilité. *Zapf (born 1918), who had originally been influenced by the calligraphy of both Rudolf Koch and Edward Johnston, entered the printing house of Koch's son, Paul in 1938; since then he has designed some 175 typefaces for hand and photo composition and digital laser systems. He uses calligraphy as a basis for all letter-crafted disciplines and his typefaces are now one of the most widely used. (The type used for this book is in fact Monotype Zapf.)*
REPRODUCED WITH MR ZAPF'S PERMISSION

W. Yeo

CALLIGRAPHY NOW

The western revival

In recent years England has seen a notable revival of Calligraphy, that is to say of beautiful and formal handwriting. This revival has already had echoes on the continent and in America and bids fair eventually not only to lead to the wide production of highly finished manuscripts for those who can afford them, but also to influence for good, through school-teachers and improved copybooks in many countries, the types of handwriting and lettering now in vogue.
SIDNEY C. COCKERELL, 1914

The 20th century has indeed seen a remarkable revival in Western calligraphy: exhibitions, publications (books and journals), the foundation of professional societies, teaching courses at Polytechnics and Art Schools, and a widening circle of sometimes highly gifted amateurs and fine professional scribes engaged in practising the craft. The motivation for this new trend goes back to a number of movements and sentiments which made themselves felt during the last century. A decisive factor was without doubt the growing reaction against certain negative aspects of the Industrial Revolution such as the domination of everyday life by shoddy, machine-made and mass-produced objects without any inherent value. This engendered a nostalgic yearning for the past which in turn promoted an interest in medieval art and craftsmanship – sentiments intellectually underwritten by the philosophy of John Ruskin (1819–1900) and artistic movements such as the Pre-Raphaelite Brotherhood. Twentieth-century calligraphy emerged, rooted in the stimuli generated by the Arts and Crafts Movement of the 1880s and 1890s, and the individual work of William Morris and, most of all, Edward Johnston.

After around 1870 the poet and artist William Morris (1834–1896) – until then much occupied with creating designs for wallpapers, glass, textiles, tapestries and print – began to write and illuminate medieval and humanistic-style manuscripts. Over much of the next decade he experimented with various scripts, studying scribal techniques and using quill and parchment to achieve results. His calligraphy showed good rhythmic quality

Calligraphic brush-work in a painting by Wendy Yeo (see *163*). REPRODUCED WITH PERMISSION OF WENDY YEO

LOVE FULFILLED.

HAST thou longed through weary days
For the sight of one loved face
Hast thou cried aloud for rest,
Mid the pain of sundering hours
Cried aloud for sleep and death
Since the sweet unhoped for best
Was a shadow and a breath —
O long now for no fear lowers
O'er these faint feet-kissing flowers
O, rest now; and yet in sleep
All thy longing shalt thou keep.

Thou shalt rest, and have no fear
Of a dull awaking near,
Of a life for ever blind,
Uncontent and waste and wide,
Thou shalt wake, and think it sweet
That thy love is near and kind.
Sweeter still for lips to meet;
Sweetest, that thine heart doth hide
Longing all unsatisfied
With all longing's answering
Howsoever close ye cling

but less understanding of the shapes of letters and their inner relationship. Nevertheless his manuscripts [134], and the research and patronage connected with his work, created much interest and opened the way to the calligraphic reforms of the 20th century, and with it a general revival of the craft. In 1890 Morris founded the Kelmscott Press and successfully tried his hand at engraving, type designing and high-quality printing. In due course he became one of the moving spirits behind the foundation of the Central School of Arts and Crafts (originally founded by the architect, designer and educationalist William Richard Lethaby) where eventually Sir Sydney Carlyle Cockerell (1867–1962), once Morris's secretary, taught lettering and calligraphy. But the person most decisively responsible for the revival of

135 A page from Edward Johnston's Manuscripts & Inscriptional Letters. For Schools & Classes & for the use of Craftsmen, *first published in London 1909*AD. *Johnston had originally based his style on some 10th-century* AD *manuscripts of the Winchester School but in later life he also experimented with a variety of Gothic and Italic hands. One of his discoveries was that the broad-edged pen made thick and thin strokes by direction rather than pressure.*

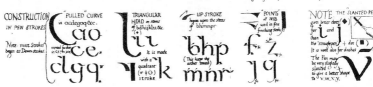

Western calligraphy was Edward Johnston (1872–1944) who, impressed by Morris's ideas, abandoned his study of medicine to become a scribe and in the process rediscovered the lost technique of writing. Johnston realised that the nature and form of script were determined by the way the pen was held [135], and that the proportions of a letter were in direct ratio to the breadth of the pen's edge which, if trimmed chisel-wise, could produce that range of graduation from the thickest of strokes to the finest of hairlines which characterize the best medieval works he had so carefully studied in the British Museum Library (now The British Library). In 1899 Johnston began to teach in London, first at the Central School of Arts and Crafts and, later, at the Royal College of Art. As a teacher Johnston had a decisive influence on 20th-century

calligraphy and typography, particularly in England and Germany. His pupils included Anna Simons (who was to introduce his method in Germany, Austria, Switzerland and the Netherlands; *see* p.85), Eric Gill [136], Noel Rooke, William Graily Hewitt, Percy J. Delf Smith (who became the honorary Secretary of a short-lived Society of Calligraphers) and T.J. Cobden-Sanderson (who founded the Doves Press which together with Morris's Kelmscott Press greatly increased the status of book production by commissioning calligraphers to design the type).

Other art schools followed the example of the Royal College of Art and offered courses in lettering and writing. The first was Birmingham, Leicester College of Art was the next and eventually the subject became part of the curriculum in art schools throughout the country. Type design (for long in the control of engineers) passed into the hands of artists and calligraphic scholars such as, for example, Stanley Morison, Jan van Krimpen, Bruce Rogers, Victor Hammer and others. By selecting fine alphabets for font material, they ensured that those alphabets were used not only for books (printed as well as manuscript) and book covers, but also in the sphere of the private

136 The four Gospels, Golden Cockerel Press, 1931, by Eric Gill. The initial letters and opening words of chapter two of the Gospel (St Matthew's), with a wood engraving showing the three wise men with the Virgin and child. Typography, engraving and design by Eric Gill.

market. Indeed Johnston himself did some of his best work – church service books, wedding gifts, presentation addresses and the like – in the course of commissions from private patrons and public bodies. Calligraphy had indeed always been in demand for this type of work but now it received a new impetus and in the hands of the most talented scribes, a new quality. Johnston's first book , *Writing & Illuminating, & Lettering* published in 1906, consisted of 500 pages illustrated with his own and Rooke's drawings and reproductions from historic manuscripts. It was instructive, stimulating, technically helpful, and in due course it became an important handbook for calligraphers not only in Great Britain but also in Germany, America and in places as far afield as Australia. Other writing manuals followed: in 1909 Johnston's other major work, a portfolio *Manuscript and Inscription Letters*; then Graily Hewitt's *Handwriting Manual* (1916); eventually (in 1932) Alfred Fairbank's *A Handwriting Manual* and (in 1955) J.H. Benson's *The First Writing Book: Arrighi's 'La Operina'*, both going back to the early copy-books of the Italian masters. Although America was in general about a decade behind Britain in organizing an effective arts and crafts movement, it had developed its own tradition of writing manuals (*see* p.199); for example, Frank Chouteau Brown's *Letters and Lettering: a Treatise with 200 Examples*, a highly sophisticated work, had appeared in Boston four years before Johnston's first book.

The manipulation of letterforms has always been at the heart of Western calligraphy and the 20th-century revival of the craft was closely connected with a reform of letter carving (NG; p.202). In England this reform, largely promoted by Eric Gill (who provided plates for Johnston's second book), based itself to a considerable extent on the Roman lettering on Trajan's column; analysed in detail, such letters were soon taught in every art school and became models for sign writing, street names, memorials, foundation stones, and so on.

This newly conscious use of letterforms touched other aspects of life too. On the continent of Europe graphic artists, painters and, after the destructive violence of the First World War which put into question the optimism of previous experiments, politically-motivated groups of artists such as, for example, the Dadaists, the Constructivists, and eventually also the more positive Bauhaus, began to make use of lettering. The aim of the Dadaists, a nihilistic group of artists, founded in 1917 in Zurich, was to demolish current aesthetic standards which they linked with bourgeois values, and seeing letters as the normal expression of a conventional society, they began to turn them into instruments of attack; the chaos of typefaces used for their magazine *Dada* illustrates the message. The Constructivists on the other hand used the disposition, the size and the weight of the components of individual letters to create unique abstract patterns which they saw as a representation of the contemporary machine age and the new revolutionary order in Russia which had replaced the decadence of the past. Their work embraced posters,

advertisements, letter and newspaper headings; their preferred letterform was sans serif, a functional letterform without historical commitment. The most important focal centre for such new experiments was, however, the Bauhaus which flourished in Germany between 1919 and 1933. Its aim was to end the schism between art and technically-expert craftsmanship, mainly within the environment of architecture, but also by teaching typography in order to find new and positive letterforms. Among the best results were a practical machine alphabet typeface called Universal (Herbert Bayer, 1925) and Paul Renner's Futura Sanserif.

Painters too began to treat letters as an important part of their visual vocabulary. Cubists, Surrealists and the then fashionable Collagists began to include single letters or fragments of newspaper in their paintings. The 'secret writing' pictures of Paul Klee (1878–1940) and Max Ernst (born 1891) employed the principle notion of (still legible) writing which turned towards more abstract brush movements in the hands of such artists as Mark Tobey (*see* p.216) and Hans Hartung (born 1904). Letters in a painting were used to underline a theme, add a message and with it become an integral part of a picture itself; or they could simply provide a visual effect by using the idea of layout linked to meaning. A good many artists have used (and are using) lettering in this way, from Pablo Picasso (1881–1973) and Joan Miro (born 1893) to Franz Kline (1910–1962), who under De Kooning's influence developed his characteristic action paintings of slashing black and white calligraphy, and eventually Andy Warhol (1928–1987) and the Pop Art movement. Pop Art, which emerged in the 1950s, set out to challenge conventional ideas of good taste and the hermetic inviolability of art itself; the use of letters is often in the form of advertisements and billboards, reminiscent, at times, of the early Constructivists.

In 1915 the London Transport Services commissioned Johnston to design a new alphabet for its publicity and signs. The result was his sans serif block-

137 In 1915 Edward Johnston received a commission to design a special type for the use of London Transport Services. The result was a block-letter alphabet based on classical Roman proportions which, during the coming decades, exerted considerable influence on the choice of letterforms used in advertising; Johnston's original letters can still be seen all over London.
PHOTOGRAPHED BY HILARY HENNING AND RICHARD KENNEDY

138 A collection of advertisements; from a scrapbook belonging to Miss Kathleen Strange.

letter alphabet based on classical Roman proportions which became the inspiration for many such types [137]. By reaching commerce, calligraphy and lettering began to play an important role in everyday life and in the everyday business of people. Newspapers, journals and magazines began increasingly to display more lavish and in many cases well-written and composed advertisements [138]. It is in the field of commercial advertising that some modern scribes have found a lucrative outlet. There are shop signs, billboards, house signs, cards marking various occasions [139], menus, invitations, tombstones, posters, record sleeves, book jackets [140], wrapping paper [141], shopping bags, T-shirts [142], corporate logos, specially designed initials [143], TV-titles and the wide variety of neon signs illuminating our cities at night – the examples are more or less endless.

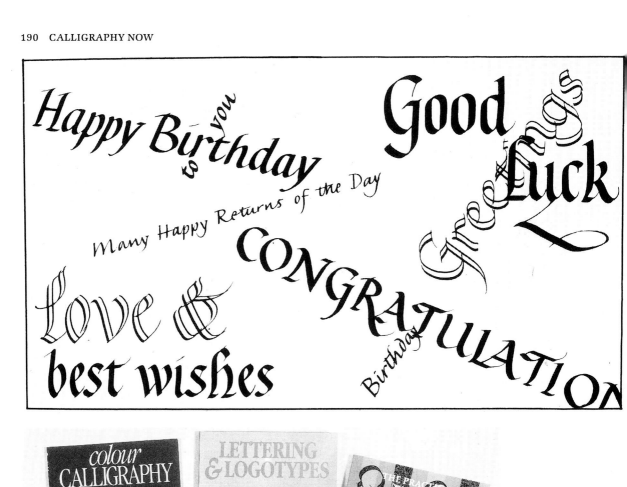

139 A single-colour birthday card using different styles of script, in different sizes, and an imaginative layout to much effect.
REPRODUCED WITH PERMISSION FROM ROSEMARY SASSOON'S, *THE PRACTICAL GUIDE TO CALLIGRAPHY*

140 Book jackets offer a wide range of possibilities for the use of a variety of scripts, colours and layouts.
PHOTOGRAPHED 1994

141 Fine writing, calligraphy and pen-drawn pictures have been used widely and effectively for advertising. Design for a wrapping paper.
REPRODUCED WITH PERMISSION FROM ROSEMARY SASSOON'S *THE PRACTICAL GUIDE TO CALLIGRAPHY*

142 Decorating T-shirts with words or short messages has become more and more popular over the years. In fact the practice follows well-established traditions: for example, the garments used by Christian priests during mass, coronation robes, and the shirts inscribed with messages of the Koran.
PHOTOGRAPHED BY HILARY HENNING AND RICHARD KENNEDY

143 Variations of the letter A. Elaborate decorated initials have always been a key note of Western calligraphy. Printers followed similar traditions and eventually, in the 19th and 20th centuries AD, commercial artists and advertisers did the same.
BY COURTESY OF MISS KATHLEEN STRANGE

On the whole the successful revival of calligraphy during the first half of the 20th century was based on three inter-related factors: the teaching of lettering and calligraphy in art schools and polytechnics; the growing number of exhibitions which introduced the subject to a much wider audience and by doing so created further interest; and the various societies, journals and books which encouraged standards and invited active practice.

In 1921 Edward Johnston's pupils and successors working at the Central School of Arts and Crafts founded the Society of Scribes and Illuminators which produced an excellent and still active journal [144] of worldwide distribution; a year later the Society held its first public exhibition. This was soon followed by the creation of smaller research groups to study particular problems and techniques related to calligraphy, such as writing on skins, preparation of inks, methods of gilding, or styles of cursive handwriting. The findings of these groups eventually provided the basis for the compilation of the first *Calligrapher's Handbook* during the 1950s (HC; p.31). Several members of the Society (such as Alfred Fairbank and Joan Kingsford) wrote manuscripts for private patrons, some of which can now be seen in national museums and libraries. In 1931 the Society arranged, in co-operation with the Victoria and Albert Museum, an exhibition of 'Three Centuries of Illuminated Addresses, Diplomas and Honorary Freedom Scrolls' with contributions by Edward Johnston, Graily Hewitt, Ida Henstock, Laurence Christie, Daisy Alcock and other contemporary scribes. Further exhibitions followed, a good many of which were subsequently taken to America (New York, Boston, Chicago) and the continent of Europe (Paris, Copenhagen, etc). The end of the Second World War created demand for Rolls of Honour for the Services which lasted well into the 1960s. In 1951 the Society, together with four other major crafts societies, and aided by a small Government grant, founded the British Crafts Centre under the chairmanship of John Farleigh. The Centre provided stability and, over the next decade, launched a series of major exhibitions.

Had Sidney Cockerell's forecast, made so confidently in 1914, been fulfilled? Yes and no. The middle of the 20th century did indeed see a general revival of all major crafts, art schools expanded, but (an uneasy coincidence) almost simultaneously, calligraphy as a subject was dropped from the curriculum, since it was held to have no useful role to play in industry; indeed, within a decade, very few art schools taught it as a subject. But by then a large number of professional, and some of the amateur, scribes were producing very good work. In addition, several calligraphic societies flourished, the most important one being the Society for Italic Handwriting founded in 1952 under the direction of Alfred Fairbank. The year 1971 saw the establishment of the Government-funded Crafts Council which provided grants and bursaries. Calligraphy was also flourishing in other European countries and, even more so, in America. The exchange of exhibitions and teachers encouraged new ideas and provided additional stimulus.

The Scribe

JOURNAL OF THE SOCIETY OF SCRIBES AND ILLUMINATORS

Summer 1988 Number 43

ISSN 0265-6221

144 Cover of The Scribe, *Journal of the Society of Scribes and Illuminators (1988). An example of the German calligrapher, painter and book artist Hans-Joachim Burgert's work. In Burgert's (born 1928) opinion letterforms and the arrangements of words in a printed text should not just be a succession of mechanical symbols, but the text should also be enriched by a symbiosis between visual symbols and meaning. Some, though by no means all of his calligraphic compositions are definitely illegible. The text here reproduced is from Genesis 1:31 and reads 'Und Gott sah alles was er gemacht hatte und siehe es war sehr gut').*

What did not materialize was the general improvement in everybody's handwriting, incidentally also one of the declared aims of Fairbank's Society for Italic Handwriting. Despite much individual effort, such as Rosemary Sassoon's Johnston-based Foundational Hand, and, most recent and perhaps most promising, the attention given to the subject in Britain by the New National Curriculum, standards have, if anything, declined. The tools used for writing (biro, ball point, and so on) and the inroad into everyday life made by computers, telex, fax, and telephone have not helped. In fact, in many cases, typeface seems to be the only acceptable form of formal writing, handwriting itself becoming all too often an ill-defined, ill-disciplined 'cursive' which hardly serves the purpose of communication. But then Cockerell's forecast and the optimism of the largely politically-thinking early reformers (who believed that it was human nature to improve, that people, once shown a particular way and encouraged to move into a particular direction, will eventually do so of their own accord) had always been based on a misunderstanding. Good handwriting is not the same as calligraphy, but even good handwriting had in the past been a necessity only for the copyists/clerks, and the need for good copyists (and even clerks) has long since gone. Calligraphy is also not an accomplishment that can simply be taught to willing adults and less willing schoolchildren; it requires talent, originality and dedication. In addition, though we still need good and legible handwriting, we no longer need it in quite the same way as in the days when thousands of diligent clerks laboured in commercial houses and Government offices. In fact, handwriting has ceased to be the most essential means of communication and information storage. But this should in no way blind us to the real achievements of contemporary calligraphers and the fact that modern calligraphy, especially work produced after the 1950s (*see* p.216) has remained alive to contemporary streams of thinking and reflects much of our attitude to life and society.

Continental Europe

The 20th-century revival in the art of writing and lettering was not restricted to Great Britain. Parallel (and not always unconnected) movements occurred in other parts of Europe, most notably Austria and Germany.

In Austria the main exponent of this new trend was Rudolf von Larisch (1856–1934) whose work in the Imperial Chancery in Vienna had given him ample opportunity to study historic manuscripts and compare the various hands he found there with (less impressive) contemporary standards. His pamphlet *Zierschriften im Dienst der Kunst* ('Decorative lettering and writing in the service of art'), published in 1899, led, three years later, to a teaching appointment in lettering at the Vienna School of Art and, with it, to a position

Jupiter und Apollo stritten, welcher von ihnen der beste Bogenschütze sei. Laß uns die Probe tun! sagte Apollo.-Er spannte seinen Bogen und schoß so mitten in das bemerkte Ziel, daß Jupiter keine Möglichkeit sahe, ihn zu über;

24. ¹/₂ der Originalgröße. Vereinfachung einer bestimmten Buch-stabenform. Stahlfeder.

Am andern Morgen fiel starker Schnee. Ein-scharfer Ostwind fegte ihn über die Heide, über die Marsch ins Meer. Wenn aber die kleinen, vom Winde gejagten Flocken einen Halt fanden und war es auch nur ein Heidestrauch oder ein Man!

25. ³/₄ der Originalgröße. Gewöhnliche Schreibschrift eines Kursteilnehmers. „Grenzen" der gewöhnlichen Schreibschrift.

wöhnliche Schreibschriften sehr dekorativ wirken können. ■
■ Bei solchen Schriften kann am ehesten eine Anlehnung an Vorbilder Platz greifen. Je mehr sich der ornamentale Schriftcharakter der ge-wöhnlichen Schreibschrift nähert, umso gerin-ger ist die Gefahr, daß durch Kopiatur das Handschriftliche verloren geht. Selbst in den

145 Rudolf von Larisch, Unterricht in ornamentaler Schrift, Vienna , 1911. The early 20th century witnessed a renewed interest in calligraphy, not only in Britain but also on the conti-nent of Europe. Von Larisch, originally an official at the Imperial Court in Vienna, published his first book (Zierschriften im Dienst der Kunst) seven years before Edward Johnston's pioneering work, but soon equalled the latter's standing in his native Aus-tria. Unlike Johnston, he believed that calligraphy did not rest on the study of historical hands, but was a natural vehicle for crea-tive self-expression. Though von Larisch and Johnston held differ-ent views, and encouraged different teaching methods, in 1909, when meeting in London, they found themselves in mutual sym-pathy.
VICTORIA AND ALBERT MUSEUM, L825–1912

of influence [145]. His most important work *Unterricht in Ornamentaler Schrift* ('Instructions in decorative writing and lettering'), published in 1906, further extended the scope of his studies and had considerable influence in German-speaking countries. Historically and geographically Vienna has always stood at the border between East and West and von Larisch's approach reflected this duality: unlike most Western scribes who concentrate on the outward manipulation of letterforms, he held that the calligrapher should express intuitive feelings in his work and that the pattern of letters on a page should be in harmony with the rhythm of writing and also with the material used (von Larisch encouraged the use of glass, metal, textiles, wood, and pottery).

In Germany the revival of calligraphy was largely based on the work of Rudolf Koch (1874–1934) and on the teaching of Johnston's star pupil, Anna Simons (*see* p.85). Koch combined tradition and inventiveness in the use of Gothic letterforms (always a German favourite, though by then Roman types too were coming into regular use); he was an excellent teacher, creating a highly successful and influential Workshop Community in his native Offen-bach, but reserved his best work for type designs. Whereas Johnston had seen writing as the central discipline of his craft, Koch gave this place to lettering in the broadest sense. Koch inspired a whole generation of art teachers, type

146 Friedrich Poppl, Quotation from Ludwig Feuerbach, 1960. The script sug-gests quick and free pen movements, and a fine sense of spacing, but the overall effect is one of discipline. Poppl, who died in 1982, was a member of the Arts and Crafts School at Wiesbaden, Germany, and later also Profes-sor at the Technical College there. He specialised in designing alphabets for typeset-ting and photoprinting. Interesting is the white-on-black effect.
VICTORIA AND ALBERT MUSEUM, MS CIR. 164–1966)

Die Bücher sind anzene
Kapellen, die der Mensch in den
wildromantischen Gegenden des
Lebens auf den höchsten und
schönsten Standpunkten errich-
tet, und auf seinen Wanderungen
nicht bloß der Aussicht wegen,
sondern hauptsächlich deswegen
besucht, um sich in ihnen von
den Zerstreuungen des Lebens
zu sammeln und seine Gedanken
auf ein anderes Sein, als nur das
sinnliche, zu richten.

LUDWIG FEUERBACH

designers, calligraphers, wood engravers and illustrators. In Europe the link between art schools, printing houses and the workshop of craftsmen had always been much closer than in Great Britain (HC; p.74) and most early pioneers in the field of calligraphy were also type designers of some note. This dual tradition is still alive in the work of such calligrapher/type designers as Friedrich Poppl (born 1923; 'calligraphy will always remain the starting point for script design'; [146], Walter Kaech, Imre Reiner, Karl Georg Hoefer [147], and, perhaps most prominent, Hermann Zapf (b.1918) [132, 133].

In the Netherlands this claim goes to Jan van Krimpen (1892–1958); in Czechoslovakia to the book artist and calligrapher, Oldrich Menhart (1897–1962); in Estonia to the versatile Villu Toots (born 1916); and in Scandinavia to Erik Lindegren whose survey of *Lettering and Printing Types* was published in 1975. All of them looked for a way to link tradition with new means of expressing letterforms; in the words of the German calligrapher Gottfried Pott, 'it is our goal to maintain contact with great writing traditions and at the same time to realise new impulses of our time'.

147 Karl Georg Hoefer, Pinselstudien (Brush studies), 1962. Written on paper in the form of a Japanese book, with coloured inks and gold. The work contains a variety of alphabets ranging from formal square capitals to an at times almost unre-cognisable script. The use of the brush and the highly cursive way of writing (and connecting) individual characters are remi-niscent of Far Eastern traditions.
VICTORIA AND ALBERT MUSEUM, MS L 136–1966

North America

American calligraphy, at first largely based on practical considerations, goes back to a desire for improved handwriting and the availability of imported English manuals such as William Mather's *Young Man's Companion* (London, 1681) which taught an English version of Italian Humanistic mixed with remnants of the older Gothic Secretary hand. Edward Cocker's (*see* p.173) books were well known, though it seems those of John Ayres (*see* p.176) less so. The first known American-printed manual for handwriting appeared in Philadelphia in 1748 under the imprint of Franklin & Hall. This was George Fisher's *The Instructor, or American Young Man's Best Companion, containing Instructions in Reading, Writing and Arithmetic and many other Things beside the Art of making several Sorts of Wines* which gave (when not dealing with 'several sorts of wines') examples of 'Round Hand', 'Flourishing Alphabets', 'Italian Hand' and 'Gothic Secretary'. Benjamin Franklin was quite frank about the fact that most of the book (except for the writing models) had been pirated from an early (1725) well-known English work, declaring, somewhat loftily, that the 'British edition contained many things of no interest to those living in these parts of the world,' therefore 'in their place I have inserted other matters more immediately useful to us Americans'. (SM; p.18).

Pride of place among American copy-books is usually given to the work of Abiah Holbrook (1718–1769; who also trained a group of young Bostonians in his South Writing School) which appeared under the title *The Writing Master's Amusement. A New Alphabet in Knot-work: adorned with a Variety of Scripture-Pieces, written in all the Hands of Great Britain, and embellished with Borders, the Whole performed with the Pen* (1767), propagating basically a fine version of English copperplate. Other copy-books (or treaties on handwriting) followed, such as for example W. Dawson's *The Youth's Entertaining Amusement* (Philadelphia 1754); Christopher Sower's *Hoch-Deutsch Amerikanische Calender* (Philadelphia 1755); Thomas Powell's *The Writing Master's Assistant* (1764); and (most important) the first extant purely American-designed, made and produced copy-book, namely John Jenkins's *The Art of Writing, reduced to a Plain and Easy System. On a Plan entirely New* (Boston, 1791). Jenkins's [148] book taught an orthodox version of the English unlooped Round Hand to the 'Gentlemen and Ladies and to the Young Masters and Misses throughout the United States' (SM; p.19).

During the 19th century attempts to improve handwriting led to the creation of several 'systems' (that is, methods of teaching) and 'colleges' where they could be taught. In fact, during the first half of the century, over 100 writing masters were distributing copy-books which taught rapid writing (a 'Running Hand') to men of business (DJ; p.142). After the 1960s these were distributed by mail order and in the form of self-instructors. Among the first

C Noyes.

THE
Art of Writing,
Reduced

Plain and easy *To a plain entirely*
SYSTEM *new.*

To a

in seven books

BY

John Jenkins Writing Master.

Revised *enlarged* *Improved.*
Book I.

Containing a plain easy and familiar

Introduction,

Which may be considered as a GRAMMAR to the ART.

Writing is the Key to Arts and Sciences, the Register & Recorder of them all.
It is the life and soul of COMMERCE, the Picture of times; Rule of futurity. *Moore*

CAMBRIDGE,
1813.
Printed for the Author.

148 John Jenkins, The Art of Writing reduced to a plain and easy System, *1813. Jenkins, who was self-taught, based his system on the theory that the Round Hand could be divided into six basic strokes of the pen. He believed that once those had been mastered everybody would be able to write a good and legible hand.*
VICTORIA AND ALBERT MUSEUM, L 619–1916

manuals to propagate this style were Henry Dean's *Analytical Guide to the Art of Penmanship* (Salem, 1894) and Benjamin Howard Rand's *A New and Complete System of Mercantile Penmanship* (Philadelphia, 1814). Other writing masters followed suit, some enjoying an exceedingly wide readership. In 1830 Benjamin Franklin Foster published his *Practical Penmanship being a Development of the Carstairian System* which sold some two million examples in America, England and France. Strangely enough, in Europe Foster's script became known as the 'American system' though it was in fact heavily influenced by the Englishman Joseph Carstairs's invention of the 'talanto-

149 *Platt Roger Spencer's* Spencerian Key to practical Penmanship, *published by his sons in 1866, two years after his death. Spencer concentrated on the business hand but a good number of his examples were derived from Benjamin Franklin Foster.*
VICTORIA AND ALBERT MUSEUM, L 612–1916

graph' (a method by which a ribbon was tied around the thumb and the first and second fingers to force the unfortunate pupil to use his whole forearm and not just his hand).

Well known and commercially successful was the Spencerian College of Penmanship and Business which dominated the market for some 35 years. Founded by Platt Roger Spencer (1800–1864) in Ohio it propagated a sloping, semi-angular style, which was rapid and legible while at the same time lending itself quite easily to embellishments [149]. Spencer himself had begun to teach handwriting at the age of 15 (having become dissatisfied with

the scripts he saw on village notices) and he and his five sons ran the college (and eventually a chain of such colleges in 44 cities) from a log cabin at the family farm while at the same time travelling around the country to teach at various academies. Beside his regular style, Spencer offered a reduced version which he called 'ladies' hand' and in 1848 published *Spencer and Rice's System of Ladies' Epistolary and Ornamental Penmanship, carefully prepared for the Use of Public and Private Schools and Seminars.* Loops and flourishes and an extended slant were gradually considered more suitable for the female sex (*see* p.84), a concept successfully exploited by Jenkins and later used by Benjamin Foster who in 1829 became Master of the Art of Writing at the Female Academy at Albany, NY. As the 19th century progressed competition mounted between those who emphasised a plain practical business hand and others who delighted in flourishes which could occasionally lead to such extravagance as quill-written pen pictures of animals, humans and the portraits of national heroes; as time passed the 'flourishers' grew however increasingly more defensive. Another successful 19th-century writer/entrepreneur was Charles Paxton Zaner who in 1888 founded the Zanarian College of Penmanship, also in Ohio (Columbus). He abandoned the shading of letters altogether and taught a uniform thickness of line to encourage speed; this eventually produced a 'commercial cursive' or 'business hand', which, like copperplate in the 'Old Country', soon found favour amongst those anxious to advance their career prospects. Other such colleges, for example the Iowa Corporation, founded by Austin N. Palmer in 1894, promoting a good and legible handwriting 'among the Youth of our Country', followed.

Modern American handwriting derives thus largely from the teachings of H. Dean, B.F. Foster, P.R. Spencer and A.R. Dunton (who was involved in a lengthy dispute with Spencer – American writing masters being often as quarrelsome as their European counterparts). At the beginning of the 20th century the Italic style and the use of the broad-edged pen were greatly advanced by Frances M. Moore, who after having studied in London under G. Hewitt, published her manual in 1926. Since then it has been mainly the formal and semi-formal Italic hand that has made headway in the United States (HC; p.103), finding favour not only as a model for everyday handwriting but also amongst those actively engaged in the pursuit of calligraphy. In the beginning it took some effort to convert teachers and pupils to this style; more recently such books as Fred Eager's *Italic Way to Beautiful Writing* (1974) have given further impetus in this direction.

Apart from English copy-books individual immigrant groups brought their own styles which were often cherished together with other forms of folk art by their descendants as part of their ethnic identity. The Pilgrim Fathers had brought contemporary English scripts (Gothic Secretary and a mixed Secretary/Italian hand), and trade between the two continents introduced in due course contemporary French and Dutch styles. Under the influence of

150 Birth certificate written in the local Dutch (Deutsch) Pennsylvanian style called Fraktur and decorated by a watercolour border and stylized flowers in red, yellow and green. This style, which was first defined in Johann Neudoerffer's copy-book (Nuremberg, 1538), dominated the German-speaking countries for the next four centuries; in the 18th century a version of it was transplanted to America by German immigrants.
THE AMERICAN MUSEUM IN BRITAIN, BATH

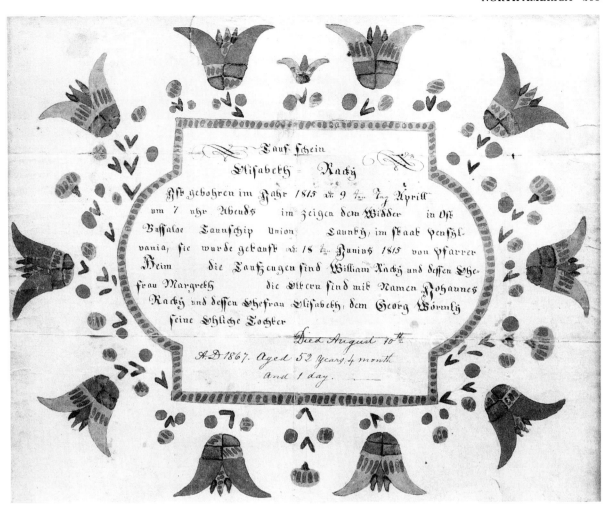

visions, the Shakers, believers in Christ's Second Appearance, who had come to America in 1774, produced elaborate spiritual manuscripts. Another interesting example is a style generally referred to as Fraktur [150] which originated amongst the Moravian and Mennonite settlers in Pennsylvania. Used mainly for certificates (baptism, marriage, birth), house blessings (*Haussegen*) and as examples of fine penmanship (*Vorschrift*) it based itself on the fairly austere contemporary German Gothic hand but acquired an appealing element of naivety by combining lettering with bold, colourful and often symbolic designs. In vogue between the mid-18th and the mid-19th century it also became an inspiration for wall decorations in Pennsylvanian farmhouses.

At the beginning of the 20th century, several attempts were made to reform not only handwriting but also lettering and type design. Such reforms centred mainly around men like Frederic W. Goudy (1865–1945), Bruce Rogers (1870–1957) and, most important of all, William A. Dwiggins (1880–1956), a well-known type-designer whose calligraphy owed little to European influence but showed great gaiety, character and originality. In 1925

Dwiggins formed a wholly imaginary 'Society of Calligraphers' (an early practical attempt having failed to win sufficient supporters) and issued beautiful certificates of honorary membership to a number of people in the field of publishing and graphic arts whom he thought worthy of such recognition. But the contact with Britain continued. In 1913 Ernst Frederick Detterer (died 1947) of Chicago came to London to take private lessons with Edward Johnston. After his return to America he began to establish a calligraphic tradition of formal penmanship, especially in the Mid-West, and in 1931 became Curator of the John M. Wing Foundation at the Newberry Library in Chicago where he founded a Calligraphy Study Group which greatly influenced the development of American calligraphy. A very versatile calligrapher was John Howard Benson (1901–1956) from Rhode Island who studied in New York at the National Academy of Design at a time when lettering had not yet gained a recognised place in art education. In 1950 he published a manual (*Elements of Lettering*) and five years later a translation (the first in English) of Arrighi's *La Operina* (*see* p.71). Other influential teachers and calligraphers were Arnold Bank (born 1908), Edward Karr (born 1909), Paul Standard (born 1896), and Lloyd Reynolds (*Italic Calligraphy and Handwriting*; 1969). In 1958 Reynolds went a step further and mounted an exhibition at the Portland Art Museum entitled 'Calligraphy: the Golden Age and its Modern Revival' which was the result of many years of historical study, research and practical work. Another influential exhibition (mostly works of British calligraphers) was organised by P.W. Filby in 1959 at the Peabody Institute Library in Baltimore on 'Calligraphy and Illumination'; this was followed, two years later, by 'Calligraphy and Handwriting in America, 1710–1961'. Filby was also connected with an exhibition on 'Two Thousand Years of Calligraphy' held in 1965 at the Walters Art Gallery in Baltimore, which was accompanied by a detailed and scholarly catalogue.

Today calligraphy-related activities concentrate themselves mainly around well-known teaching centres (such as New York, Rhode Island, Chicago, Portland, Oregon, Boston, California), a wide use of fine writing in commerce (much more pronounced and more positive than in Europe, it encourages experiments), and individual circles where calligraphy is practised and taught both as an art form and a traditional craft. On the whole calligraphy is increasingly alive, widely practised and appreciated; there are now more groups, more conferences, more exhibitions, and more periodicals produced by influential societies, such as *Alphabet* (for the Friends of Calligraphy, San Francisco), *Calligraphy Idea Exchange* (a quarterly magazine), and *Calligraphy Review* [151]. There are also more courses at art schools or run by private individuals and groups (some of them formal and structured, others less so), more national and international conferences, and a good deal more general awareness of calligraphy than in Europe. One of the reasons lies perhaps in the fact that in America there is less divide between calligraphers, artists, designers and amateurs. The role of amateurs should not be

151 This cover of Calligraphy Review *(1988) uses a section from Ann Hechle's calligraphic exploration of the nursery rhyme 'Lavender's Blue'*

'Lavender's blue
 dilly dilly
lavender's green
when I am king
 dilly dilly
you shall be queen'.
Hechle, a British calligrapher, often uses the sense, sound and meaning of words as a guide to her work. The present composition, which took almost two years to complete, consists of one single vellum panel (70 × 54 cm in size) incorporating thirteen smaller ones, all showing separate interpretations of the verse.

underestimated; the writing masters of previous centuries did, after all, keep the tradition alive by teaching to all who were willing to learn. After the 1950s, which saw a general regrouping of ideas and resources, an additional stimulus was provided by some prominent British calligraphers [151] such as Sheila Waters, David Howells and (most of all) Donald Jackson [*see* PLATE XII] taking up teaching appointments at American centres, stimulating workshops and the foundation of new societies which in turn created a further need for tutors. There has also been an increase in media coverage, a large number of books covering special aspects of calligraphy, and periodicals promoting both an interest in formal historical scripts while at the same time introducing new trends and new practitioners to the audience.

Eastern continuation

In the Islamic countries and in the Far East the situation has always been rather different. There printing did not inaugurate a break with tradition, and in consequence, calligraphy never became a disinherited art. Without any Industrial Revolution there was also no definite rupture in the fabric of society, and traditional values continued. Western influence, despite long periods of political and economic dominance, was in the final instance peripheral. Moreover, calligraphy had never been a craft bound to form and function but an expression of deeply felt sentiments connected with the inner life of the people: in Islam this meant the message of the Koran, and in the Far East the individualist essence of an otherwise communal culture (or as the contemporary Japanese calligrapher Naruse Eizan puts it 'when you write calligraphy you are portraying yourself on paper').

Today calligraphy continues to thrive in Japan [152, 153] where it is not only a major art form but also a lucrative business. Prices for a good piece of calligraphy start very often around £4,000, while items sold during one of the large and prestigious exhibitions which are staged regularly in the big cities can change hands for as much as £1,000,000. In the West nobody would be prepared to invest such sums in a fine piece of writing.

Calligraphy has retained its position, practically unchanged, within the environs of Buddhist and Zen monasteries. But it is also taught as a subject at university level. There are special schools of calligraphy, and university professors and teachers act as advisors or trustees to the main exhibitions. Together with sculpture and painting, calligraphic items are represented at the annual, Government-sponsored Nitten exhibitions. Works of calligraphy are displayed in most major museums (a new trend since traditionally calligraphy has always been displayed in the home). There are at present many prestigious societies and circles practising calligraphy. It is also taught as part of the school curriculum; those who have not acquired a good handwriting by the time they reach adulthood often feel embarrassed about it. Unlike

in the West, good handwriting is still important. Children are taught how to write, how to handle the brush and how to sit properly. 'Well written' still implies calligraphic aspirations, not just textual excellence [154].

Traditional styles of calligraphy are of course widely practised and many modern calligraphers look for inspiration in forms of writing used in China [155] at the beginning of the Christian area. But, in addition, a number of new, partly experimental styles have emerged, especially in the post-war period. One such style is Zen'ei shodo, an abstract avant-garde form of calligraphy, done at great speed (rather like Western action painting) and with abstract titles (sometimes only numbers) which can be written in Roman letters. Zen'ei shodo has its own masters but it is not universally admired and not truly within the tradition. Other trends come from various directions: the Modern Poetry Movement, Single Character Calligraphy, or calligraphy using only *kana*, or a mixture of *kanji* and *kana* signs. There are also prominent modern Zen and Siddham masters (such as for example Hisamatsu Sinchi and Tokuyama Gijun respectively) whose work is much valued, aesthetically as well as financially.

How then does calligraphy fare in Communist China? There are without doubt certain ideological difficulties when it comes to accommodate what was for so long an elitist art form. *Information China*, a 'comprehensive and authoritative reference source of New China' organised by the Chinese

始建國天鳳元年

王門大煎都兵完

堅析傷溥

一九八乙之二十四月

臨

Academy of Social Science and published in three large volumes in 1989 devotes altogether only two pages of volume three to the subject of calligraphy. When it comes to contemporary trends it states that:

'in recent years there has arisen a craze for calligraphy in the cities. Most prominent are the calligraphic activities of old people. They hold exhibitions and found publications, playing a considerable role in giving publicity to the effectiveness of calligraphy in practising moral culture, moulding temperament and building both physical and mental health. A calligraphic contest jointly held by the Central TV Station and the Chinese Calligraphers' Association in 1986 attracted numerous lovers of calligraphy and aroused their enthusiasm for the art. Master calligraphers of modern times include She Yinho (1883–1971), Sha Menghai and Lin Sanzhi.'

The entry concludes, somewhat ruefully, that 'to develop Socialist fine arts on the basis of the national heritage is the historical mission of people of the present era, but there is no ready formula to follow to achieve this goal.'

But in the aftermath of the Cultural Revolution calligraphy does tentatively flourish, and not only amongst 'old people'. Good writing has a place in the school curriculum though not perhaps in quite the same way as in Japan (there is of course less leisure time and, given the predominantly rural character of China, a much lower level of literacy). But encouragement is not altogether lacking; there are children's competitions with prodigies being feted and even sent abroad to demonstrate their skill in front of foreign audiences. Calligraphy is also taught at art schools and some artists, such as Wang Jianan (who recently visited London), are experimenting with new ideas and new styles in a manner which would not have been possible in pre-Communist China. Calligraphy may no longer be an elite art form (the old elite has long since gone) but it is now making inroads into many aspects of everyday life. Calligraphers are hired to design notepaper heading, head boards for houses and commercial buildings; they are employed to write menus for restaurant owners, and publishing houses use their services for writing book titles and chapter headings. There are still schools of calligraphy where traditions are preserved and the art of seal carving is very much alive. Also alive is the time-honoured habit of conserving the calligraphy of famous statesmen for posterity, if no longer always in stone, then certainly in printed form. During Mao's ascendancy examples of his handwriting [156] were widely published, and characters written by him were on the mast-head of the *Peoples Daily*.

For many countries which have been under colonial rule, the latter part of the 20th century has been one of patriotism and rediscovery, enabling them to re-evaluate their own identity. Contemporary Islamic calligraphy is thus greatly influenced by a growth in awareness among Muslims which has engendered a strong sense of ethnic, religious and national identity. Today calligraphy flourishes in the Muslim countries of North Africa, the Middle

156 *Because of its inherent prestige, Chinese calligraphy has always played a significant role in the cult of personality and has, as such, been used for political propaganda. During the time of his ascendancy, the handwriting of Chairman Mao Zedong was widely displayed throughout China on posters, as newspaper headlines or, as here, reproduced together with his poetry.* BRITISH LIBRARY, ORIENTAL AND INDIA OFFICE COLLECTIONS, 15597.C.1

East and Southeast Asia (especially Malaysia). There are well-known exponents of various schools, frequent exhibitions, societies (sometimes state-encouraged and/or state-funded), and there are also (as has always been the case with Islamic calligraphy) a good many patrons. Most interesting, however, is the fact that apart from traditional forms of calligraphy, there is a rich harvest of new ideas and experiments. Many calligraphers accept a certain amount of what one must call non-Muslim influence from their surroundings rather then relying entirely on geographical or national elements, but such elements are on the whole subordinated to the calligrapher's awareness of Islam.

At present a number of definite trends can be observed and isolated within Islamic calligraphy (IRF; p.368). Traditional forms [see 68] have of course continued, and their main exponents and patrons can be found (though by no means exclusively) within the sphere of religious Muslim schools. But many modern calligraphers have studied at Western universities and come into contact with Western concepts of art [159]. Since Muslim countries are now politically independent such influence is in a way more easily accepted and absorbed. It is also nearly always modified, given a truly Islamic (and often also local) flavour, and, most importantly, it is hardly ever purely imitative. One such trend is to be seen in a form of figurative calligraphy in which calligraphic and figural elements are integrated in a fashion which makes it

157 *Modern Arabic calligraphy by Nab Mahdaoui (born 1937), untitled, ink on parchment, 1980s. Mahdaoui was born in Tunis and studied at the Ateliers Libres de Carthage and at the Santa Andrea Academy in Rome. In this work he uses Kufic letterforms to create an explosive composition; the words themselves have no meaning.*
BRITISH MUSEUM, DEPARTMENT OF ORIENTAL ANTIQUITIES, OA 1991.6.–02

158 *Calligraphic silk screen print by Ahmed Moustafa; a composition based on the* surat al-ikhlas, *dated 1938.*
BRITISH MUSEUM: AO 1987 6–4, 04

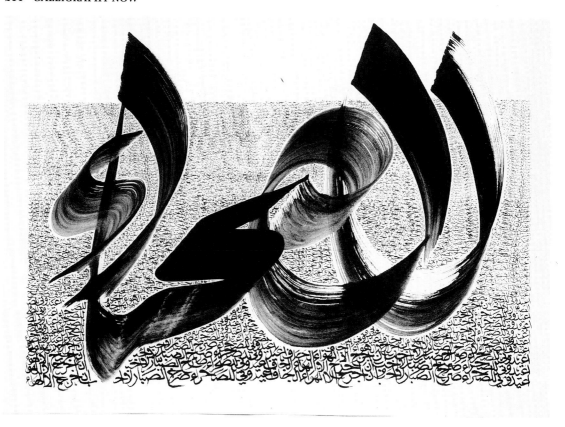

impossible to separate one from the other. Another school is a certain type of expressionistic calligraphy which, though related to contemporary Western ideas and movements, uses a decisively Islamic 'vocabulary'; in this style emotional elements are expressed through distortion and exaggeration. Another style turns letters and words into symbols which can then be used to express ideas [158]. Finally, a form of abstract calligraphy exists where letters and geometrical shapes are used only for their outward form, quite divorced from the tradition and also from any verbal message [157]. This, of course, is a radical departure from the original purpose of Islamic calligraphy which has only one objective, namely that of conveying the message of the Koran.

Nationalism and feelings of national identity have also influenced the development of contemporary Korean calligraphy. After the middle of the 20th century Korea saw not so much a revival but a definite revitalization of its calligraphy and, even more important, for the first time a form of calligraphy which developed along strictly nationalistic lines. Up to then Korean calligraphy had been largely derivative, first (since the beginning of the Christian era) from Chinese ideas and then, after 1920, from Japanese concepts of calligraphy. Today many modern calligraphers [160] no longer rely entirely on the Chinese script but use, increasingly, King Sejong's truly Korean alphabet (*see* p.116).

159 Modern Arabic calligraphy by Hassan Massoudy (born 1944); Al-Sahra, 1982. Massoudy was born in Iran and trained in Baghdad as a calligrapher. In 1969 he attended the École des Beaux Arts in Paris. His composition is made up of the Arabic word for desert (al-Sahra) superimposed on the following lines of poetry: 'take me back to the desert, I only like to be flayed by the dry wind.'
BRITISH MUSEUM, DEPARTMENT OF ORIENTAL ANTIQUITIES, OA 1987.1.–190

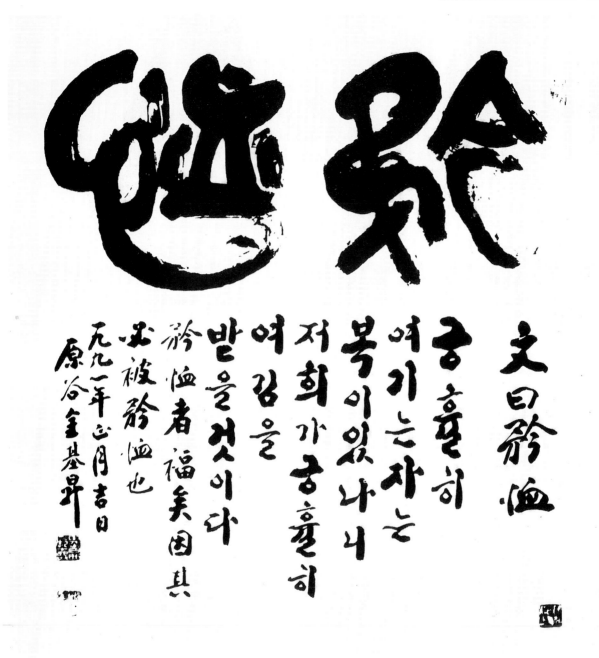

160 An example of the work of Kim Ki Seoung as shown at the '30th exhibition of Calligraphy by Kim Ki Seoung' in Seoul, 1990. Kim Ki Seoung, one of Korea's leading contemporary calligraphers, studied Chinese painting and calligraphy in Shanghai and after his return to Korea opened the Daeseung Calligraphic Institute which encouraged calligraphy as well as research into the subject. He has taught at the Seoul National University College of Fine Arts, the Sukmyong Women's University and the Sangmyong Women's University. In his own work he makes extensive and imaginative use of the National Korean alphabet (Hangul); in 1966 he published (in Korean) a much needed and long overdue 'History of Korean Calligraphy'.

Symbiosis ?

What then of the future? Judging from present trends what direction is calligraphy likely to take?

For Eastern as well as Western scribes the middle of the 20th century marked not so much a turning point as a pause, and with it a chance to take stock. The newly found confidence in their national identity not only encouraged Islamic calligraphers to express themselves in a manner which was both traditional and inventive, but also enabled them to come to terms with ideas some of their young people had assimilated at Western universities and art schools. But Western artists and calligraphers, too, have been influenced by their Eastern counterparts [161]. Already in the 19th century the architect and designer Owen Jones had published *The Grammar of Ornament* (1856) in which he drew attention to Islamic design by examining Eastern and Western motifs. His ideas were not lost on William Morris and his successors. By the end of the 19th century Western painters began to appreciate and study Eastern concepts such as an awareness of the problem of two-dimensional design and the overall quality of pattern; in fact, French Impressionists owe much to Oriental concepts, especially to Japanese Ukiyo-e ('Floating World') paintings. As the 20th century progressed a number of individual artists felt increasingly more drawn to Eastern concepts and began to make use of Oriental techniques in their own work.

One artist whose work transformed itself greatly under the influence of Chinese and Japanese calligraphy was the American Mark Tobey (1890–1976). Originally a portrait painter, Tobey travelled to China in the 1930s and began to work on calligraphy under the influence of the Chinese artist Deng Kui. Though a stay in a Zen monastery in Kyoto failed to provide him with the obligatory enlightenment, he was profoundly moved by the similarity of spiritual intensity in most Western as well as Oriental art and in consequence rejected both perspective and three-dimensional reality, using, in his own words, 'the calligraphic impulse to carry ... work into some new dimension'. After the 1960s Oriental culture and Eastern philosophy became a growth industry among certain groups of Western artists and intellectuals and a good number of Western calligraphers tried to master Chinese or Japanese calligraphy, form circles and teach their own disciples. Not all such ventures were entirely successful. Tobey had wisely realised that he himself would always remain a Westerner and that any successful symbiosis has to be based on the acceptance of one's own identity. However, the new ideas proved greatly stimulating, successfully challenging some of the most basic concepts of Western calligraphy: the classical formality, the reliance on form and function and the absolute need for legibility ('unambiguous communication').

The logical step from calligrams [*see* 98], text pictures [162], and calligra-

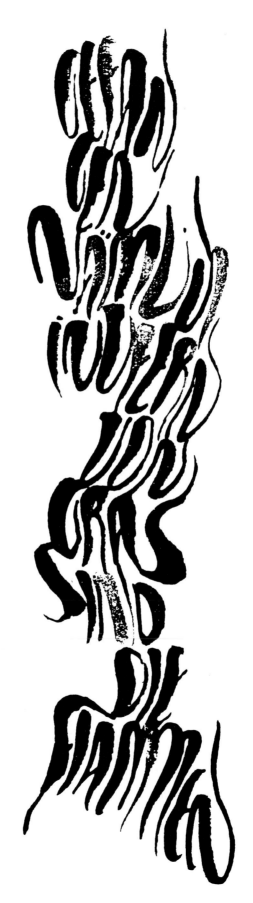

161 Hans Joachim Burgert (born Berlin 1928), a calligrapher, painter and musician, comes close to the traditional Chinese concept of calligraphy. In some of his brushwork lines take their inspiration from nature. An example from his book Ludus Scribendi III (1969) which reads 'Gefangen naehmlich in Ufern von Gras sind die Flammen' (but imprisoned by banks of grass are the flames).

REPRODUCED WITH MR BURGERT'S PERMISSION

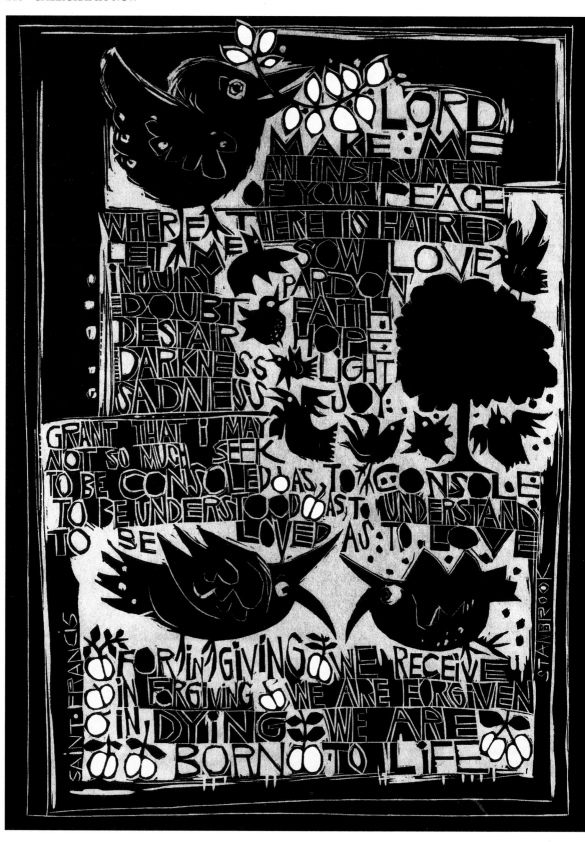

phic paintings led to 'painting with words': to a link between the visual expression of emotions and calligraphy. Calligraphic compositions are now often conceived as wall hangings (a Far Eastern concept; Western and Islamic traditions base themselves on the book) and looked upon in the same way as paintings. Letter-sculpture, like the ones produced by Hans Schmidt (NG; p.211) moves calligraphy into the third dimension. The rigid 'Trajan' orthodoxy (*see* p.187) no longer dominates the scene as letter carvers create

162 A text picture (lino-cut) by the American artist Meinrad Graighead making use of Francis of Assisi's prayer. Produced during the time when Graighead was still a Benedictine nun, it forms part of a calligraphic series called 'Posters of God' (c.1970). The basically regular shape of letters has been hacked into crude forms which are welded into a rough unity. Graighead, who is also a painter, has used the figures of birds, trees and flowers to illustrate the page in manner reminiscent of medieval traditions. PROPERTY OF THE AUTHOR

163 A painting by Wendy Yeo making use of calligraphic brushwork. Yeo was born in Hongkong but trained at the Slade School in London and now lives and works in England. Her paintings combine Western and Chinese techniques and traditions. REPRODUCED WITH PERMISSION OF MS WENDY YEO

164 Expressive calligraphy moves from the purely verbal towards the visual. It requires a loosening up of strict letterforms, writing (rather like Far Eastern calligraphers) with speed, without hesitation, writing 'to music, staying with the beat, letting your hand dance freely across the paper'.
REPRODUCED WITH PERMISSION FROM ROSEMARY SASSOON'S *THE PRACTICAL GUIDE TO LETTERING & APPLIED CALLIGRAPHY*

their own style, often integrating their work into the concept of a building (a good example is Ralph Beyer's lettering in Coventry Cathedral).

At the same time as Eastern calligraphers started to experiment with abstract art, Western calligraphers began to discover the possibilities of creating visual images with the help of letterforms, colours, materials, writing instruments (pencil, brush, spray-can or felt marker being used in addition to the pen), and an original management of space in order to express their ideas and feelings. In some ways these various new forms of Expressive Calligraphy [164] which break the boundaries of traditional lettering are moving away from being simply a craft (which in Johnston's words provides serviceable and useful things) towards the realm of art (which exists in its own right). At the beginning of the century Rudolph von Larisch had made a tentative step in the same direction; German calligraphy, too, had, early on, opted for inventiveness. Already Rudolf Koch had felt that the revival of calligraphy was more likely to come from a new beginning than from a study of historical forms. Out of this a number of new trends have emerged. There is for example the tendency to link letters with images that draws on both

165 Some examples of graffiti, London, 1993. Graffiti has a long history. In classical Rome professional poster painters wrote election manifestos and advertisements on house walls (dipinti and graffiti); in fact some 1600 such examples have been found in Pompeii alone.
PHOTOGRAPHED BY HILARY HENNING AND RICHARD KENNEDY

medieval Western traditions and the Far Eastern integration of painting and calligraphy. Another new experimental trend, Polylineal calligraphy [see PLATE XIII], goes a step further by not just interpreting but actually altering the text, in some cases making it illegible, communicating visually not just verbally; sometimes patterns are formed reminiscent of Islamic or Far Eastern calligraphy. Graffiti [165] is another important mode of written expression which uses a variety of letterforms, sometimes plain capitals, sometimes hardly legible cursive forms of script (graffiti appeals indirectly, it is not an inscription), sometimes purposely obscured characters and

abbreviations. Graffiti is mainly an urban art form; and there are at present in cities like London and New York groups of practitioners which centre around a 'teacher' and his style. Graffiti has of course a long history; we have only to think about the notices found in the ruins of Pompeii and Herculaneum in Italy (1st century AD) or those on the way up to the rock fortress of Sigiriya in Sri Lanka (6th century AD). It can also be used as a political tool – for example the wall writings of students in China during the unrest which led to Tiananmen Square.

The place most open to change has been America where calligraphy has always depended on outside influence: first on English copy-books and immigrants, then on Edward Johnston, to a lesser extent on other European movements, and eventually also on trends coming from China and Japan. There is the danger that self-expression and inventiveness without any traditional basis will soon lose themselves in a search for shallow effects. British calligraphers have never quite deserted their sound grounding and the discipline imposed by historical letterforms, and today the various forms of Free or Expressive Calligraphy exist side by side with traditional [166] and ceremonial work; indeed the best contemporary calligraphers are equally proficient in both [167].

> If you let what is written sink in then you will discover that there is more written than just the written words. Only when you can see through the surface crust of words and lines does the text reveal its true secrets, its deeper meaning. And that is what is really written.
> ARIE TRUM

166 Julian Waters, Littera scripta manet (letters made by hand); Roman Capitals in watercolours written with a large handmade brass poster pen. Waters was born in England in 1957 but now lives and works in the United States. 'I look at lettering as a huge palette which includes calligraphy, type-forms, and everything in between. The colours of that palette can be mixed into an infinite variety of blends'.

167 In the Land of Mordor where the Shadows lie. Variation 5 by Donald Jackson; 1988. From J.R.R. Tolkien's The Lord of the Rings. Written with black Chinese stick on hand-made paper. Underneath the freedom and originality there is still an echo of traditional discipline REPRODUCED WITH MR JACKSON'S PERMISSION

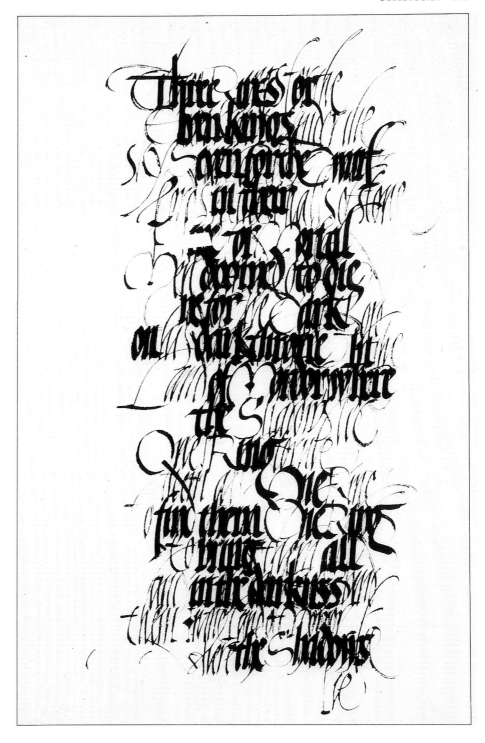

SELECT BIBLIOGRAPHY

ABBOTT, NABIA *The Rise of the North Arabic Script and its Kur'anic Development* With a full description of the Kur'an manuscripts in the Oriental Institute, University of Chicago. Chicago, 1939

ADAMS, STEVEN *The Arts and Crafts Movement* New York, 1987

AHMAD, SYED BARAKAT *Introduction to Qu'ranic Scripts* London, 1984

ALEXANDER, J.J.G. *The Decorated Letter* London, 1978

ANDERSON, DONALD M. *The Art of Written Forms: the Theory and Practice of Calligraphy* New York, 1967

ANGEL, MARIE *Painting for Calligraphers* London, 1984

ANGLE, MARIE *The Art of Calligraphy; a practical guide* London, 1978

ATIL, ESIN *The Brush of the Masters* Washington, 1978

AVRIN, LEILA *Scribes, Script and Books: the Book Art from Antiquity to the Renaissance* London/Chicago, 1991

BABINGER, FRANZ *Die gross herrlichen Tughra: Beitraege zur Geschichte des Osmanischen Urkundenwesens* Leipzig, 1975

BAKER, ARTHUR *Brush Calligraphy* New York, 1984

BAKER, ARTHUR *The Calligraphy Manual* London, 1982

BAKER, ARTHUR *Calligraphic Alphabets* London, 1974

BEGLEY, W.E. *Monumental Islamic Calligraphy from India* Villa Park, 1985

BENSON, JOHN HOWARD *The first Writing Book: Arrighi's La Operina* Oxford, 1955

BILLETER, J.F. *Chinese Calligraphy to date* Geneva, 1989

BROWN, MICHELLE P. *A Guide to Western historical Scripts from Antiquity to 1600* London, 1990

BROWN, YU-YING *Japanese Book Illustration* London, 1988.

BUEHLER, C.F. *The fifteenth-century Book: the Scribes, the Printers, the Decorators* Philadelphia, 1960

BUTTERWORTH, EMMA M. *The complete Book of Calligraphy* Wellingborough, 1981

CAMP, ANN *Pen Lettering* rev. edn. London, 1984

CARTER, HARRY *A View of early Typography* Oxford, 1969

CATICH, EDWARD M. *Letters redrawn from the Trajan Inscription in Rome* Davenport, 1961

CATICH, EDWARD M. *Reed, Pen and Brush Alphabets for Writing and Lettering: Portfolio of 27 Alphabets with descriptive Book* Davenport, 1968.

CHIANG, YEE *Chinese Calligraphy, an Introduction to its Aesthetic and Technique* 3rd edn. Cambridge (Mass.), 1973

CHIANG, YEE *Chinese Painting and Calligraphy 5th century BC - 20th century AD* Beijing, 1984.

CHIBETT, DAVID *The History of Japanese Printing and Book Illustration* Tokyo, 1977

CHILD, HEATHER (ed.) *Calligraphy today; twentieth' century Tradition and Practice* 3rd edn. London, 1988

CHILD, HEATHER *The Calligrapher's Handbook* USA Taplinger, 1985

CHI-MAI, CH'EN *Chinese Calligraphers and their Art* New York, 1966

COBBDEN SANDERSON, T.J. *The ideal Book or the Book beautiful, a Tract on Calligraphy* Berkeley, 1982

DIRINGER, DAVID *The Hand-produced Book* London, 1953

DODD, ERICA CRUIKSHANK *The Image of the World: a Study of Quranic verses in Islamic Architecture* Beirut, 1981

DROGIN, MARC *Medieval Calligraphy: its History and Technique* London, 1980

EARNSHAW, CHRISTOPHER J. *Sho, Japanese Calligraphy: an in-depth Introduction to the Art of writing Characters* Vermont/Tokyo, 1989

ECKERT, CARTER J. et al. *Korea old and new: a History* Seoul, 1990

EDGU, FERIT *Turkish Calligraphic Art* Istanbul, 1980

ELLSWORTH, ROBERT HATFIELD *Later Chinese Painting and Calligraphy, 1800–1950* New York, 1987

FAIRBANK, ALFRED *A Handwriting Manual* rev. ed. London, 1975

FAIRBANK, ALFRED *The Story of Handwriting: Origin and Development* London, 1970

FAIRBANK, ALFRED and WOLPE, BERTHOLD, *Renaissance Handwriting: an Anthology of Italic Scripts* London, 1960

FANG ZHOALING *Painting and Calligraphy* Hongkong, 1981

FARUQI, ISMAIL R. and FARUQUI, LOIS LAMAYA *The cultural Atlas of Islam* London, 1986

FILBY, P.W. *Calligraphy and Handwriting in America 1710–1961 assembled and shown by the Peabody Institute Library, Baltimore, Maryland, November 1961 – January 1962* New York, 1963.

FOLSOM, ROSE *The Calligraphers' Dictionary* With an introduction by Hermann Zapf. London, 1990

FONTAIN, JAN and HICKMAN MONEY, L. *Zen painting and Calligraphy* Philadelphia/Boston, 1971

DE FRANCIES, J. *Visible Speech – the diverse Oneness of Writing Systems* Honolulu, 1989

FU, SHEN C.Y., et al. *Traces of the Brush – Studies in Chinese Calligraphy* New Haven, 1977

FU, SHEN C.Y., LOWRY, GLENN D. and YONEMURA, ANNE *From concept to context: approaches to Asian and Islamic Calligraphy* Washington, 1986

GAUR, ALBERTINE *A History of Writing* 3rd revised edn. New York/London, 1992

GAUR, ALBERTINE *Writing Materials of the East* London, 1979

GHAFUR, MUHAMMAD ABDUL *The Calligraphy of Tatta* Karachi, 1968

GOEPPER, ROGER *Worte des Buddha, Kalligraphien japanischer Priester der Gegenwart* Koelin, 1982

GOEPPER, ROGER *Sho: Pinselschrift und Malereien in Japan vom 7.-19. Jahrhundert* Koeln, 1975

GOETZ, HEINZ (ed.) *Chinesische und Japanische Kalligraphie aus zwei Jahrtausenden* Muenchen, 1987

GOINES, DAVID LANCE *A constructed Roman Alphabet. A geometrical Analysis of the Greek Roman Capitals and of the Arabic Numerals* Boston, 1982

GORDON, HUGH *The Gordon Book: Lettering for Commercial People* Cincinnatti, 1918

GOURDIE, TOM *Calligraphy for the Beginner* London, 1983

GRAY, NICOLETE *A History of Lettering, creative Experiment and Lettering Identity* Oxford, 1986

HALEM, HILLMANN von (ed.) *Calligraphy in Modern Art* Papers read at a Symposium organized by the Goethe Institute Karachi, and the Pakistan-German Forum. Karachi, 1975

HAMEL, CHRISTOPHER DE *Medieval Craftsmen: Scribes and Illuminators* London, 1992

HARRIS, DAVID *Calligraphy: Inspiration, Innovation, Communication* London, 1991

HARVEY, MICHAEL *Calligraphy in the Graphic Arts* London, 1988

HEAL, AMBROSE *English Writing Masters and their Copybooks* Introduction on the development of handwriting by Stanley Morison. London, 1931

HOEFER, KARLGEORG *Schriftkunst* Edited by Gottfried Pott and Herbert Maring. Hardheim, 1989

HUNG, WILLIAM S. *A complete Course in the Art of Chinese Calligraphy* Hongkong, 1983

HUNTER, D. *Papermaking, the History and Technique of an Ancient Craft* 2nd edn. New York, 1947

JACKSON, DICK *Copper plate Calligraphy* New York, 1979

JACKSON, DONALD *The Story of Writing* 2nd edn. London, 1987

JAMES, DAVID *Qur'ans of the Mamluks* London, 1980

JESSEN, PETER (ed.) *Masterpieces of Calligraphy, 261 Examples 1500–1800* New York, 1981

JOHNSTON, EDWARD *Formal Penmanship and other papers edited by Heather Williams* London, 1971

KAECH, WALTER *Rhythm and Proportion in Lettering* Switzerland, 1956

KAUKOL, MARIA J.C. *German Calligraphy to date* 1980

KAPR, ALBERT *Kalligrafische Expressionen* Leipzig, 1988

KARLGREN, BERNARD *Sound and Symbol in Chinese* London, 1962

KHATIBI, ABDELKEBIR and SIJELMASSI, MOHAMMED *The Splendour of Islamic Calligraphy* London, 1976

AL-KHATTAT, HASHEM *Islamic Calligraphy* London, 1978

KIM, SCOTT *Inversions, a Catalogue of calligraphic Cartwheels* Peterborough, 1981

KIM, YONG-YUN *Hanguk Sohwa Immyong Saso: Biographical Dictionary of Korean Artists and Calligraphers* Seoul, 1959

KNIGHT, STAN *Historical Scripts: a Handbook for Calligraphers* New York, 1984

KOTZENBERG, HEIKE *Bild und Aufschrift in der Malerei Chinas: unter besonderer Beruecksichtigung der Literatenmaler der Ming Zeit (1368–1644) T'ang Yin, Wen Cheng-Min und Shen Chou* Wiesbaden, 1981

KRIMPEN, JAN van *On Designing and Devising Type* New York, 1957

KWO, DA-WEI *Chinese Brushwork in Calligraphy and Painting, its History Aesthetics and Techniques* Montclair, 1981

LAI, T.C. *Chinese Calligraphy, its Mystic Beauty.* Kowlon, 1973

LAI, T.C. *Chinese Calligraphy, an Introduction* London, 1975

LAUF, D.I. *Tibetan Sacred Art: the Heritage of Tantra* London, 1976

LEDDEROSE, LOTHAR *Mi Fu and the classical Tradition of Chinese Calligraphy* Princetown, 1979

LEGEZA, LASZLO *Tao Magic, the Secret Language of Diagrams and Calligraphy* London, 1975

LINGS, MARTIN and SAFADI, YASIN HAMID *The Qur'an* Catalogue of an exhibition of Qur'an manuscripts at the British Library, 3 April–15 August 1976. London, 1976

LONG, JEAN *The Art of Chinese Calligraphy* Pool, 1987

LONG-YIEN CHANG, LEON and MILLER, PETER *Four thousand Years of Chinese Calligraphy* London, 1990

LIVINGSTON, MARCO *Pop Art* Catalogue of an exhibition held at the Royal Academy of Arts, London, 13 September 1991 – 19 April 1992. London, 1992

LOSTY, J.P. *The Art of the Book in India* London, 1982

MACDONALD, BYRON J. *The Art of Lettering with the Broad Pen* New York, 1973

MAHONEY, DOROTHY *The Craft of Calligraphy* London, 1981

MAZAL, OTTO *Palaeographie und Palaeotypie, Geschichte der Schrift im Zeitalter der Inkunabeln* Stuttgart, 1984

MCLUHAN, MARSHALL *The Gutenberg Galaxy* Toronto, 1962

MINORSKY, VLADIMIR *Calligraphers and Painters: a Treatise by Qadi Ahmad son of Mir-Munshi (ca A. H. 1015/A. D. 1606)* Translated from the Persian with an introduction by B.N. Zakhoder. Washington, 1959

MITCHELL, C. AINSWORTH *Inks, their Composition and Manufacture including Methods of Examination and a full List of British Patents* 14th edn. London, 1937

MOOKERJEE, AJIT and MADHU KHNANNA *The Tantric Way: Art, Science, Ritual* Delhi, 1977

MORAN, JAMES *Printing Presses – History and Development from the fifteenth century to Modern Times* London, 1973

MORISON, STANLEY *American Copy-books, an Outline of their History from Colonial to Modern Times* Philadelphia, 1951

MORRIS, IVAN *The World of the Shining Prince: Court Life in Ancient Japan* Penguin Books, 3rd edn, 1979

MOTE, FREDERICK W. and CHU, HUN-LAM *Calligraphy and the East Asian Book* (edited by Howard L. Goodman) Princeton, 1988

MURASAKI SHIKIBU *The Tale of Genji* Translated by E.G. Seidensticker. Penguin Books, 1976.

NAKATA, YUJIRO *Chinese Calligraphy* New York/Tokyo, 1983

NAKATA, YUJIRO *The Art of Japanese Calligraphy* 3rd ed. New York/Tokyo, 1983

NASH, RAY *American Penmanship 1800–1850: a History of Writing and a Bibliography of Copy Books from Jenkins to Spencer* Worcester, 1969

NASH, RAY *American Writing Masters and Copybooks; History and Bibliography through Colonial Times* Boston, 1959

NATH, RAM *Calligraphic Art in Mughal Architecture* Calcutta, 1979

OSLEY, A.S. *Luminario: an Introduction to the Italian Writing Books of the sixteenth and seventeenth Centuries* London, 1972

OSLEY, A.S. and WOLPE, BERTHOD *Scribes and Sources: Handbook of the Chancery Hand in the sixteenth century. Texts from early Masters selected, introduced and translated* London, 1980

PARKES, M.B. *English Cursive Bookhands 1250–1500* Oxford, 1969

POMMERANZ-LIEDTKE, G. *Die Weisheit der Kunst, chinesische Steinabreibungen* Leipzig, 1963

RAHMAN, P.I.S.M. *Islamic Calligraphy in Medieval India* Dacca, 1979

REED, R. *Ancient Skins, Parchment and Leather* London/ New York, 1972

REYNOLDS, LLOYD J. *Italic Calligraphy and Handwriting* New York, 1969

RICE, D.S. *The unique Ibn al-Bawwab Manuscript in the Chester Beatty Library* Dublin, 1955

RUBINSTEIN, RICHARD *Digital Typography – an Introduction to Type and Composition for Computer System Design* Reading, Mass., 1988

SAFADI, YASIN HAMID *Islamic Calligraphy* London 1978

STANFORD, JAMES HUGH *Ikkyu Sojun: a Zen Monk of fifteenth century Japan* Harvard, 1972

SASSOON, ROSEMARY *Computers and Typography* London, 1992

SASSOON, ROSEMARY *The practical Guide to Lettering and Applied Calligraphy* London, 1985

SASSOON, ROSEMARY *Handwriting, a new Perspective* London, 1990

SEI SHONAGON *The Pillow-book of Sei Shonagon* (Translated from Japanese by I. Morris). Penguin, 1981

SCHIMMEL, ANNEMARIE *Calligraphy and Islamic Culture* 2nd edn. London, 1990

SCHIMMEL, ANNEMARIE *Islamic Calligraphy* (Iconography of religions). Leiden, 1970

SHELLEY, DONALD A. *The Fraktur – Writings or Illuminated Manuscripts of the Pennsylvanian Germans* Allentown, 1961

SHEPHERD, MARGRET *Calligraphy now: new Light on traditional Letters* New York, 1984

SHIMIZU, YOSHIAKI and ROSENFELD, JOHN M. *Masters of Japanese Calligraphy: 8th–19th century* New York, 1984

SMITH, PERCY C. DELF *Civic and Memorial Lettering* London, 1946

SOGEN OMORI *Zen Buddhist Calligraphy* London, 1983

SOGEN OMORI and KATSUJO, TERAYAMA *Zen and the Art of Calligraphy: the Essence of Sho* London, 1983

STARY, GIOVANNI *Die chinesischen und mandschurischen Zierschriften* Hamburg, 1980

STEVENS, JOHN *Sacred Calligraphy of the East* London, 1988

STRIBLEY, MIRIAN *The Calligraphy Source Book, the essential Reference for all Calligraphers* Philadelphia, 1986

SULLIVAN, MICHAEL *The Three Perfections: Chinese Painting, Poetry and Calligraphy* London, 1974

TARR, J.C. *Calligraphy and the Chancery Script* San Leandro, Cal., 1973

THORPE, J.A. *The Gutenberg Bible – Landmark of Learning* San Marino, 1975

TSIEN, TSUEN-HSUIN *Writing on Bamboo and Silk: the Beginning of Chinese Books and Inscriptions* Chicago, 1962

UPDIKE, DANIEL B. *Printing Types: their History, Form and Use: a Study in Survival* Oxford, 1952

VINCE, JOHN *Creating Pictures with Calligraphy* London, 1987

WAGNER, CHARLES L.H. *The Story of Signs. From earliest recorded Times to the present 'Atomic Age'* Boston, 1954

WANG, FANGYU *Dancing Ink: pictorial Calligraphy and Calligraphic Painting* Hongkong, 1982

WELCH, ANTHONY *Calligraphy in the Arts of the Muslim World* Catalogue of an exhibition shown in Asia *House Gallery* in the winter of 1979, Folkstone, 1979

WHALLEY, JOYCE IRENE *English Handwriting 1540 – 1850* London, 1969

WHALLEY, JOYCE IRENE *The Pen's Excellence: Calligraphy of Western Europe and America* New York, 1980

WHALLEY, JOYCE IRENE *The Universal Penman, a Survey of Western Calligraphy from the Roman Period to 1980* Catalogue of an exhibition, Victoria and Albert Museum, July–September 1980. London, 1980

WHALLEY, JOYCE IRENE *Writing Implements and Accessories. From the Roman Stylus to the Typewriter* Vancouver, 1975

WILLETTS, WILLIAM *Chinese Calligraphy – its History and aesthetic Motivation* Hongkong, 1981

WONG, KWAN *In the Way of the Master: Chinese and Japanese Painting and Calligraphy* Houston, 1981

YAO, MIN-CHI *The Influence of Chinese and Japanese Calligraphy on Mark Tobey (1890–1976)* San Francisco, 1983

YAO, SUZANNE WEN-POU *Ostasiatische Schriftkunst* Berlin, 1981

YI, KI-BAEK *A new History of Korea* Seoul, 1984

ZAKARIYA, MOHAMMED *The Calligraphy of Islam: Reflections on the State of the Art* Washington, 1979

ZAPF, HERMANN *ABC –XY Zapf. Fifty Years of Alphabet Design* Edited by John Dreyfus and Knut Erickson. London, 1989

ZAPF, HERMANN *About Alphabets, some Marginal Notes on Type Design* New York, 1960

ZIAUDDIN, M. *A Monograph on Moslem Calligraphy With 168 illustrations of its various styles and ornamental designs.* Calcutta, 1932

INDEX